COUNTRY ROADS of ALBERTA

Liz Bryan

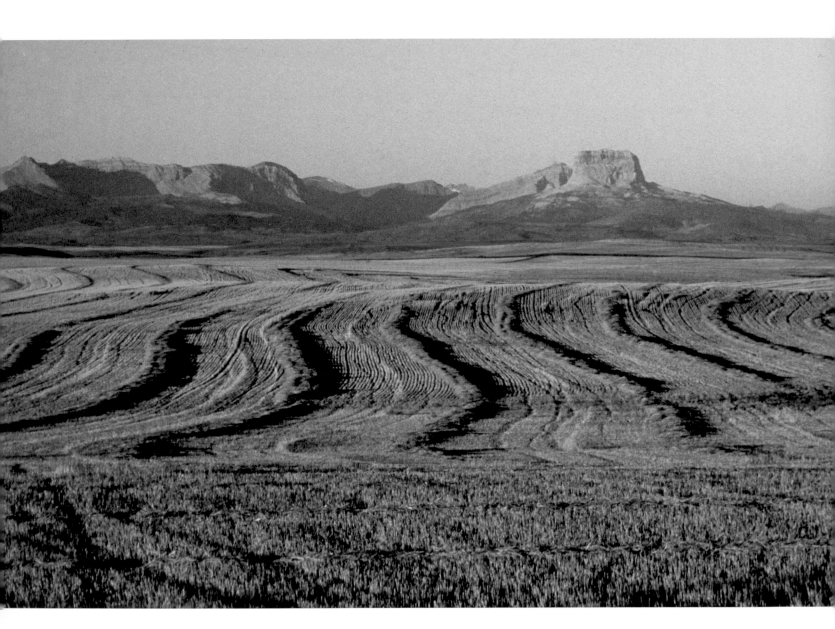

Montana's Chief Mountain, a Native icon, rises above fields of grain emblazoned by the sunrise.

Exploring the Routes Less Travelled

COUNTRY ROADS
of ALBERTA

LIZ BRYAN

VANCOUVER · VICTORIA · CALGARY

To my late husband, Jack,
who still inspires my photography

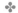

Heritage House	Heritage House
#108–17665 66A Avenue	PO Box 468
Surrey, BC V3S 2A7	Custer, WA
www.heritagehouse.ca	98240-0468

LIBRARY AND ARCHIVES CANADA CATALOGUING IN PUBLICATION

Bryan, Liz
Country roads of Alberta: exploring the routes less travelled / Liz Bryan.

ISBN 978-1-894974-29-5

1. Rural roads—Alberta—Guidebooks. 2. Automobile travel—Alberta—
Guidebooks. 3. Alberta—Guidebooks. I. Title.

FC3657.B79 2007 917.12304′4 C2007-902510-2

LIBRARY OF CONGRESS CONTROL NUMBER: 2006940148

Edited by Wendy Fitzgibbons
Proofread by Marial Shea
Book design and layout by Jacqui Thomas
Maps by Ana Tercero
All photography by Liz Bryan

Printed in China

Heritage House acknowledges the financial support for its publishing program from the Government of Canada through the Book Publishing Industry Development Program (BPIDP), Canada Council for the Arts, and the province of British Columbia through the British Columbia Arts Council and the Book Publishing Tax Credit.

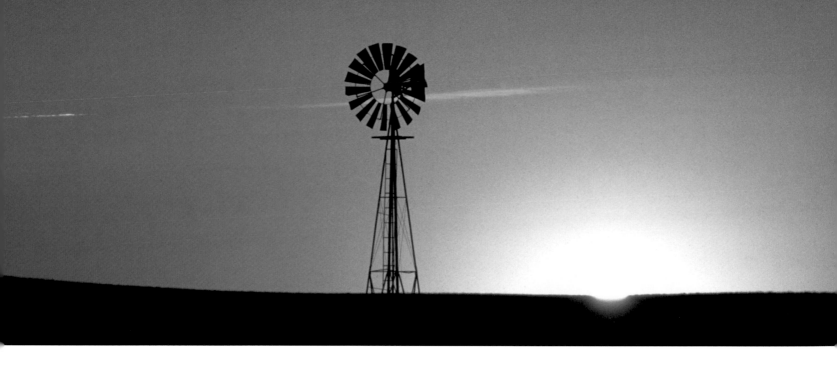

INTRODUCTION

The scenery of Alberta is as diverse as its topography. Fringed along its western edge by ranges of high mountains, the land descends through the soft shoulders of foothills to stretch out, seemingly forever, onto the plains. By far the largest of the three major zones in this Canadian province, the plains were once smothered under tonnes of grinding glacial ice and are undeniably horizontal—but hardly ever flat. Instead the land undulates, sculptured into low hills and ridges, deep coulees and potholes; there are sandhills that blew into existence around ancient lakes and river valleys ground down into the bedrock of far earlier eons. It is an old, worn land, one that has endured blistering heat and numbing cold, but its appeal is undeniable, that of a rolling landscape wide open to the changing light and the moods of the prairie sky.

The first people to call this land home hunted buffalo here. On unbroken hilltops and coulees are ancient tipi rings that mark their campsites and medicine wheels whose stones still hold memories of ancient ceremonies. Where the earth has been cultivated, nurtured fields, bright with every imaginable shade of summer green and harvest gold, spread an inviting tapestry over the land. And stitched among the fields are the embroideries of later human intervention: grid roads, homesteads, old barns, churches and graveyards of the first European immigrants, small towns and villages, railway stations and grain elevators. Despite more than 100 years of cultivation, there remains plenty of wildlife here: deer and antelope, goat and moose, beaver and prairie dog and birds everywhere, from hawks to hummingbirds and magnificent flocks of ducks and geese. But the huge numbers of wild buffalo are mostly gone, reduced to domestic herds cooped up in ranch fields.

Country Roads of Alberta is primarily a celebration of this province's many landscapes, some still wild and all most beautiful: the old bones of Earth, gentled by eons of wear and covered by a

Prairie rainstorm.

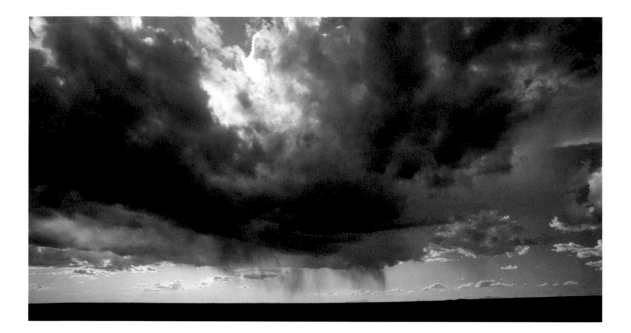

gorgeous coat of grass and flowers, trees and fields, basking under a vast and ever-changing sky. This prairie arch is so overwhelming that any appreciation of scenery must include its clouds, storms, rainbows, sun dogs, sunrises and sunsets—and the special, tender blue of a prairie summer. The book is also a guide to some of Alberta's loveliest roads, with driving directions and maps, along with snippets of archaeology, history, geology, ecology and many other things of interest along the way. Each road is a journey into the heart of beauty in southern Alberta.

THE GRID ROAD SYSTEM

It is relatively easy to find your way around the Alberta countryside, because it is stamped with the grid lines of roads and townships imposed on most of western Canada by the Dominion Land Survey, beginning in 1871. Surveyors based their plan on the geographical lines of latitude and longitude and divided the prairie land into squares, a unique checkerboard survey that covers 800,000 square kilometres, the world's largest survey grid. Starting near Winnipeg, the surveyors established north–south meridian lines roughly four degrees of longitude apart, intersected every 24 miles (38.6 kilometres—these distances were configured long before Canada adopted the metric system of measurement) by east–west base lines that start from the Canada–United States boundary. The meridians progress westward through Saskatchewan to the fourth meridian, which constitutes the border between Alberta and Saskatchewan, and the fifth meridian, which slices through Alberta roughly along the north–south line of Highway 2. The area between meridians is further divided into north–south "ranges," numbered east to west.

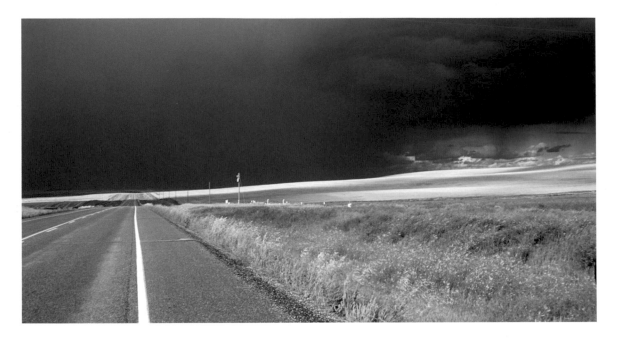

Within this grid, surveyors plotted townships roughly 36 miles square and divided into one-square-mile sections, numbered in a back-and-forth sequence. Odd-numbered sections were kept in government hands and were usually granted to the railways, though two sections in each township were set aside for schools. Even-numbered sections, divided into quarters, were made available for settlement, except for lands awarded as compensation to the former "landowner" of the territory, the Hudson's Bay Company. To visualize this system, which defined more than a million homesteads on the Canadian prairies, picture a chessboard: the black squares are odd numbered, the white squares even.

To navigate this geographical game board, travellers need to know the grid road system. Surveyors allocated road allowances between sections. North–south "range roads" are one mile apart; east–west "township roads" are two miles apart. This seems very sensible and easy to follow—but there is a problem. Because the earth is a globe, the lines of longitude (Alberta's range lines) converge at the poles and thus cannot be drawn continuously perpendicular to lines of latitude (Alberta's base and township lines). To maintain the integrity of a square grid, the Dominion surveyors put in "correction lines" every 24 miles. At these intervals, the range roads are offset by 300 feet (100 metres) or so to bring them back into line. This explains the eccentric "jog" that travellers experience as they drive the north–south roads. West from each meridian line, range road numbers start again from zero.

Most Alberta roads and highways adhere to the established grid unless prevented by intervening hills and mountains, lakes and rivers or the uneven landscape of glacial debris. But some

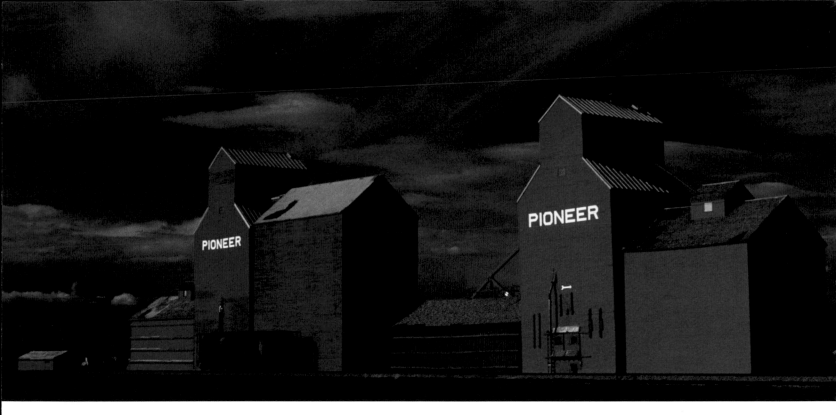

Part of a vanishing Alberta landscape, the grain elevators at Stavely flaunt their colours in the sunset.

routes, notably parts of highways 14, 15 and 16 east of Edmonton, follow a southeast-to-north-west bearing because they run parallel to train tracks, which were built on the diagonal through the railway allotments—the odd-numbered squares on the checkerboard.

Some of the country roads described in this book follow older trails along the land's natural routes through foothills and mountains, but many are the range and township roads of the surveyed grid. Most are unpaved—muddy when wet, dusty when dry—and many of the "settlements" marked on road maps may not exist, at least in terms of providing gas, accommodation or other amenities for tourists. Some seem to have disappeared altogether. But there are numbered signposts at nearly every grid road intersection in Alberta. If you have a good range road map, you will always be able to pinpoint exactly where you are.

Some advice: keep your gas tank reasonably full, and carry a cellphone. These beautiful roads are also some of the least travelled. Indispensable is the *Alberta Range and Township Road Atlas*, published by MapArt Publishing and readily available at most Alberta service stations. ❖

The Milk River rises in Montana and curves briefly into Alberta before slipping south again to join the Missouri River on its way to the Gulf of Mexico. It is one of only three Canadian streams to feed into the Mississippi watershed and the only one in Alberta. It is a beautiful stream, still wild, and it flows through some of the most interesting country in all of Canada—badlands and relic prairie, virtually untouched by "civilization," where rare plants and wildlife still flourish. The river was named in 1805 by Meriwether Lewis of the American Lewis and Clark Expedition because it was, as he described it, "…about the colour of a cup of tea with the admixture of a tablespoonfull of milk." The explorers saw the river in high water, churned up with glacial silt and brown mud from its banks, but at other times, the water is clear. Its wide, sheltered valley, tufted green with cottonwood and willow, is a linear oasis in the arid grasslands of the border country. And it has a geological tale to tell.

Toward the end of the most recent ice age (which just about smothered all of Alberta), the mountain glaciers to the southwest melted first, sending torrents of water onto the plains. But the ancestral river channels were still blocked by a thick sheet of continental ice to the east, and the meltwater backed up, forming a lake whose southern rim was the Milk River Ridge. As levels rose, the raging waters burst through the ridge and poured south into the Milk River through such breaks as Whiskey Gap, Lonely Valley and half a dozen coulees. Engorged by this fierce water flow, the Milk cut deeply into the land, down through ancient earth layers to the days of dinosaurs and far beyond. Eventually the continental ice melted, and the major rivers of southern Alberta resumed their original courses, heading for Hudson Bay. The meltwater lake drained and the Milk River shrank to its former size, still flowing south. Today, the river is known to geologists as an "underfit stream" and meanders through a surprisingly broad valley,

The magic of sunset turns the Milk River cliffs to gold.

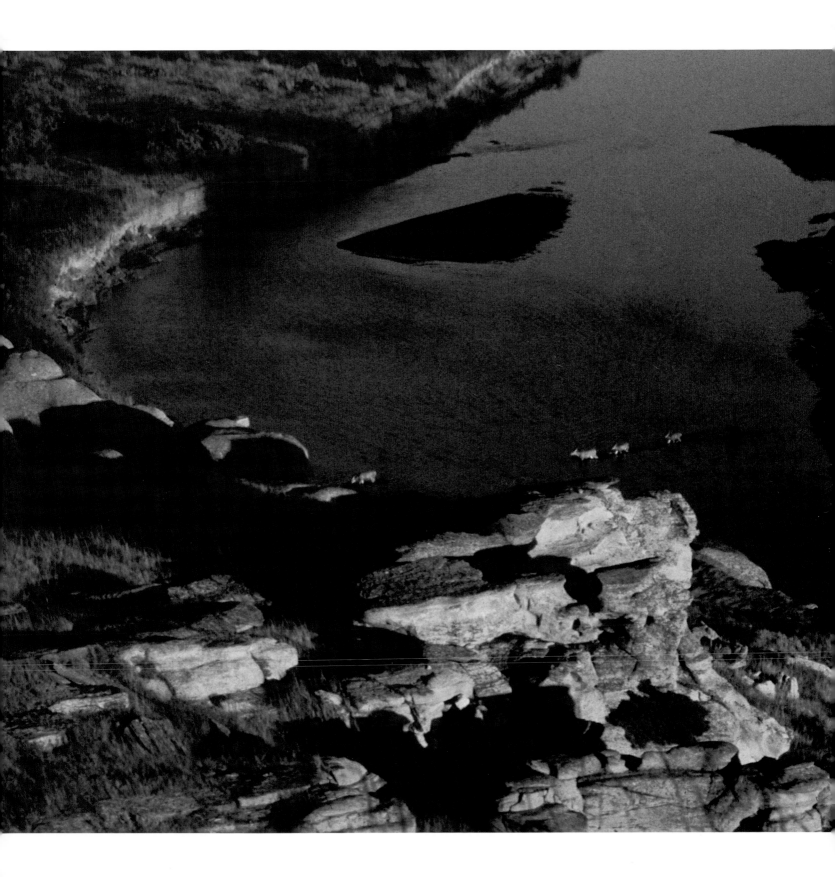

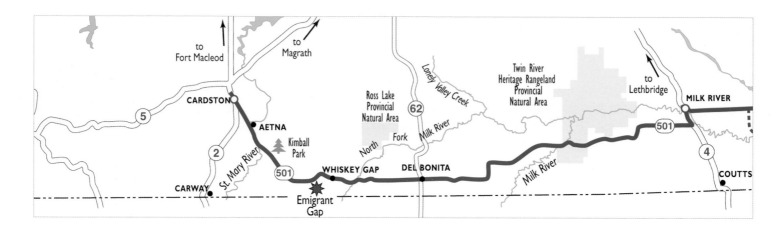

Keeping as close to the Canada–United States border as possible, this journey follows the lovely Milk River through some of the wildest lands of Alberta. It's a long day from Pincher Creek to Medicine Hat; allow for more time if you plan to visit Writing-on-Stone.

LEGEND

○	large community	- - -	optional route
●	small community	‖	bridge
✴	place of interest	♟	church
🌲	park/recreation site	✳	ferry

cut nearly 400 metres deep below the prairie level. Here, millennia of wind and water erosion have carved sandstone canyon walls into badlands every bit as stupendous as those of the Red Deer River farther to the north.

Where the badland hoodoos are thick and mysterious and the blue humps of the Sweetgrass Hills empower the horizon to the south, the Milk River Valley became a sacred place for the First Peoples of the plains. It was here that young men came for vision quests, fasting in solitude among the rocks, looking for guidance from the spirit world. Scratched into vertical sandstone bluffs along the river are pictures of epic events from the days when buffalo and wildlife were plentiful and tribesmen fought behind giant shields with bows and arrows. Archaeologists believe this rock art was inspired by visions—dreams turned to stone to outlive the dreamer. Other "writings" may be records of tribal events, the newspapers of the day. Certainly, later pictures portray the arrival of Europeans, the first guns, horses, wheeled wagons, forts, flags and gallows, even automobiles. Much of this art is protected within Writing-On-Stone Provincial Park, where the largest collection of Aboriginal rock art in Canada sheds light on the human history of the plains.

Because the Milk River in Alberta flows through arid land—the country that Captain John Palliser on his 1857 journey of discovery called "unfit for settlement"—much of the river's watershed

was never carved into homesteads or broken by the plough but was left as open rangeland. It is wild land still, rich with native grasses, flowers and wildlife, where tangible traces of Aboriginal life—the tipi rings of campsites, buffalo jumps, cairns and medicine wheels—can still be found.

There is little public road access around the river; perhaps the best way to appreciate the landscape is by canoe. But Secondary Highway 501, which stretches east–west across Alberta just north of the Montana border, cuts through it, provides some river access and, best of all, leads to Writing-On-Stone Provincial Park, the high point of any excursion along the boundary. Start this journey on Highway 2 south of Cardston where the 501 branches east and leads across the province to the Saskatchewan border. It's a route to consider at any time of year, though summer is best at Writing-On-Stone, when park interpretive programs are in full swing. Wild-flowers are at their peak among the sagebrush in late spring, fall brings cottonwood gold to the river valley, and you can count on seeing herds of pronghorn antelope at any time.

Cardston lies on the edge of mountain country: the Rockies dominate the horizon. South of the city, Secondary Highway 501 turns its back on the peaks of Waterton and heads southeast across the prairie. About five kilometres ahead, a signpost points north to the former Mormon community of Aetna, positioned alongside the trail that immigrants followed north from Salt Lake City around the turn of the last century. The hamlet, named for the Italian volcano, had a store, school, church, blacksmith shop, even a creamery and a cheese factory, although today little remains. Of the church, only the bell has survived, on display outside the modern Aetna gas station and store at the junction.

The road continues straight southeast and crosses the St. Mary River, a tributary of the Old-man, which in turn flows into the Bow—all waters that drain north into Hudson Bay. Tucked beside the river, Kimball Park with its shady campground provides good birding in a classic mix of fescue grassland and dense cottonwood forest. Beyond the river, the road rises to cross the

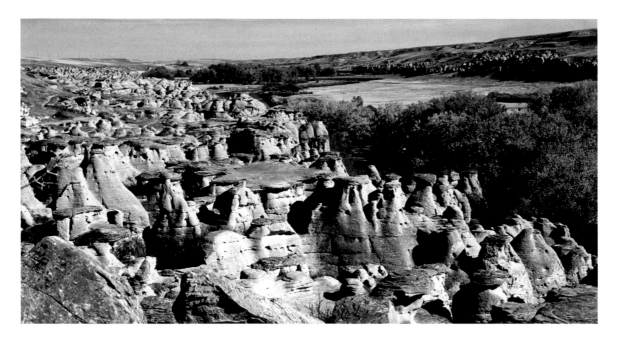

Eroded by long years of wind and rain, the sandstone valley rim is a maze of fantastic hoodoos and pinnacles.

swell of the Milk River Ridge. (In Montana, the ridge is known as the Hudson Bay Divide.) No steep mountain pass marks this grand division of the waters—the ridge here rises gradually, at its height a scant 400 metres above the prairie. As you drive along, the low heave of the ridge is north, the sensational thrust of Montana's Chief Mountain and other lofty peaks of the Rockies to the southwest across the fields.

Highway 501 veers sharply east as it nears the Montana border, but straight ahead at the bend is the continuation of the Old Mormon Trail that led settlers into Canada through Emigrant Gap, a scenic option, though the road no longer goes through into Montana but ends at a ranch gate. Highway 501 curves around the southern edge of the ridge and heads east for the largest of the meltwater cuts, Whiskey Gap, notorious for its illicit liquor trade. Whiskey was smuggled north from Fort Benton in Montana by mule team and pack horse, destined for the crudely built "forts" where traders bartered a rotgut version of the brew to local Natives. This illicit trade was stopped—or at least curtailed—when the North West Mounted Police (NWMP) came west, established a fort on the Oldman River (today's Fort Macleod) and set about policing the border from a string of tiny outposts. During American Prohibition, liquor flowed again across the border, this time from Canada into Montana. When in turn Alberta became "dry," the whiskey trade once more flowed the other way.

Strategically placed near the Montana border, the gap became a prime site for settlement. The Canadian Pacific Railway pushed through a branch line, and three grain elevators sprouted up like exclamation marks against the hills. The community was first named Fareham, a sober

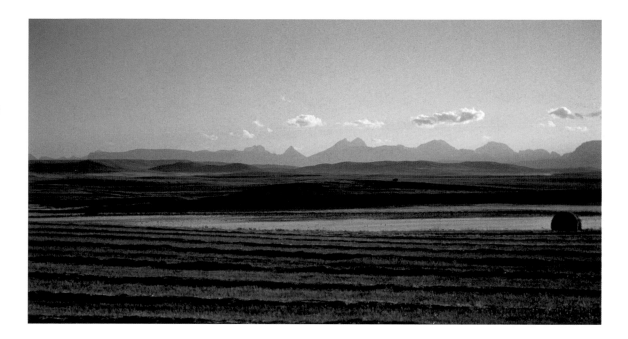

Pearly evening light on the distant Rockies.

expression that was soon voted out in favour of the more colourful colloquial name. Today, there is little left in Whiskey Gap. The railway track was pulled up, the elevators torn down; some of the buildings were moved away, others burned. Only the church remains, incorporated into a private home whose Gothic windows reveal its previous incarnation. Although there is little here to tempt you to stop, as you drive through this sharp little canyon you can't help but be aware of its geological as well as historical significance.

Once through Whiskey Gap, the land enters the Milk River watershed, dipping down to cross the South Fork of the river, then rising into the curvaceous bumps of the ridge's south side, past a picturesque ranch, an old schoolhouse, tumbledown barns, abandoned trucks and other signs of a more populated past. The first road north provides access to (but not into) Ross Lake Natural Area, one of several such protections recently given to this stretch of pristine grasslands—some of the last remaining in the Canadian west.

About 18 kilometres beyond Whiskey Gap, the community of Del Bonita sits astride Highway 62. North is the town of Magrath; south, the United States border and the Montana customs port also called Del Bonita. The Spanish name, which means "of the beautiful," might reflect an interesting aspect of Alberta history. By the Louisiana Purchase of 1803, Spain claimed all the lands in western America drained by the Mississippi River. This included the watershed of the Milk River in today's Alberta. It is doubtful that Spain ever knew the full extent of its colonial territory, and it is sure that the local inhabitants, the Blackfoot, were not aware that Spain existed! The only imports to penetrate this edge of the far-flung Spanish Empire were horses,

which were brought into the New World by conquistadores in the 17th century and strayed (or were stolen and traded) north, where they revolutionized the Native way of life.

The Alberta hamlet of Del Bonita has seen more affluent times. The general store and post office at the crossroads, however, is usually open and the coffee ready. Across the road sit two buildings moved here from Whiskey Gap, one of them the old hotel, and a little farther on is a fairly new community hall. Just north up the highway is an Alberta Culture sign and cairn commemorating the Lease Country and the last great Alberta land rush. This started in 1894 when rancher William McIntyre bought 25,000 hectares of land on the south side of the Milk River Ridge, where damper slopes supported luxuriant fescue grasses. Later the ranch subleased an additional 32,000 hectares of range, and when this lease was cancelled in 1912, the land was made available for homesteading. On April 1 of that year, a month before applications for the land could be accepted, 40 hopeful people were already lined up outside the land office in Lethbridge. Prepared to stay there day and night in order to keep their places in the line, they pitched tents and improvised shelters. As the number of tents grew, city officials marked squares on the sidewalk outside the land office and assigned each would-be homesteader a number corresponding to the piece of sidewalk they were occupying. The "squatters" could then go home, sure of their place in the queue, and the city street was clear.

When the land office opened on May 1, 325 people filed inside by number to register for their homesteads—one of the most orderly "land rushes" in Alberta history. The new settlers converted the former leasehold into farms and ranches and established the communities of Twin River, Del Bonita, Lens, Rinard, Shanks Lake and Hillmer. Of these it seems that only Del Bonita has survived, although the name Twin River remains on the map as a provincial "natural area," a large protected tract centred where the South Fork of the Milk flows into the main river about 30 kilometres west of Del Bonita. The historic McIntyre Ranch, now owned by the Thrall family, still exists, and it is known for its wise stewardship. Other rangeland has been overgrazed, but here fine fescue grasses still grow thick, along with myriad wildflowers.

East from Del Bonita, the westernmost block of Montana's Sweetgrass Hills comes into view along the southern horizon. On the relatively flat prairie land between here and Saskatchewan, three distinct uplifts of the hills—East, West and Gold buttes—dark with pine forests, dominate the landscape. After fresh snowfall they appear sharp and spectacular, and in summer heat they become a gentle, hazy blue. These peaks were never engulfed by glaciers, though ice surged all around them and left the thick layers of hummocky till that gives a well-muscled look to all the glaciated plains. They are not volcanoes—though the sharp cone of central Gold Butte might suggest it—but they are of volcanic origin, intrusions of liquid magma that solidified at depth

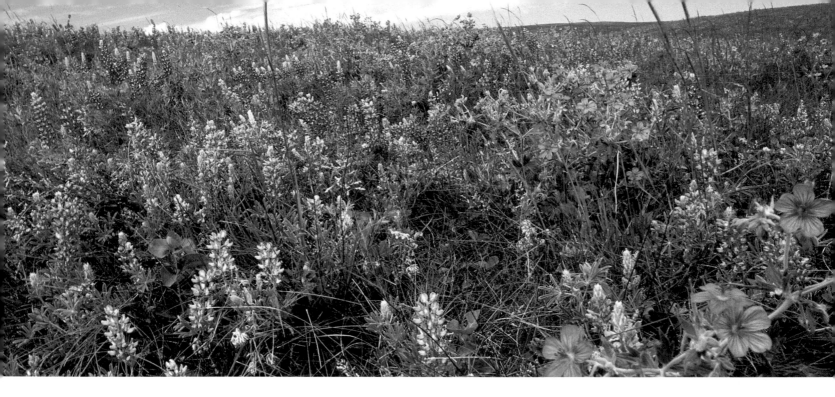

Wildflowers on the high, moist southern slopes of the Milk River Ridge.

and were subsequently uncovered by the erosion of overlying sediments. This igneous underpinning comes to light in southern Alberta at several places, mostly as linear dikes of volcanic rock and strange formations such as those known as the Great Wall and the Rooster's Comb.

Called Les Trois Buttes by early explorers and Sweet Pine Hills by First Nations tribes, the Sweetgrass peaks stand nearly 1,000 metres above the plains. Here, in the montane ecological zone, cooler and wetter conditions encourage evergreen forest and a wide variety of birds, animals and plants not found on the plains below. In the past, the hills supported large populations of bighorn mountain sheep, grizzly bears and wolves, but these, like the bison, no longer range here. Streams draining the hills' northern slopes flow into the Milk River, though these are mostly intermittent.

Twin River Heritage Rangeland Natural Area protects 19,000 hectares of virtually untouched grassland around the confluence of the two streams of the Milk River. It is one of only six large blocks of unaltered grassland remaining on the glaciated plains of North America, and thus it is a very special place, worthy of its designation as a "natural area." Its southwestern boundary begins about where Highway 501 meets and crosses the main stream of the Milk, and it stretches north almost to Warner and east almost to the town of Milk River, but there seems little to distinguish this protected enclave from the land around it — it is all wild and beautiful. At the river crossing is the well-named Oasis Ranch, with an odd little silo and shed. The cliffs that border the river here are home to a swarm of swallows.

The Milk flows northeast through the reserve, and 20 kilometres farther on it cuts south of the town of Milk River beside Highway 4, a major international route from Lethbridge to Great

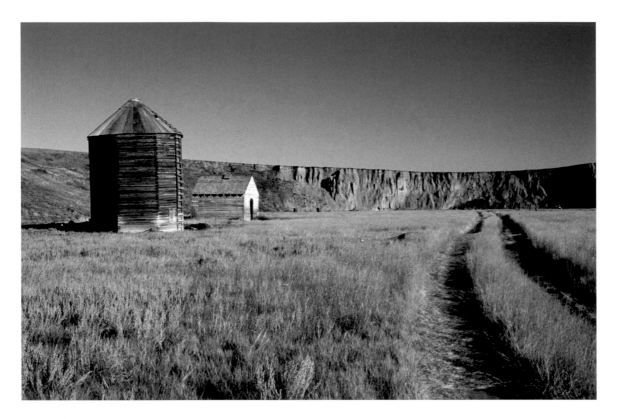

By a loop in the river, an old silo and shed front cliffs full of swallow nests.

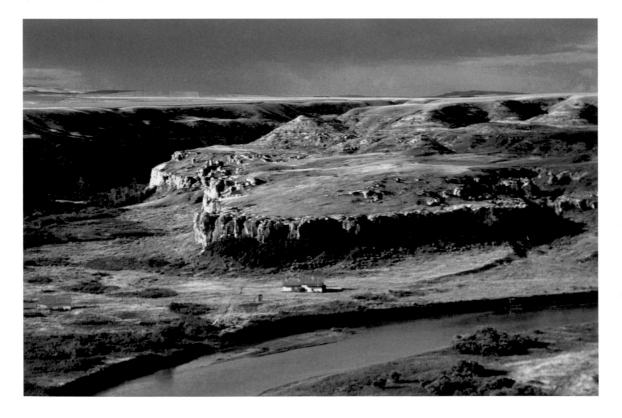

At the mouth of aptly named Police Coulee, the NWMP post stands guard at an old river crossing.

Falls, Montana. The border-straddling town in Montana is Sweetgrass; in Alberta, it's Coutts. Secondary Highway 501 crosses Highway 4 and continues east through the town, but whereas the road cuts straight, the river meanders away to the south, cutting deeply into the landscape, incising a canyon that, at its extreme easterly end, is the deepest of any in the Canadian prairies. Secondary Highway 501 charging east through the flat prairies reveals no inkling of the spectacular beauty of the river in its wide meltwater valley, deep and out of sight.

There are, however, two side roads that cross the river east of Milk River; the first leads across Coffin Bridge, the second across Weir Bridge into Van Cleeve Coulee. As you can see from the map, both these bridges meet Secondary Highway 500, which leads to Writing-On-Stone across yet another bridge (Deer Creek) to the east. All three crossings provide good river access for boaters. Canoeing the Milk downriver from the town of Milk River to Writing-On-Stone is an increasingly popular undertaking because the river is gentle, the scenery superb and the weather usually fair. May and June are the best months for this, for the river is often too shallow later in the summer.

Past the Coffin Bridge turnoff, 501 dips through badland rimrocks into Verdigris Coulee, a huge meltwater channel that still accommodates intermittent lakes worth scanning for white pelicans and other waterfowl. In this coulee, and others, can be found Native petroglyphs, including some of the syllabic symbols invented in 1841 by the missionary James Evans to enable the Cree language to be written.

The provincial park at Writing-On-Stone (the turnoff is about 12 kilometres east) is a very special place. The scenery is stunning. The beautiful sapphire ribbon of the summer river coils through a remarkable sheltered landscape of soft green willows and cottonwoods, with the blue hills of the Sweetgrass etched on the horizon. Here the soft sandstone of valley walls, topped by harder bands of ironstone, have been eroded by wind and water into fanciful contortions, full of holes and arches, caves and pinnacles, prime nesting sites for owls, falcons and golden eagles. But this beauty is more than skin deep: it is resonant with the sanctity of its Native past. Here the First Peoples came for vision quest and left their records on the rocks, enigmatic links to a very different perception of Earth. Here, too, is later history: a reconstruction of the early North West Mounted Police outpost established in 1897 to guard an important north–south trail that crossed the river, a route often travelled by Blackfoot war parties, then by cattle rustlers and rum-runners. The outpost beside the river sits at the mouth of Police Coulee, a day's hard ride from other posts along the border. Surely one of Alberta's most scenically situated—and loneliest—the post was closed for good in 1918.

Writing-On-Stone Provincial Park is a rich wildlife-viewing area. Here can be found 22 different mammals, 60 nesting birds and 265 species of plants. Numbers tell only part of the sto-

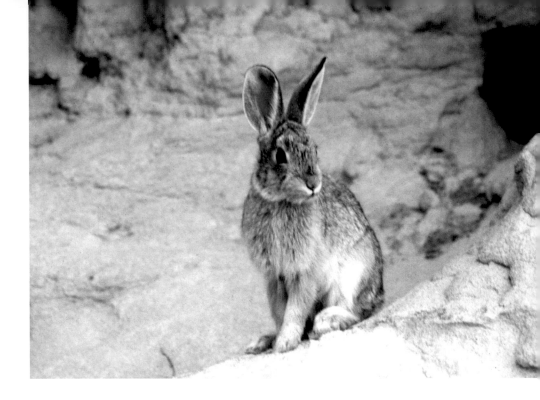

Nuttall's cottontail rabbit.

ry. Sit quietly in the evening and listen to coyotes howl and owls hoot while bats flutter gently against a starry sky. Stand on the valley rim as the sun goes down and paints the sandstone cliffs a magical red-gold, and watch while deer step fastidiously across the river. Walk through the hoodoos by day and catch glimpses of rock wrens, cottontail rabbits, golden eagles and prairie falcons. A flash of blue might be a lazuli bunting, a bird rare in Alberta; a scurrying tail among the rocks, a western rattlesnake. Understandably, the campsite in the shade of tall cottonwoods by the river beach is very popular; reservations in summer months are advised. Park interpretive tours to the petroglyphs and to the police post across the river are popular, too, and also require advance registration. Since much of the park is an archaeological reserve, only a few backcountry areas are open to the public, but the trails through the enchanting hoodoos are open to all.

Writing-On-Stone deserves a chapter all its own; certainly any traveller along 501 will want to stop here, if only for a few hours, and will unquestionably want to return. In fact, after the breathtaking beauty of the place, the scenery at prairie level might seem a little dull. But to the south the Sweetgrass Hills continue their seduction; as you drive east, you can see all three of the prominences. Central Gold Butte is the lowest, its peak a sharp cone. Placer gold was discovered near here, back around the turn of the last century, and miners by the hundreds rushed into the hills to pan for their fortunes. The resulting trans-border hullabaloo provided an additional reason for the NWMP presence. Near the miners' gulches of Two Bit and Eclipse, a rowdy gold-rush town was established in 1884; although the rush fizzled out, the little town of Gold Butte, Montana, lingered on. Its post office stayed open from 1895 until 1945.

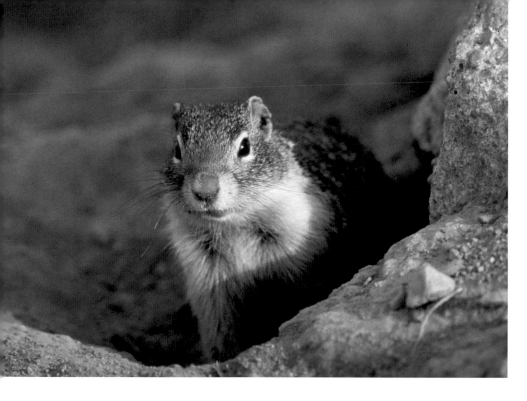

Richardson's ground squirrel among the rocks.

Beyond Writing-On-Stone, Secondary Highway 879 leads north to Foremost, and farther east, Secondary Highway 880 leads south across the river at Smith Coulee to the Canada-U.S. border crossing at Aden/Whitlash. If you are interested in the area's geology, take this road almost to the border, then turn east along Black Butte Road (Township Road 12). This will lead to one of the Canadian outliers of the Sweetgrass Hills, a rounded volcanic bump, technically a minette plug, that rises 30 metres. The road itself, which wanders east for several kilometres, leads close to some of the wild lands set aside as reserves on the south side of the deep and spectacular Milk River Canyon, where the river meanders through a maze of badland bluffs. There are no roads into the wild lands, but you can go by foot.

Off the beaten track along the valley rim, you will undoubtedly encounter pronghorn antelope, which are very much a feature of the southeastern Alberta prairie. Small herds of these fleet-footed creatures can usually be seen in roadside fields, particularly in early evening. The name antelope is a misnomer: the animals are not members of the antelope family but are single-species relics of the prehistoric Antilocapridae family found only on the plains of North America. There are about a million of them on the plains; 10,000 to 20,000 live in the Milk River region, at the northern limit of their tolerance for snow and cold. Luckily, warm chinook winds often strip snow from the winter prairie, enabling the animals to find grass. Pronghorns have incredible eyesight—wide-angle vision equivalent to eight-power binoculars—and both males and females have horns. Lightweight (about 50 kilograms) and smaller than a white-tail deer, they can run at speeds of 80 kilometres an hour, faster than their main predator, the coyote. Although they will bolt at the sight of a human, they will often take no notice of an automobile and can be photographed through a vehicle window.

Beyond the 880 intersection, 501 travels almost due east for 16 kilometres to cross the south end of Pakowki Lake, a huge basin that collected much of the ice age meltwater from glacial outwash channels and fed them into the Milk. The name Pakowki is Blackfoot for "badwater"; Natives once blamed the lake for the loss of several horses they had ranged there, and the water still smells slightly of hydrogen sulphide. Today the lake is almost dry, but it is surrounded by some of the finest marsh habitat in the province—a birding hot spot. Although the best viewing is from Highway 885 south of Etzikom (nesting colonies of white pelican and double-crested cormorant; black-crowned night-heron, bittern and such rarities as the black-necked stilt, white-faced ibis and snowy egret), there are usually plenty of shorebirds by the bridge at the lake's southern end. There is also a particularly beautiful view of the Sweetgrass Hills from here. Less than 20 kilometres farther on is one of the few signs that this country was once fairly well populated. The old community of Pendant D'Oreille is now marked only by a cemetery and, three kilometres around a bend in the road, by a tidy little church. The name Pendant D'Oreille, literally "hanging ears," was given by French traders to Natives in the area who wore dangling shell earrings.

East from here there are several escape routes, if the day is waning and you need the comforts of civilization. You can strike north on Secondary Highways 887 or 889 to Manyberries and Medicine Hat, or you can continue east another 30 kilometres to Highway 41, the main Medicine Hat/Wild Horse border-crossing route. But if you have time, there are other roads to explore. Pinhorn Road leads to the very lip of the Milk River Canyon; Range Road 63 to the edge of Milk River Natural Area and Kennedy Coulee Ecological Reserve; and Range Road 51 leads south to the Onefour Agriculture Canada Research Substation reserve, part of which is now heritage rangeland. In the Lost River Valley near here are stands of wild yucca, a plant that can only be fertilized by one species of very rare moth. Growing alongside an old trail from Fort Benton, the yucca—and the moths—are thought to have hitched a ride up from the south in an immigrant wagon train. As in other areas of the province, one journey, and one story, leads always to another. ❖

A horse whisperer with magic hands etched into stone on a Milk River cliff.

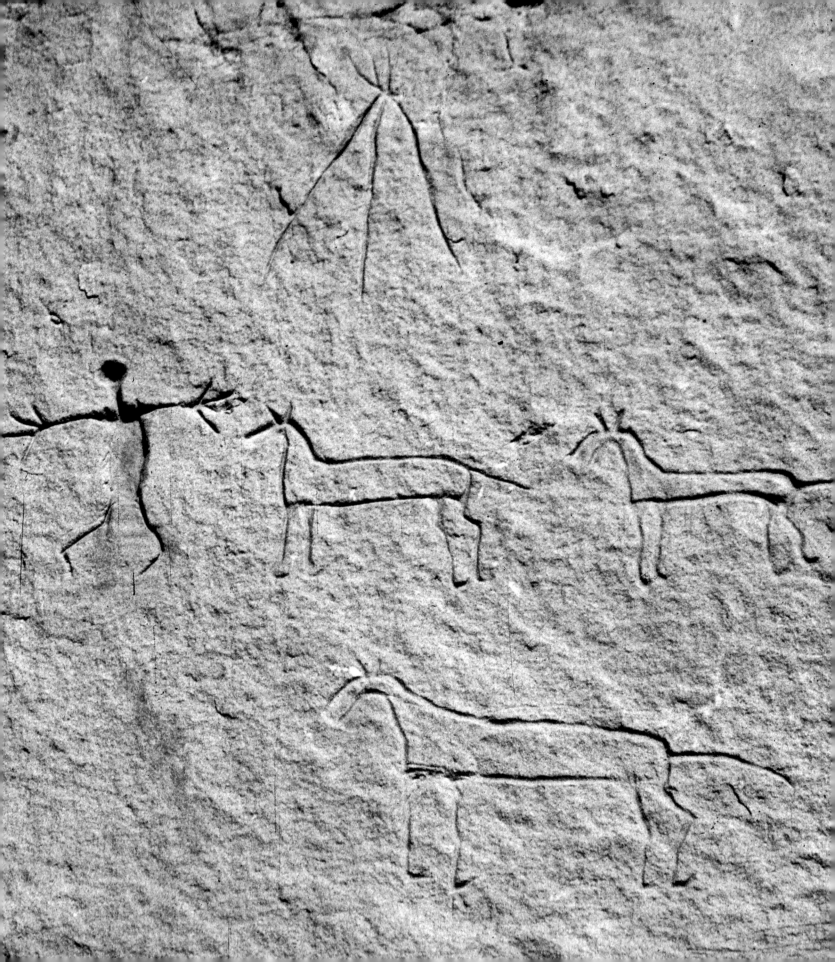

2

THREE FERRIES TO BLACKFOOT COUNTRY

Apart from Native trails across the prairie, the first transportation corridors in Alberta were forged by fur-trade explorers who strung together canoe routes along the great lakes and rivers that lace the north country. The Athabasca and North Saskatchewan rivers became a lifeline between trading posts, and later the South Saskatchewan was pressed into service as the fur-trade network extended south. But in later years, the rivers that had helped opened the land became barriers to settlement. Until—and even after—the railways pushed west, there were few large river bridges, and pioneers trundling their household goods across the prairie in horse-drawn wagons often found it impossible to reach their new homesteads.

Then, along routes the settlers travelled, entrepreneurs sprang into action. Ferrymen set up shop—often with only a crude barge they poled across the river—and roads were born from the wagon ruts. Back in 1913, at the height of homestead settlement, 58 ferries were operating in Alberta. Today, with the land cross-hatched by roads and bridges, there are only seven, four of them in the north. The three ferries remaining in the south, all of them small and limited in operation, provide a reason for a cross-country journey from the badlands east of Drumheller to Blackfoot Country east of Calgary.

A good starting place is, of course, Drumheller. To reach the first ferry, drive the tourist North Dinosaur Trail (Secondary Highway 838) along the north side of the Red Deer River. This well-travelled road passes by Midland Provincial Park (coal-mining history) and the famous Royal Tyrrell Museum (dinosaurs) and climbs to highlands full of pumpjacks bringing up oil and gas from more than a kilometre deep in the earth. The view from up here across the river is worthwhile, but a little farther on is Horsethief Canyon, a badland maze where stolen horses would be taken to "lose" their brands. From the parking-lot overlook here, the views are even

Sunset at the Blackfoot Fair.

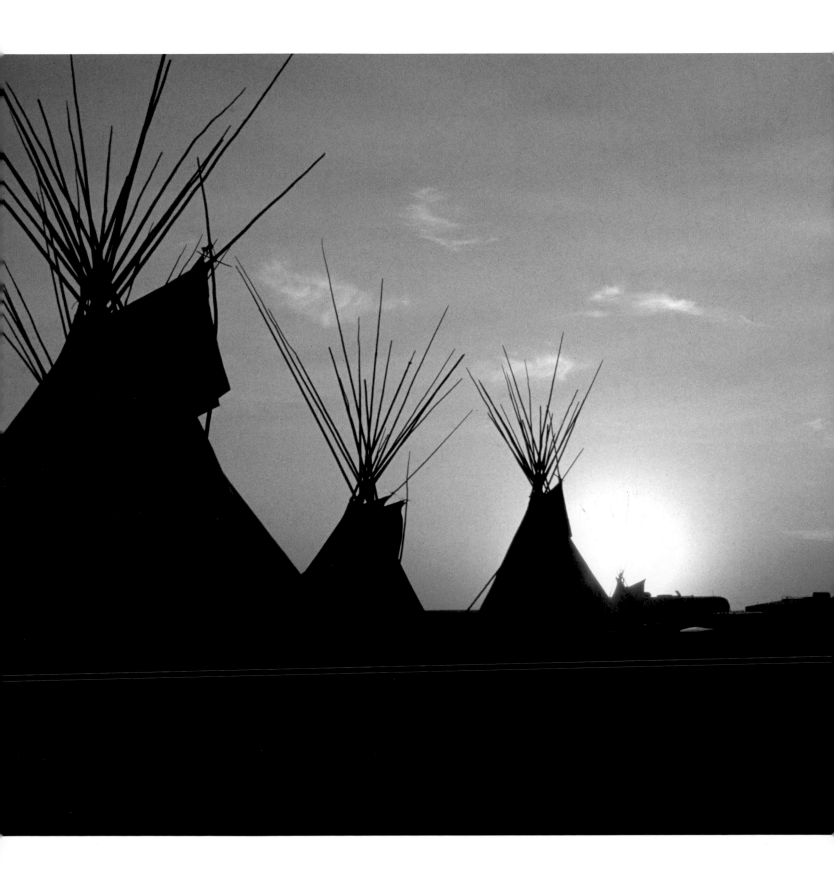

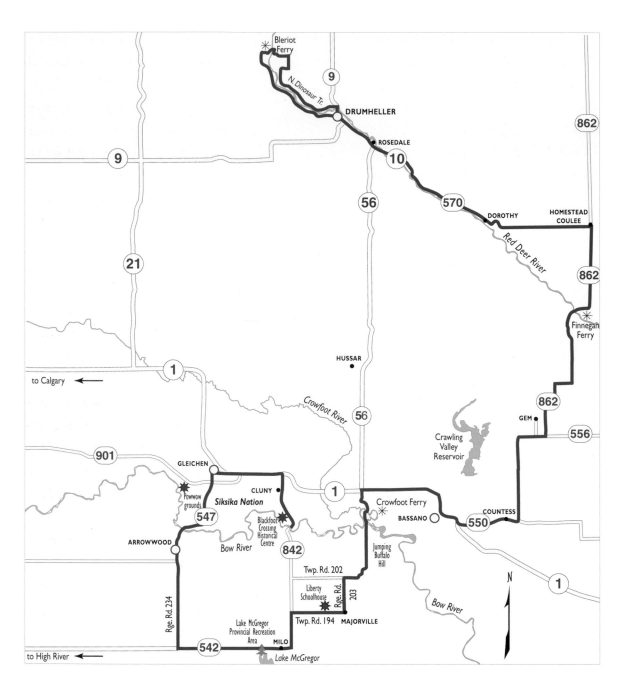

There are only three ferries left in southern Alberta, and on this country journey you'll ride them all, from the badlands to Blackfoot Country. A good day from Drumheller, provided you don't tarry too long among the dinosaurs.

LEGEND

○	large community	- - -	optional route
●	small community	⊓	bridge
✹	place of interest	⛪	church
🌲	park/recreation site	✳	ferry

better. A nearby large rock contains fossilized oysters, relics of the ancient sea that covered Alberta some 67 million years ago. From the plateau, the road winds down through a colourful coulee to the Red Deer River and the halfway point of the Dinosaur Trail, the Bleriot Ferry, which operates "from break-up to freeze-up," 7 a.m. until midnight daily. Luckily, the river is free of ice during the tourist season, and it's the tourist trade that keeps this ferry busy. The ferry is named for the first operator, André Bleriot, who came from France in 1901 and established a homestead in nearby Munson. In 1910, he journeyed to France for a bride and on his return started a river ferry, which was then known as the Munson Ferry. In its first year of operation, it carried more than 1,200 vehicles. Today, it ferries more than 24,000 a year. Nothing more than a flat-topped scow attached by cables to an overhead line, the first ferry was operated by the river's current; a rudder underneath could be adjusted to catch maximum water flow. In 1958, a motor was installed. And in 1966, its name was changed to honour its first ferryman. André Bleriot was well known in his adopted country, but his brother, Louis, was famous internationally: An airplane designer in France, he became the first man to fly across the English Channel. This feat, accomplished in 37 minutes in 1909, brought him a huge cash prize and instant, worldwide acclaim.

The Bleriot Ferry is free, comes on demand and crosses the Red Deer River to Bleriot Ferry Provincial Recreation Area, shady under a canopy of cottonwood and willows. It's a great place to camp and to launch a canoe. Take the ferry across the river and continue through the dry flats to more badland hoodoos on the other side of the valley. Climb up through another coulee onto the high prairie, turn left at the junction, and follow the South Dinosaur Trail (Secondary Highway 837) back 22 kilometres to Drumheller.

Fifty kilometres downstream from the Bleriot Ferry, another ferry crosses the Red Deer at Finnegan. From Drumheller to Dorothy, the first part of the road to Finnegan (mostly Highway 10) provides much to see. The badland valley is full of relics of the area's coal-mining past, and the road passes beside the famous, often photographed hoodoos beside the river. Dorothy is the picturesque epitome of a bleached ghost town, with a single grain elevator and two churches (see chapter 8). Beyond Dorothy, Secondary Highway 570 climbs up from the river and strikes due east across the dry prairie, passing a sad old farmhouse sitting in a field of bright clover. At Homestead Coulee, 26 kilometres east of Dorothy, Secondary Highway 862 heads south toward the river and the ferry crossing. On a hot summer day, it's a pleasure to wait here, listening to the sounds of the water in the shade of an arching cottonwood.

The ferry has always been known as Finnegan's after its first operator, John Finnegan, who came from Scotland in the 1880s to work as a carpenter for the Canadian Pacific Railway (CPR) at Gleichen. Later, he took up a homestead on the Red Deer River and went into the transportation

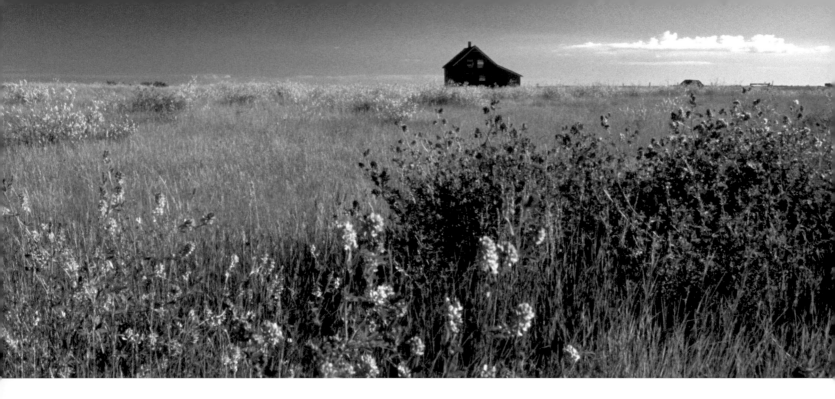

business. There's no settlement of Finnegan, though it's marked on the provincial map. Almost identical to Bleriot's, the ferry here is hung on a high cable across the river, and it runs on much the same schedule. The ferry operator (at the time of writing a ferrywoman) will come out of her house on the high bank across the river and will usually drive her car onto the ferry to bring it across. One summer there were swarms of tiny flies above the river, and she covered her face with a net. Traffic on this ferry is far less likely to be tourists' vehicles than heavy trucks, so stay well behind the latter on the gravel road if you want to keep your windshield intact.

Highway 862 leads south, crossing mainly rangeland, but watch for a huge field of smiling sunflowers beside a farmhouse. The route bends abruptly several times and intersects with others, but it's clear which road to follow: it's the widest and most travelled. Turn off for a look at the little town of Gem, with its two grain elevators and neat little church, and then connect via Secondary Highway 550 to Countess and to the Trans-Canada Highway near the town of Bassano.

A railway settlement, Bassano was named in 1884 for the Marquis of Bassano, a CPR share-holder from Italy. The community became famous for a huge earth and concrete dam that was built on the Bow River in 1910–14 to bring irrigation water to the huge expanse of CPR-owned dry prairie between Calgary and Brooks. The railway barons knew that irrigated land would attract colonists and that colonists would provide traffic for their railway. When it was built, the 24-spillway gravity dam was one of the largest of its type in the world, and it cost a phenomenal $17 million. One of the major hurdles for irrigation canals was deep Crawling Valley. To cross this and maintain a gravity flow, water had to be carried for half a kilometre on a 10-metre-high wooden trestle. The dam, refurbished in 1984, lies just southwest of the town, part of the Eastern

Old ranch house sits alone in a field of flowers, east of Dorothy.

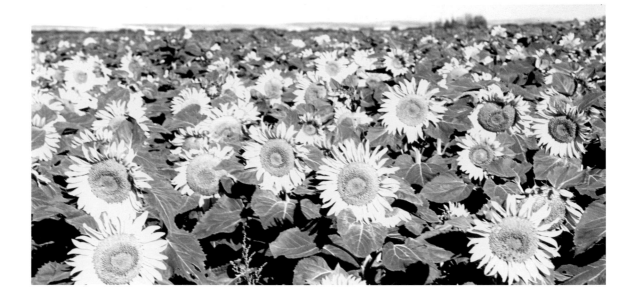

Field of sunflowers near Gem.

Irrigation District (owned by a group of local farmers since 1935) that today brings water to almost 114,000 hectares of farmland and 12,000 hectares of managed wetland habitat. There's a good viewpoint with picnic tables at the dam site.

All the large reservoirs around here are part of the same huge irrigation scheme, including Lake Newell, near Brooks, and the Crawling Valley Reservoir to the north. The latter was dammed in 1985. Water backed up into the long grassland coulee to create a lake some 16 kilometres long and two kilometres across; it drowned many ancient Native sites. Now the reservoir is a haven for shorebirds and wildlife and is a popular recreation site; camping, fishing (for pike, walleye and some trout) and boating are favourite pursuits here. To visit this reservoir, keep on the Trans-Canada west of Bassano, turn off on Township Road 220 and follow the signs.

The third of the southern ferries, Crowfoot, lies less than 20 kilometres west of Bassano, just south of the highway, but drive slowly or you might miss the small sign. The turnoff is immediately opposite Highway 56, which goes north to Drumheller via Hussar. The unnamed gravel road crosses the railway and comes down to the Bow River just downstream of the Crowfoot Creek mouth, which explains this ferry's name. Crowfoot was one of the great Blackfoot chiefs who participated at the signing of Treaty 7 at Blackfoot Crossing, farther upstream. The Blackfoot (Siksika) Nation reserve lies south of the river here. From the high bank, the ferry in midstream as it glides across looks very much like a Venetian gondola. Like the others it is motor-driven, guided by cables; it operates only from spring through fall. Why is there still a ferry here when there is a road bridge a scant 15 kilometres west? Back in the 1920s, before the bridge was built, it was needed by local farmers hauling their grain to the railway line across the river, but now, apparently, it's a shortcut for trucks hauling heavy loads.

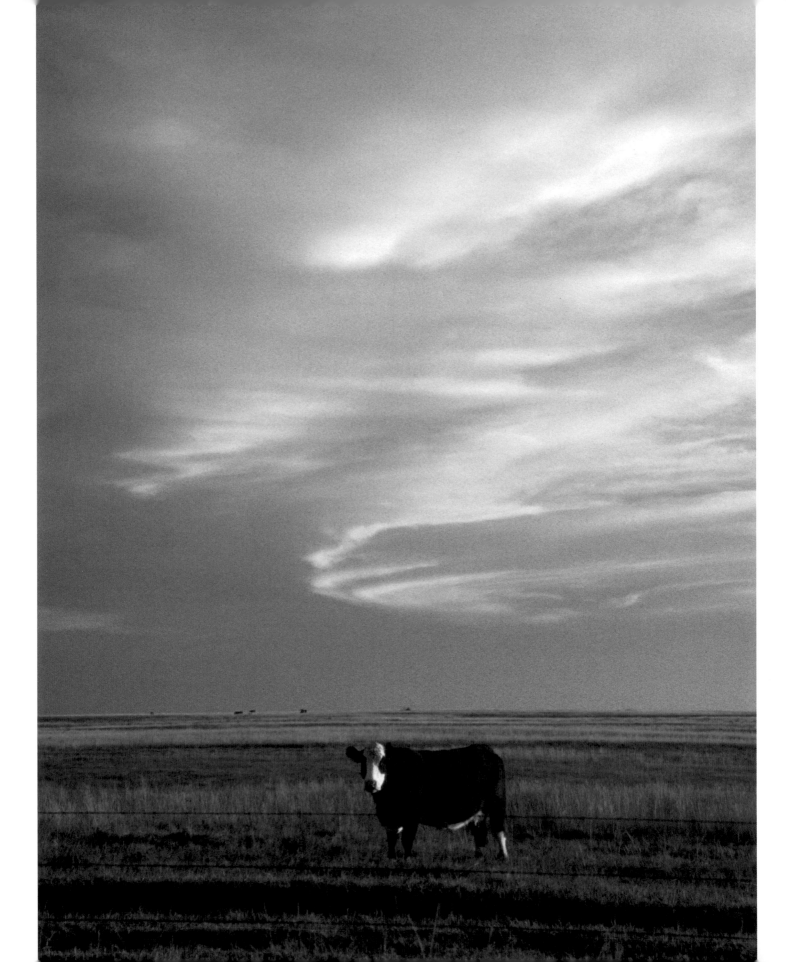

RIGHT

Elegant Liberty Schoolhouse sits empty in a canola field.

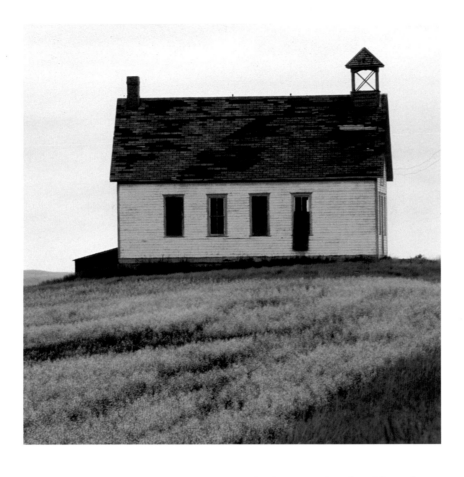

LEFT

Cattle graze the dry prairie under an amazing sky.

Across the river, the gravel road climbs over the shoulder of Jumping Buffalo Hill. At the next T-junction, turn right onto Township Road 202, which leads west to Secondary Highway 842, but almost at once take the first left onto Range Road 203, one of a cross-hatching of country roads that flank the hills here. For practical purposes it doesn't matter which road you choose, but 203 is a scenic one. It leads to Majorville, where only a single building marks the site of a pioneer settlement, but nearby, on a hilltop rippling with summer canola gold, is the beautiful old Liberty Schoolhouse, abandoned but intact. From a distance this elegant structure, complete with a bell turret, looks a bit like a church. To find the school, drive west on Township Road 194. (It is possible to drive from Majorville on oil company roads to a medicine wheel—see chapter 5.)

Beyond the school, the road connects with Secondary Highway 842. Turn south and head for the village of Milo at the north end of another irrigation reservoir, McGregor Lake. Water is led by canal from the Bow River diversion near Carseland into this 35-kilometre-long lake that fills the southern end of Snake Valley and flows into the Travers Reservoir on the Little Bow River. These large and costly water diversion projects were needed to make dry prairie land suitable

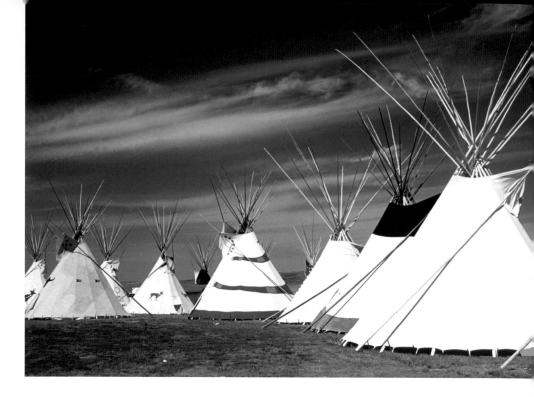

Colourful tipis at the August Blackfoot Fair near Gleichen

for wheat farming. Milo started early, in 1909, but when a railway spur came near, the town pulled up stakes and hauled itself, literally, closer to the tracks. Here, three grain elevators were built, as well as two churches, a school and the usual assortment of essential businesses. Unlike some others, Milo did not fade away when the railway left but kept a strong sense of community. McGregor Lake has become famous for sport fishing—northern pike and rainbow trout—and the recreation area at the north end, shady with hundreds of planted trees, is popular. White pelicans and double-crested cormorants nest here, and the lake is a migration staging ground for geese and other waterfowl. In fall, at the sluice gate at the northwestern end, visitors can watch whitefish spawning.

From Milo, drive west on Secondary Highway 542 for a little more than 15 kilometres, then turn right (north) on Range Road 234 and head for Arrowwood, another nice little village, this one with a small museum, a couple of good places to eat and a well-stocked western outfitters. From here, take Secondary Highway 547 north into the heart of the Blackfoot reserve (the Blackfoot are now known as the Siksika Nation). The road winds down an escarpment to cross the Bow River on a one-way bridge. The landscape here has changed little since the 1880s. The river is lovely, and along its banks the largest and densest stands of balsam poplar in the province colour the days of autumn with pure gold. Here the Siksika have a golf course–resort, and along the road that parallels the river is a small church. Except for special occasions, the colourful tipis are gone from the reserve, replaced by rows of small houses. Cross Secondary Highway 901 (a shortcut to south Calgary) and continue to Gleichen. The August Blackfoot Fair and Powwow takes place a short distance west of the intersection, inside a dance arbour shaped like a huge tipi. Visitors are welcome here.

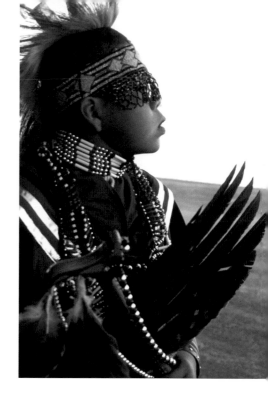

Gleichen, just south of the Trans-Canada Highway, is a town divided: south of the CPR tracks it's Siksika territory; north, it's an old CPR settlement, named after a town in Scotland. You might choose to end this excursion here and make a bolt back to Calgary. But there are a few special places still left to explore.

Drive east on Highway 1 to the Cluny turnoff (south, on Secondary 842) and drive through the village of Cluny, with its old Roman Catholic church. Along the road as it nears the river, a memorial to Chief Crowfoot looks south over the old ford known as Blackfoot Crossing, the site where the Blackfoot in 1877 signed Treaty 7. And farther along, just before the road dips down to the river, there's a striking piece of modern architecture, its shape mimicking that of a tipi village. This is the new Blackfoot Crossing Historical Centre, designed to showcase Native history and arts and to recount the story of the mysterious earth-lodge village that lies below.

Young Blackfoot dancer, complete with eagle feathers.

Whereas the early nomadic people of the grassland plains used portable tipis for shelter, the Mandan and Hidatsa tribes to the southeast—in today's North and South Dakota—developed agricultural villages and built permanent lodges, seating them securely in the earth and building walls and roof structures supported on wooden poles. (Some of these have been reconstructed on the banks of the Knife River in North Dakota.) Foundations of a similar earth-lodge village—11 circular house pits with postholes, fortified by a ditch and palisade—have been found on the banks of the Bow River right here. Today, little remains to be seen, though the place has been designated a National Historic Site.

The Cluny village puzzles archaeologists because it doesn't fit the southern mould. The house pits seem too small and lie outside the protective palisade, not inside. Could the pits have been for storage? Or defence? Strangely, after all the work needed for its construction, it was inhabited for only a couple of months. There are a host of questions that so far have no clear answers. Who were these people? Where did they come from, and why? Why did they leave so soon, and where did they go? Their only trace seems to be a distinctive type of pottery, again similar but not identical to pottery made in the Mandan villages. Archaeologists and the Siksika people are still trying to find answers.

A visit to the Blackfoot Crossing Centre, where all the stories of the Blackfoot, including that of the earth-lodge village, will be told, makes a fine journey's end. ❖

INTO THE CYPRESS HILLS AND BACK AGAIN

On a hot, dry summer day in southeastern Alberta, the dark blue shoulders of the Cypress Hills beckon with promises of cool waters, shady woods and air pungent with pine. Though the hills themselves are an alluring destination, the roads leading up to them through the grasslands are also lovely, worth driving for their own sake, and there are several fascinating places to visit en route.

The name Cypress is a misnomer: there are no cypress trees here. To early French Canadian fur traders, the evergreens in the hills were les cyprès, a term that was easily but erroneously anglicized. The local Cree called the region "Beautiful Uplands"; the Blood, "the Grizzly Bear Hills"; and the Blackfoot, "Striped Earth" for the many layers of different soil deposits visible in cliffs and outcrops. To all the Natives in the area, the hills were sacred.

A remnant block of ancient sea and river sediments standing 600 metres above the plains (peaking at 1,466 metres on the Saskatchewan side of the only interprovincial park in Canada), these hills have always been a refuge. When Pleistocene glaciers ground down from the north, they covered only part of these uplands, leaving about 200 square kilometres exposed, a flat-topped nunatak, or island, in a sea of ice. Here, relict plants and animals survived, some well away from their main populations. There are aspen, lodgepole pine and spruce that belong in the montane regions of the Rockies; foothills fescue grass that would be at home on the Milk River Ridge; birds such as juncos and warblers from the northern forests; as well as glacier lilies and species of snails found only in the high mountains.

The wooded sanctuary of the Cypress Hills was also a prime hunting ground. As early as 15,000 years ago, the first plains people trapped and killed mammoths and mastodons, as well as camels and horses, fossils of which have been uncovered in the hills' eastern slopes. In later eras, they hunted bison and grizzly bears. But the hills' prime resource was trees: the tall, slender

Astounding red rock spheres adorn an outcrop of bearpaw shale south of Seven Persons.

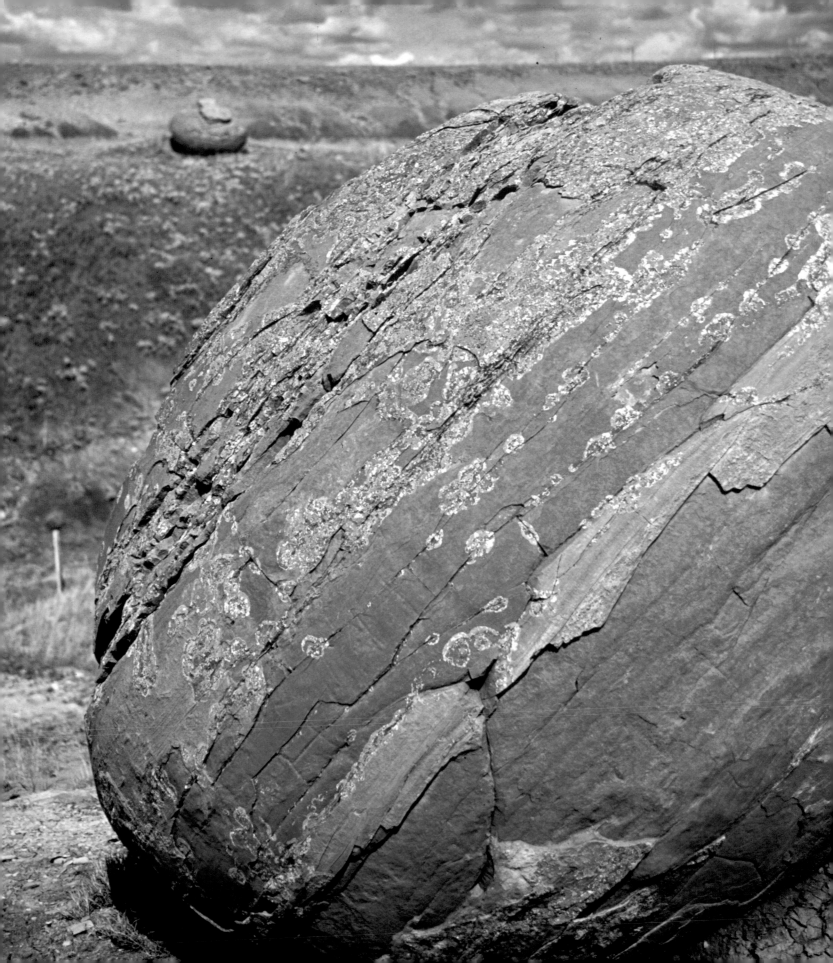

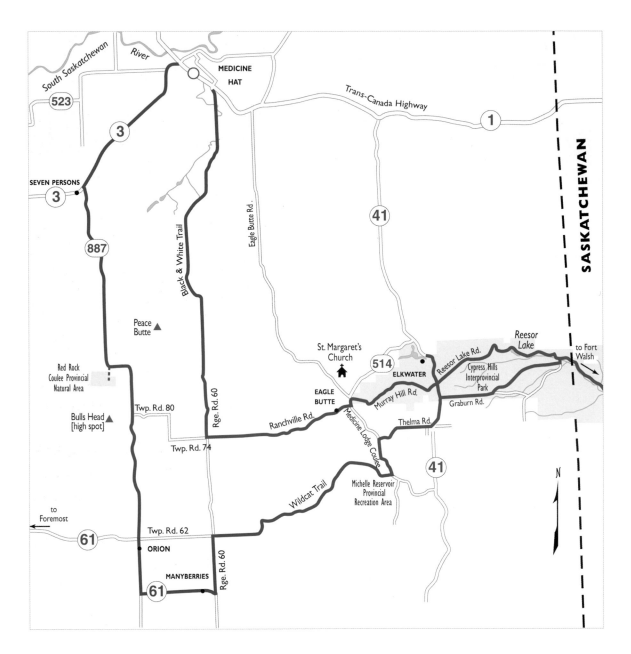

The Cypress Hills, straddling the Alberta–Saskatchewan border, deserve a longer look. This country journey provides just a taste. It's a day's circle trip from Medicine Hat; allow more time to tour Fort Walsh. Some unpaved roads.

LEGEND

○	large community	- - -	optional route
●	small community		bridge
✴	place of interest	⛪	church
🌲	park/recreation site	✳	ferry

Restored Fort Walsh, once the headquarters of the NWMP, sits secure behind a stockade in a fold of the hills.

stems of lodgepole pine were vital for the construction of lodges or tipis, and tribes throughout the southern plains came here for their supplies. Remains of an 8,000-year-old camp have been excavated near Elkwater Lake, high on the western edge.

With the arrival of Europeans, the great sustaining herds of buffalo on the plains were quickly diminished, bringing an end to the First Peoples' way of life. A few buffalo lingered in the sheltered folds of the hills, along with the last wolves and grizzly bears, and when Métis and American hunters arrived for the final kills and to set up trading posts, there was trouble. The traders bartered "firewater"—cheap, adulterated whiskey—for Native buffalo robes and wolf pelts, and the "wolfers" used poisoned bait that often killed native dogs. The situation seethed with unrest and finally boiled over into massacre. When word of "Indian trouble" in the colonial West reached the ears of government, the North West Mounted Police were sent out to establish law and order, riding west all the way from Winnipeg in 1875. They stamped out the whiskey trade, provided food and supplies to the starving Natives and established Fort Walsh on the east side of the hills in what is now Saskatchewan.

Today, a National Historic Park encompasses the site of Fort Walsh. Much of the land in the Cypress Hills, with its grasslands, forests, coulees, cliffs and wetlands, retains a pristine look and still shelters wildlife that elsewhere is threatened: bobcat, elk, trumpeter swan and northern leopard frog. Even the swift fox, long gone from the hills and now reintroduced into the Milk River area, may soon make a comeback here. And many species of birds and wildflowers add to the area's diversity. The hills are a sanctuary, indeed. In 2004 they were declared a "dark

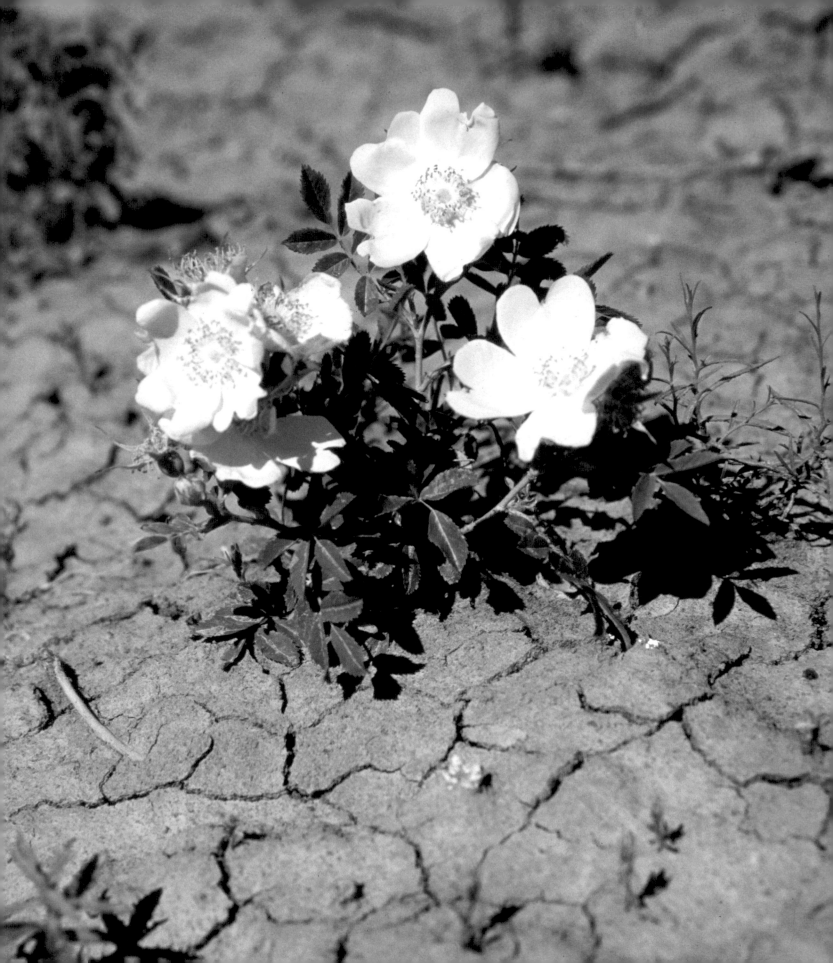

sky preserve," a designation established in partnership with the Royal Astronomical Society of Canada to protect the nocturnal environment; bright lights are banned here, giving visitors an opportunity to appreciate the glories of a starry night sky.

This journey begins at Seven Persons, southwest of Medicine Hat on Highway 3, where there is not even a hint of the hills that lie to the south. The hamlet takes its intriguing name from a near-by creek where a party of Blood warriors led by Calf Shirt attacked and killed seven Cree in 1872. Secondary Highway 887 leads south from Seven Persons, crosses Seven Persons Creek in its wide coulee and climbs steeply again to prairie level, past an old, white-painted homestead. Farmland here is irrigated via canals from the St. Mary River, far to the southwest. The small, sharp hill to the east is known as Peace Butte. Did the Cree and the Bloods reconcile their differences here?

Just over 24 kilometres beyond Highway 3, Secondary 887 makes a sharp turn to the east. At the bend, keep straight south along a narrow side road: two kilometres ahead is Red Rock Coulee Provincial Natural Area. Here, at the head of a great coulee of ice age origin, lie huge, red sandstone rocks, as round as bowling balls. The two-metre-high spheres, patterned with swirls and blotches of orange lichen, lie along the coulee edges, some teetering on the brink of balance. Many of the balls are intact; others lie cracked or shattered by exposure to the elements. Their brilliant colour seems even more extraordinary against their setting: a corrugated field of pale grey bearpaw shale and sandstone, bedrock 75 million years old, the floor of the tropical sea that once covered Alberta. It is rare to find such exposed ancient formations in a land so thickly covered with glacial gravels.

What are these giant red balls? Geologists are uncertain. Some deem them concretions, for-mations that grew in layers, as pearls do, around a hard, small nodule. Evidence in weathered specimens seems to suggest this: the layers peel back like onions. They also might be simply chunks of sandstone worked smooth by flooding or glacial action, like river cobbles. Whatever their genesis, they are remarkable. Equally remarkable is the view, which extends past the red rocks and down across the deeply fingered coulee and the prairie grassland to the peaks of the Sweetgrass Hills shimmering on the horizon.

Delicate pale, wild roses bloom in the cracked, arid soil in Red Rock Coulee.

From the windy parking lot near the height of land known as the Bull's Head (at 1,075 metres the highest point in the immediate area), a short trail leads down into the coulee system, a large, sprawling complex carved by waters that once flowed south into the Milk River drainage. Follow the tracks of coyote and deer onto the coulee bottom. Here among the rocks in early summer are low-growing dryland flowers, including beautiful pale prairie roses, white evening primroses, prickly pear cacti and buffalo beans. The park is worth more than a quick picnic stop: one can spend a day exploring here. Sunrise and sunset light intensify the colours of the rocks—and the magical aura of the place.

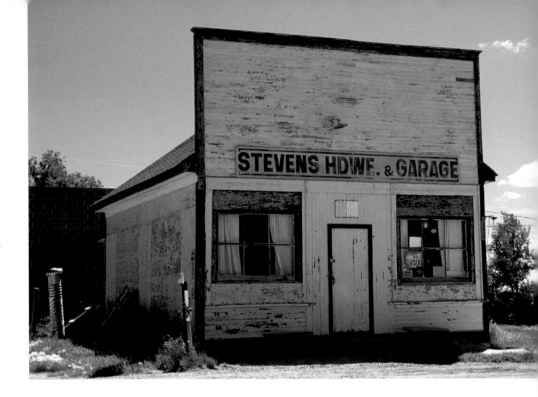

Almost a ghost town, Orion has a lively hardware store.

From Red Rock, continue south, passing an old church and its handful of bleak white crosses, then across Peigan Coulee, overlooked by a farmstead whose big old barn is topped by a sporty finial. From prairie level, the three distinct peaks of the Sweetgrass Hills dominate the south-western horizon; to the southeast, a dark smudge heralds the first glimpse of the Cypress Hills. At about 56 kilometres, Secondary Highway 887 meets Highway 61 leading west to Foremost and south to Manyberries. And here Elkwater Road leads east to the Cypress Hills. But first there are two very interesting places to visit.

Keep south on Highway 61 to Orion, a hamlet named after the constellation of the Hunter, the brightest in the winter sky. Many of the street names in the original townsite, plotted when the Canadian Pacific Railway (CPR) arrived here in 1916, were given names from Greek and Roman mythology. Alas, the lights in this stellar settlement appear to be dimming fast: at first glance it appears to be a ghost town, full of weathered derelicts. Its original name, Needmore, would perhaps be more appropriate today. But there is a general store and post office, and just up the street is Stevens Hardware store, one of the most popular places around. It has a gas sta-tion, the only one in the area, and a unique one at that: In the yard behind the store sits a big old blue flatbed truck with two drums of gasoline on the deck; if you need gas, call in at the store and Boyd Stevens will come out and fill your tank. The store itself is a marvel, more of an automobile supply/repair shop than a hardware store, packed with interesting stuff and, usually, a handful of farmers from the area, sitting around the coffee pot and discussing the weather and the crops. Continue south from Orion for five kilometres, keeping a lookout for pronghorns, which seem to like this arid land, then follow Highway 61 east to the hamlet of Manyberries, its name a

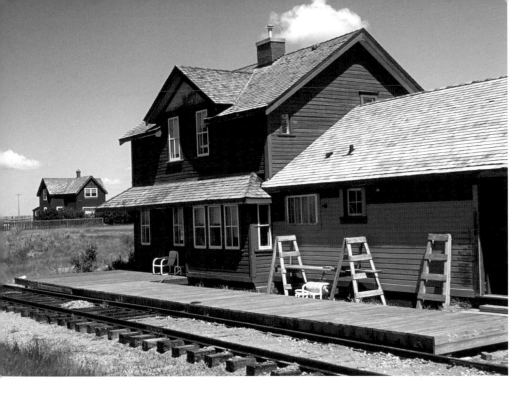

Manyberries Railway Station, now a home.

translation of the Blackfoot "Akoniskway," referring to the many saskatoons and chokecherries along the creek here. These berries were vital in the preparation of pemmican, a Native winter staple, and one that early fur traders also relied on. There is no gas station in Manyberries, nor is there a post office or general store. But there is a hotel, the Ranchman Inn, which dominates the main street. There are rooms to rent here, a restaurant and a pub called Just One More Saloon. The Manyberries Railway Station down the highway has been refurbished as a private residence, but the station platform is still there, and so is a caboose and a stretch of railway tracks. The owners have turned the station master's house into a cosy bed-and-breakfast.

Both Orion and Manyberries were founded when the CPR landed on their doorsteps in the early 1900s, a time when unusually wet weather supported bumper farm crops for the surrounding homesteaders. But that heyday did not last, and drought, grasshoppers and other dryland plagues gradually pushed people off the land. The railway settlements shrivelled, and eventually even the railway itself pulled up stakes. Nevertheless, like many others in southern Alberta, the two small settlements linger on.

From Manyberries, continue east a short distance on Highway 61, then turn north on Range Road 60 for about seven kilometres and pick up Wildcat Trail (Township Road 62) east. This unpaved and sometimes very dusty road parallels Manyberries Creek, which flows down from the Cypress Hills' western flank. The land here is rolling, open rangeland, hummocky with glacial debris, rising to hills topped with rock outcrops and rippling with long grass. Roadsides are abloom with wildflowers in early summer. Great, thick tufts of delicate blue harebells dance on their wiry stems, along with bunches of brown-eyed Susans. Ahead, there are tantalizing

glimpses of pine-covered hills. Michelle Creek has been dammed to form the small Michelle Reservoir, and here there is a provincial recreation area popular for fishing and picnics.

At the next intersection, marked by a photogenic red barn, turn left (north) through the broad bottom of Medicine Lodge Coulee. Now the hills are very close. From here there are choices: you can climb east, up twisting Thelma Road by picturesque Eagle's Nest Ranch, or continue north to Secondary 514. Both routes will lead to Highway 41, the main north–south road through the hills and the quickest way to reach them from Medicine Hat. At the townsite of Elkwater, by a lake of the same name, you can check in for park information or accommodation, admire the resident flock of wild turkeys and plan to spend a day or so in the hills. If you don't stay, at least pay a visit to Fort Walsh. Drive east through a grassy section of the hills beside Reesor Lake, then follow Battle Creek east into Saskatchewan and Fort Walsh.

It was the Cypress Hills Massacre of 1873, in which American wolf hunters killed a group of Assiniboines camped beside Battle Creek, that led the North West Mounted Police to march west in 1875 and later to establish their headquarters at Fort Walsh. (The wolfers did not shoot their prey—they poisoned it by setting out buffalo carcasses laced with strychnine. The dead wolves were then stripped of their hides, but the lethal carcasses remained to kill again. Household dogs were regularly poisoned in this way, one of the many causes of friction between the Natives and the newcomers.) Fort Walsh was western police headquarters from 1878 until 1883, then used again from 1942 as the Royal Canadian Mounted Police Remount Ranch. Here, until 1968 the Mounties raised their famous black horses for, among other duties, the RCMP Musical Ride. Fort Walsh later became a National Historic Park, and the buildings were restored.

The fort sits isolated in a valley. From a high viewpoint beside the civilian graveyard it looks much as it did 120 years ago, its whitewashed barracks secure behind a stout palisade, flying the Union Jack. Also restored are a trading post and the site of the massacre itself, it too preserved as a National Historic Site. Visitors are driven by bus from the interpretive centre down to the fort for a guided tour of the area, where costumed actors recreate daily life. It is all very well done.

For variety on your return route to Medicine Hat, follow Police Point Road southwest across the high plateau, where grassy meadows are interspersed with aspens and pine forests. In places the ruts of ox carts that drove the old supply route up from Fort Benton remain. This road connects to Graburn Road along the hill's dry southern side. The north and south slopes of the hills are very different: north, the land is deeply crumpled with the debris from the last Pleistocene ice advance, which swirled around but did not overwhelm the hills; south, the land was sluiced smooth by flooding meltwater, down almost to bedrock. The desert south side of the hills, some of the driest land in Canada, supports such rarities as burrowing owls and scorpions.

Graburn Road, named after Constable Marmaduke Graburn, the first member of the NWMP

Brown-eyed Susans along the dusty road.

Delicate blue harebells in the summer hills.

to be killed in action, leads back to Highway 41. Go north on 41 for a short distance, then take Murray Hill Road west, which leads to a forestry museum and then to one of the park's treasures: Horseshoe Canyon. Here the hills drop off steeply with cliffs of interesting conglomerate rock, and there is a great view down to the prairie. The road continues (it's rough and steep and could be closed after rains) downhill through fescue grasslands to intersect with Eagle Butte Road in Medicine Lodge Coulee.

A short distance north lies little St. Margaret's Church, seemingly in the middle of nowhere, but it's situated at a strategic geographical position: north, the streams run to Hudson Bay; south, to the Missouri and the Gulf of Mexico. Did the settlers know this when they selected the site for the church in 1908? Services were held here mainly in the summers, with clergy coming out from Irvine and Medicine Hat, but in 1969 the church was closed. Today, the privately owned building has been completely renovated and fitted out with fixtures from other abandoned churches: the altar from Coutts; the altar cross from Grassy Lake, lectern from Orion, stove from Milk River. The church is open to all, and the tiny graveyard is scrupulously cared for. It's a very peaceful place.

It's hard to find the community of Eagle Butte, though it's marked on the map just south along Ranchville Road, another beautiful grassland route to follow through the low hills down to prairie level. It intersects Secondary Highway 889, the Black and White Trail, currently an unpaved route north to Medicine Hat, but if you're in a hurry, keep going west on Ranchville until you again reach paved Secondary Highway 887, a far less dusty route to reach your destination. ❧

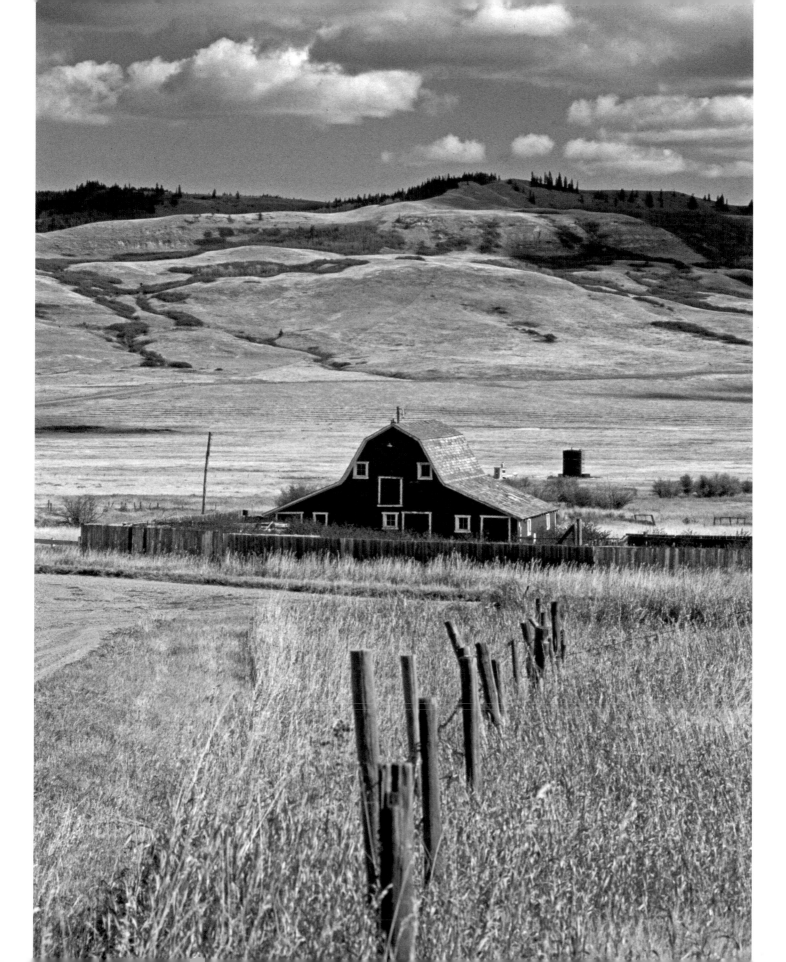

CIRCLING THE PORCUPINES

Between the Rockies' vigorous upthrusts and the recumbent lines of the grassland plains, the Porcupine Hills provide a softly rounded interface, gentle contours that stir the heart. They are always so beautiful, from the wildflowers of spring to the hazy shimmer of summer and the sharp gold of fall aspens, and even in the austerity of a landscape under the sharp shadows of snow. The hills bring magic to all the seasons.

The Porcupines are also special geologically. Unlike the mountains and the foothills that were thrust skyward by tectonic forces, the hills are technically part of the plains. Born under the tropical sea that covered most of North America in Cretaceous times, the hills are the western edge of the sea floor that was later tilted up to form the great Alberta Syncline, the arched bedrock that underlies all the southern prairies. Swelling skyward at the edge of the grasslands between Nanton and Fort Macleod, the Porcupines' bedrock of once-submerged sandstone and shale was given its voluptuous curves by hundreds of thousands of years of glacial action, for here two great North American ice sheets met and in places coalesced. The Laurentide sheet came down from the northeast, the Cordilleran from the west, and both were fierce scouring pads, polishing smooth the hills' craggy edges. Oddly, some areas of the south and central hills above 1,615 metres were left untouched by the ice. Like parts of both the Cypress and the Hand hills, these unglaciated areas provided refuge for life forms that elsewhere were extinguished.

Known to the Plains First Nations as the Porcupine's Tail, the hills were well named; from some angles, their forested backs bristle with fir, pine and spruce. They were welcoming places of shelter, for humans and the creatures they needed for survival. The buffalo are gone, but the hills still provide for white-tail and mule deer, moose, lynx, coyote, even cougar, and for hundreds of birds and other creatures, not forgetting porcupine.

The road west through the Porcupines gives a stunning view of the Livingstone Range.

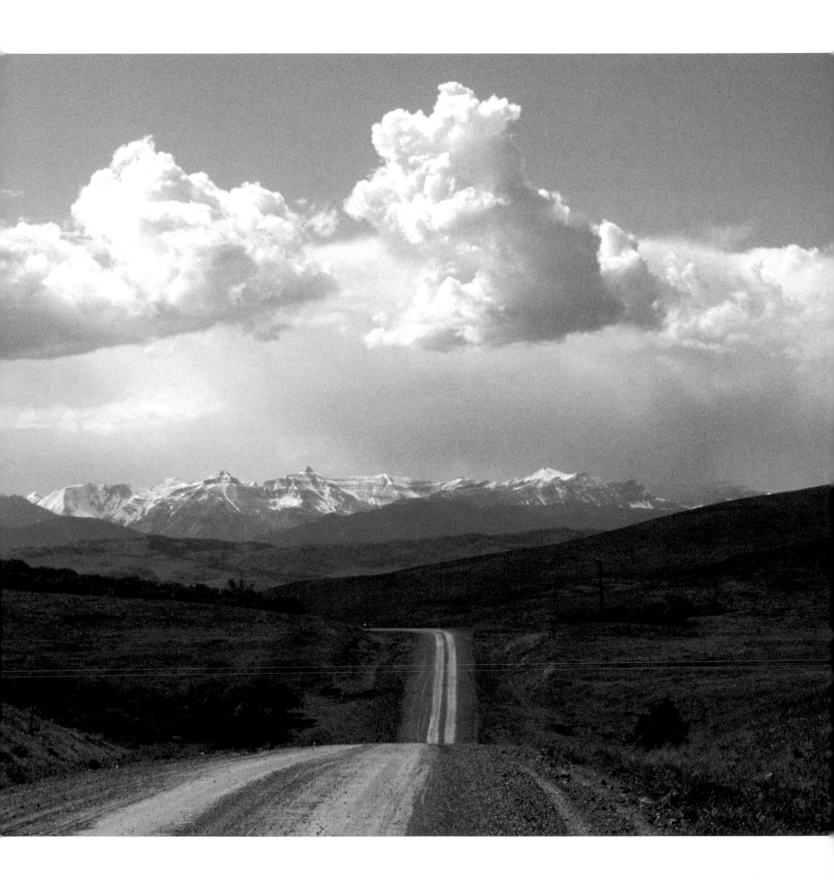

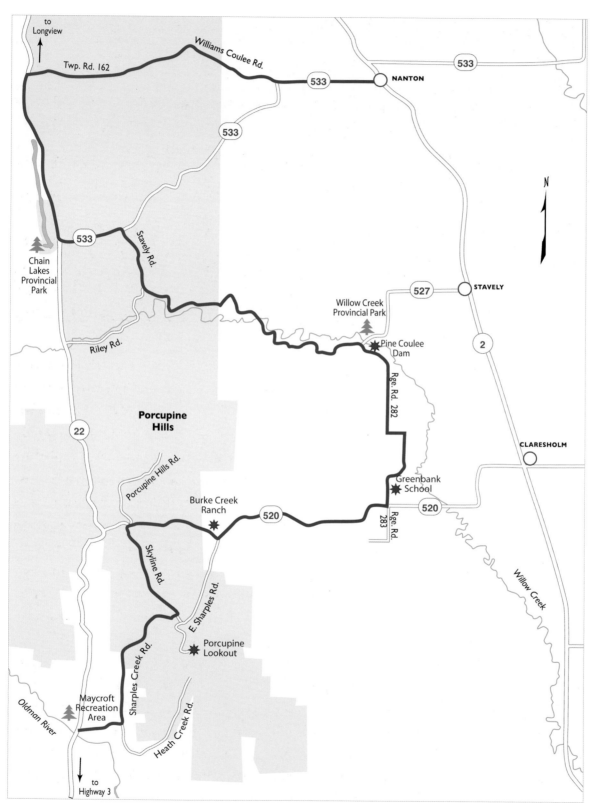

to Longview

Twp. Rd. 162

Williams Coulee Rd.

533

NANTON

533

533

533

Stavely Rd.

Chain Lakes Provincial Park

Riley Rd.

527

STAVELY

Willow Creek Provincial Park

Pine Coulee Dam

2

Rge. Rd. 282

Porcupine Hills

22

Porcupine Hills Rd.

CLARESHOLM

Greenbank School

Burke Creek Ranch

520

Rge. Rd. 283

520

Skyline Rd.

E. Sharples Rd.

Porcupine Lookout

Sharples Creek Rd.

Oldman River

Maycroft Recreation Area

Heath Creek Rd.

Willow Creek

to Highway 3

The bewitching Porcupine Hills are stitched through with several country roads. This route follows most of them, on a slow, sinuous journey from Nanton to the Crowsnest Pass. Allow a full day. Some unpaved roads.

N

LEGEND

○ large community

● small community

✸ place of interest

🌲 park/recreation site

- - - optional route

|| bridge

⛪ church

✳ ferry

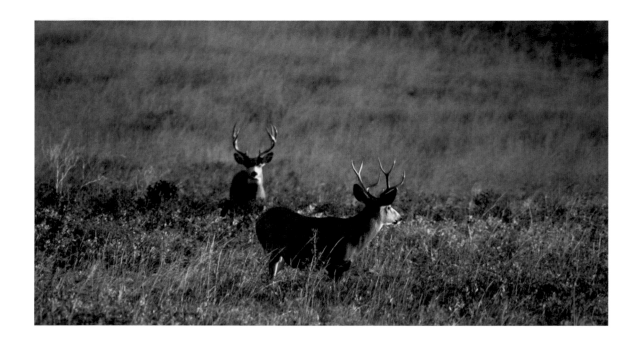

Mule deer in Williams Coulee, early morning.

Peter Fidler was the first European to explore the hills during his 1792–93 discovery trip (see chapter 14), but they were not mapped thoroughly until more than 60 years later, when Captain John Palliser and his British North American Exploring Expedition travelled through them in 1857. And soon afterward the first European settlers trickled in, mainly ranchers who "open-ranged" their cattle all year on the bountiful, sheltered grasslands. There are several historic ranches still operating here, though there are also the sad relics of those who failed, including abandoned homesteads, barns and schoolhouses.

Lying between two busy roads, Highways 2 and 22, the hills are fingered by several smaller roads that poke in from around their circumference. The two main cross-over routes are secondary highways 533 west from Nanton and 520 west from Claresholm. Both of these are partly paved. There are others that are narrow, winding and of gravel surface, and all these are beautiful, though they can be treacherous in mud or fresh snow, and they are always dusty in summer. But they are, for the most part, largely untravelled and cry out to be driven—slowly, with lots of impromptu stops for scenery and wildlife.

This journey describes a looping, S-shaped route that combines sections of the paved highways with some of the rougher roads and visits some of the most scenic places in the Porcupine Hills. It starts at the town of Nanton and follows Secondary Highway 533, striking due west, as straight as an arrow, to the base of the hills. It passes a marker for the Old Macleod Trail, the original north–south transportation route from Fort Benton in Montana to Fort Edmonton, which was used by First Nations, fur traders, ranchers and early police patrols until about 1900. The course of the trail can still be seen as ruts in farmers' fields. At Coulton's Corner, about 10 kilometres along, Secondary 533 turns sharply south to begin the hill climb.

The sad remains of Sunset School, lost in the Porcupines.

But there is a more leisurely road. Straight ahead lies Williams Coulee, which cuts through hills crowned with fascinating sandstone outcrops and glorious with balsamroot sunflowers in May. Follow this road as it winds down to cross Mosquito Creek—which, judging from the swarms of swallows nesting under the bridge, seems to be true to its name.

Near the creek bridge, Meridian Road leads north along the fifth meridian, one of the major survey lines on which the prairie township system is based (see the introduction to this book). Here, the road along Williams Coulee acquires an official designation on the grid—Township Road 162—and passes through the pioneer settlement of Muirhead, marked by a sign commemorating the post office and school, of which only a ruin remains, home to a roost of pigeons.

Thirty-six kilometres from Nanton, Township Road 162 reaches Highway 22. Head south, passing Chain Lakes on the west. Once a series of tiny, spring-fed lakes, they are no longer a chain but have been amalgamated into one long lake by dams built at both ends. Today there's a popular provincial park campsite at the southern edge, and the fishing, both in summer and in winter through the ice, is considered excellent. In spring, the lake edges are knee-deep in wildflowers, including thick beds of clover, wild geranium, aster and yellow cinquefoil. It's tempting to duck under the roadside fence and go down to the water's edge, particularly if there are white pelicans fishing on the lake. But be warned: the fence is electrified to control livestock.

At the provincial park end of the lake, Secondary Highway 533 comes in from Nanton (this is the road you would have been on if you hadn't taken the Williams Coulee detour.) Turn left here and drive uphill for about six kilometres to an unpaved side road. A sign points to Stavely (48 kilometres) and the Willow Springs Arena. This lovely, sinuous road follows Willow Creek,

*White geranium
by Chain Lake.*

crossing it several times on narrow bridges. The creek flows east through the hills, gathering water from all the little tributaries, its route picked out in fall by the gleam of golden cottonwoods, then it swings south to join the Oldman River at Fort Macleod. Where Willow Creek Road intersects with Secondary 527, the creek has carved a deep course through a large, flat area that was once a glacial lake, formed when meltwater runoff from the hills backed up against the continental ice sheet on the plains. When this ice melted, the lake drained, leaving a moist dimple, thick with willow and cottonwood. This became a traditional campsite for Blackfoot tribes who came here to hunt buffalo and collect berries; the creek provided water, and the trees gave shelter and firewood. One of their tipi rings still remains alongside the creek bridge.

Willow Creek is today a popular provincial park, an oasis in the hills that was also relished by homesteaders from the community of Stavely, who came here to swim and picnic and to hold dances on a converted sawmill platform—a platform long gone, of course. It's a great birding area: look for great blue herons, kingfishers, orioles and kestrels and the nesting holes of cliff swallows in the steep creek banks.

Explore the park and nearby Pine Coulee, part of which has been dammed to form a reservoir, but don't leave the Porcupines yet. Turn south on Range Road 282, which skirts the eastern slopes of the hills to join the road to Claresholm at the old Greenbank schoolhouse. Turn west here (it's Secondary Highway 520) and circle back through the hills again, mostly through the Trout Creek Valley. Stop by Lyndon Creek Road and look at the signpost: a surprising number of ranches are tucked away in the folds of these scenic hills. Farther west is Burke Creek Ranch, a classic collection of barns and outbuildings clustered around the original

Golden aspen a-gleam on the eastern slopes.

creek-side homestead. It's one of the old-timers, founded in 1890. In 1911 a post office, named for the early settler John Furman, was opened here; though the name Furman still appears on most maps and there's a historic-site marker, the post office is closed

You'll notice pairs of nesting boxes set up on ranch fences. In early summer these provide good opportunities for bird photography; both the colourful mountain bluebird and its nesting-site competitor, the tree swallow, will not be far away. Both are equally adept at keeping down the mosquito population. Another brilliant blue bird, perhaps flitting around wild rose bushes where it likes to nest, could be a lazuli bunting: there is a large population of them in these hills.

East Sharples Road swings off to the south just east of Burke Creek Ranch, and this is an optional connection to Skyline Road. But drive straight on: there's another way to the skyline. The road climbs, becomes steeper and more wooded as it enters the Rocky Mountain Forest Reserve, a sylvan tapestry embroidered in three different ways. In montane forests grow mature stands of Douglas fir, the oldest trees in the hills and, at more than 30 metres high, some of the tallest in Alberta. Shaded creek bottoms have been invaded by aspen parkland, a transition zone where white spruce interweave with clumps of aspen and poplar. Higher ridges are tufted with trees of the subalpine zone: Engelmann spruce, pine and alpine fir. Each forest ecosystem finds its preferred niche, according to elevation and aspect, and each carries its own displays of wildflowers. Nowhere else in Alberta do all three forests intermingle so intimately with fescue grasslands, making the hills a magnet for naturalists.

Just over the summit, before the road zooms down to meet Highway 22, there's a crossroad. East Trout Creek Road leads north about nine kilometres before petering out on the edge of

beautiful Trout Creek Basin, where marvellous hikes begin. To access Skyline Ridge, turn left (south) along Skyline Road, which truly lives up to its name as it rides the ridge line of the Porcupine Hills, the high backbone that separates east from west drainage.

Built as a firebreak and to access a forestry lookout tower, the road is a scenic treasure; you will want to stop often for stunning vistas west across the foothills to the Rockies and east down the Porcupines to the shimmering plains. There's an excellent viewpoint near the beginning of the road that is perfect for a picnic or to watch the sunset. The crest is forested with pine and spruce and interspersed with open meadows where the wildflowers, after a wet spring, are incredibly thick and varied—arnica, meadowsweet, lupine, paintbrush, shooting star and others—and there are funny little crooked dwarf poplars, bending into the wind. Below, the grassy western slopes are pricked out with the delicate trembling greens of aspen. In October, the deciduous trees and shrubs on the hills form a glowing mosaic of yellow, gold and copper, a sight to remember.

About 10 kilometres from the Claresholm Road, Skyline Road reaches a junction. Left, the road continues towards the forestry lookout and East Sharples Road back to Burke Creek Ranch. Turn right instead to follow Sharples Road West and drop down from the ridge in loopy zigzags through sloping grassland and groves of spindly aspen. In places, beaver dams have transformed Sharples Creek into a series of little ponds, connected by cascades. Cattle graze on the hills here and are quite likely to block the road. Drive slowly and with respect. The land is part of the original holdings of the historic Walrond Ranch, established in 1882. (The benchland below is known as "Waldron" Flats, a typo that has persisted.) The land in southern Alberta was early recognized as ideal open range for cattle and horses; grasslands flourished, there were mountain streams aplenty, chinook winds reduced snow accumulation and the many coulees provided adequate winter shelter. The early ranches in Alberta were huge. Cattlemen could lease up to 100,000 acres (40,500 hectares) for up to 21 years at an annual rent of one cent per acre, a government inducement that worked. By 1885 four companies, one of them the Walrond, controlled more than 40 percent of Alberta's leased acreage. Later broken up into smaller ranches, the Walrond is remembered today by the (misnamed) flats below and by the 1894 ranch house, now preserved in the Pincher Creek museum grounds.

Our route twists slowly down the western slopes of the Porcupines and across Waldron Flats back to Highway 22 by the Oldman River Bridge. Highway 3 and the Crowsnest Pass lie to the south. For a glimpse into the old-time cattle-ranching business, turn north along the highway and head toward Longview and the Bar U Ranch, a National Historic Site where, if you time your visit right, you can take in an old-fashioned rodeo, watch roundups and branding or even a cowboy game of polo. ❖

SACRED STONES

The short-grass plains of Alberta are sprinkled with traces of the first people to live here: the Cree, the Blackfoot, the Stoneys and others who forged a way of life dependent on the buffalo thousands of years before the first European explorers arrived to claim the land. Much of the original prairie has been ploughed under and the relics lost, but on the crumpled edges of river valleys and in deep coulees unsuitable for cultivation remain tipi rings, buffalo jumps and the huge piles and circles of boulders known as medicine wheels, some more ancient than England's Stonehenge. These artifacts of stone are nevertheless fragile, for they sit lightly on top of the windblown prairie, subject to disturbance by cattle—or people.

This journey goes cross-country from Stavely to Brooks along less travelled roads and visits a tipi ring site and two fine medicine wheels, the latter still held sacred by the First Nations people whose ancestors created them. From Stavely, a small town on Highway 2 with a long line of bright orange grain elevators, take Township Road 142 east through farmland watered by creeks draining from the eastern flanks of the Porcupine Hills. Cross the Little Bow River (about 15 kilometres on) and continue east to Highway 23, then turn south and head for the river again. Just before the highway river bridge, there's a quiet picnic area complete with shelters. Here, on grassy flats above the water's edge, are nine tipi rings, circles of stones that once held down the conical hide tents of the nomadic First People. An interpretive sign with a map will help you find the stones in the meadow grass where hunters often camped. Fragments of buffalo bone and chipped stone projectile points excavated at the site give a broad occupation time frame of between AD 200 and 1700; the campsite was obviously a popular one. Another sign board explains the geological reasons why the river here cuts such a loopy path through its wide valley, coiling and doubling back on itself to create very interesting patterns.

Sacred to Natives, the medicine wheel at Majorville still receives offerings of sweetgrass, fabrics and tobacco. A cruciform figure has been left at one of the outer cairns.

LEGEND

○ large community
● small community
✹ place of interest
🌲 park/recreation site
--- optional route
‖ bridge
⛪ church
✳ ferry

Only two of Alberta's protected medicine wheels, ancient sites still sacred to the Natives, are available for public viewing, and this journey will take you to them. From Stavely to Brooks, the roads can be driven in half a day. But you'll want extra time to explore and meditate. Some rough unpaved roads.

Drive south across the Little Bow River and turn east into Carmangay, a quiet little town with a hotel and a colourful old firehall. At the municipal campground there's a tipi to stay in; $10 a night will provide something of the Native experience. Any one of the town's streets will lead out to Stone House Road (Township Road 140), which heads east through a steadily climbing, rippled landscape formed on ancient, elongated dunes. Lying within the path of the strongest chinook winds, these dunes were formed after the glacial ice retreated and left the land bare of vegetation, at the mercy of the wind action. More noticeable from the air than from the ground, the dunes add interest to a land now heavily cultivated as it rises over Blackspring Ridge. The Little Bow River has been dammed to create the Travers and Little Bow reservoirs, part of a huge irrigation project that makes possible the cultivation of some 37,000 hectares of farmland. But where the land is too rumpled with glacial deposits, the short-grass prairie asserts itself; much of it has never been ploughed.

Magenta blooms on the barrel cactus.

Once over the ridge, within sight of the blue reservoir waters, Stone House Road meets Secondary Highway 843 coming north from Picture Butte and becomes Secondary Highway 522. About 28 kilometres past Carmangay, just before a transmission line, watch for an obscure turning to the south, marked by a small white arrow. This gravel road follows a fence line for about one kilometre to a cattle guard, where it turns sharply left. Ahead, a rough double track through the grass leads one kilometre to Sundial Hill medicine wheel, on top of the highest of several small but sharp hills, most of them crowned with lichen-encrusted rocks. Drive this track carefully (or walk), and avoid scaring the cattle that range this hill country. The archaeological site is surrounded by a fence and is described by a very informative government sign. A gate gives foot access up the hill. Like most of the 43 known medicine wheels in Alberta, Sundial Hill has not been thoroughly investigated by archaeologists, though ongoing measurements of lichen growth on the stones might ultimately provide a clue as to when the wheel was built.

Sundial Hill was the first medicine wheel to be mentioned in print. In 1855, surveyor George Dawson described it in his *Geological and Natural History of Canada*: "Sun-dial Hill ... a cairn with concentric circles of stones and radiating lines ... regarded with much reverence ... " The central rock pile, surrounded by a double circle of stones broken by a stone-edged "corridor," is not very high; it has been scooped out in the centre where past vandals have dug, hoping for spoils. A tough gooseberry bush in the rock pile's heart is often adorned with pieces of coloured cloth, evidence of the wheel's continuing spiritual importance to local First Nations. One can well understand why. The view is unobstructed: down over grassy hillocks to the snaky path of the Little Bow River and the reservoirs and out across the prairie. There's a scattering of wildflowers among the rocks, including clumps of yellow rubberweed and bright magenta cactus. Up here, the wind always seems supernaturally strong in the wiry grass, creating an atmosphere almost of unease. Treat the place with respect. Do not disturb any of the stones or leave any litter. To some, it is a sacred place.

Return the way you came, driving carefully over the rocky hillocks, and turn right on Secondary 522 to cross the Little Bow River again. At Secondary Highway 845, turn left (north) and

LEFT

An extensive view south to the Bow River, from the cairn at the centre of the Majorville medicine wheel.

after four kilometres turn left again on Township Road 142 to visit the two reservoirs, Travers and Little Bow, where there is a well-groomed provincial recreation area. Islands in Little Bow Reservoir support nesting colonies of cormorants, terns and gulls, and there are many grassland birds, including warblers and bluebirds, phoebes and rock wrens, swallows and horned larks.

Back on Highway 845, turn north (left) to pass the community of Lomond and join Secondary Highway 539 east to Bow City. Birders will want to duck south along here and drive around Badger Lake, home to large numbers of nesting waterfowl. But to reach the medicine wheel, take Range Road 183, which heads north through the huge Ducks Unlimited Medicine Wheel Project, a $1.7-million investment in the preservation of wetlands and the management of native prairie on the adjoining uplands. The project was so named because it lies very close to Majorville Cairn medicine wheel, on one of the hills to the north. In fact, the road seems to point the way: the wheel is a distinct blip on the horizon. Beside the road by the wetlands' edge is a memorial to Bob Eberhardt of Ducks Unlimited: a tall white stone inside a circle of piled stones, itself very much like a medicine wheel.

RIGHT

The road to Majorville Cairn points the way: the medicine wheel is the blip on the horizon.

Range Road 183, which passes through lands leased by the Lomond Grazing Association, is narrow and very muddy when wet, since it meanders between huge, shallow lakes and marshes, in spring and summer loud with croaking frogs and the fluster of nesting shorebirds. Along the way, there's a fine old pioneer house, long abandoned, sitting in a garden of yellow blooming butter-and-eggs. If this road is too wet to travel, there is another way to reach the medicine wheel trail from the highway: take Range Road 185 north to four steel grain bins, then turn east

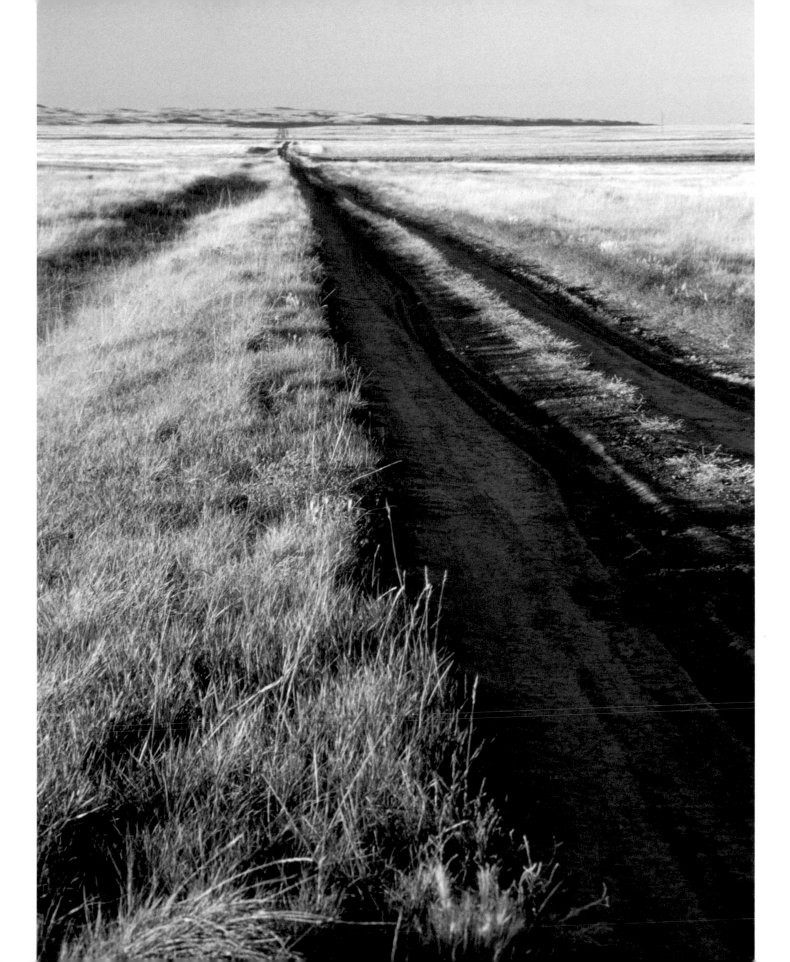

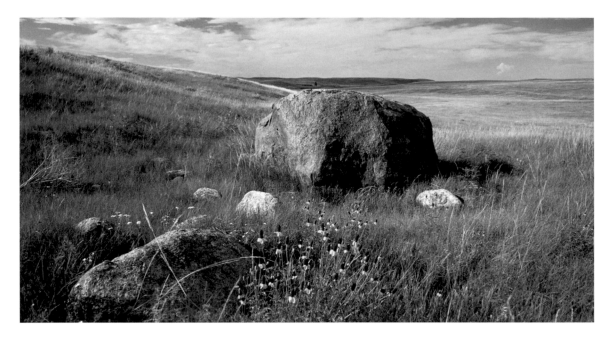

to meet up with Range Road 183 at a cattle guard where a Lomond Grazing Association sign reminds travellers to stay on roads and treat the land with respect. It is considered a courtesy to call the association when planning to venture onto these leased lands.

Drive across the cattle guard, scan the adjacent small pond (avocets and black-necked stilts have been seen here) and follow the tracks under the transmission lines and past the site of Amethyst School (which lasted only a year, from 1917 to 1918), marked by a decorative black iron sign. The next landmarks are two large erratic boulders used by buffalo as rubbing stones, shiny with centuries of use. A man-made wooden support holds a huge nest, probably that of a hawk, near a dugout. About five kilometres past the cattle guard, the track veers left and climbs a short, very steep hill onto a plateau rimmed on the east by smaller hills. On top of one of these there is a prominent cluster of rocks, like a nest, and it's worth the short walk over to see it, if only for the view down to the Bow River. From here it's less than one kilometre to the medicine wheel fence, where there is another most informative sign.

Majorville Cairn medicine wheel is one of the few that have been thoroughly investigated. When archaeologists stripped down half of the huge central mound of stones and analyzed its contents they found, mostly by cross-dating the stone artifacts, that construction began here 5,000 years ago, making it older than the Egyptian pyramids or Stonehenge. The cairn is the most obvious feature at Majorville, a mound of beautifully coloured rocks. Less easy to see is the surrounding large circle of stones connected to the cairn by 28 radial lines. If the cairn is the hub of the wheel, and the circle the rim, these short connections are the spokes. It was

constructions like this that first gave rise to the wheel analogy. The details of this design at Majorville, however, are clearly apparent only from the archaeological plan, a copy of which is included on the interpretive sign below. On the ground, many of the stones are deeply buried and lost in the ungrazed grass.

Medicine wheels, because they are so old and their true purpose unknown—now unknowable—prompt all kinds of theories and ideas. Some people think there is more to Majorville than the stones on top of the hill, that it is the centre of a huge temple spread out over 100 square

Prairie coneflower, or Mexican hat.

kilometres, connected by sighting lines to the many other cairns and rings in the area. Some of these are aligned to the sunrise at both the solstice and the equinox and to several other celestial sights. Certainly it is a place that seems, even today, to be deeply revered: offerings are often left here—as well as coloured cloth, there may be figures made of sagebrush, or twists of tobacco. It is a wild and heady site, one that is hard to leave and will be long remembered.

Unless you want to try your hand at route finding (the track you came in on continues north toward the tiny—really non-existent—settlement of Majorville, by way of oil exploration roads), you must return the same way back to the wetlands and Highway 539 and continue east to the village of Bow City, where the road crosses the Bow River on a spanking new bridge. Originally on the south side of the river, the settlement was founded on deposits of coal so rich that promoters called the place New Pittsburgh. A few small mines opened, but the area never lived up to its promise. However, under consideration is a huge new development near here, fortunately on the other side of the river from the medicine wheel; it involves a surface coal mine and eventually two coal-fired thermal electric generating plants. If this goes ahead, the whole look of this part of the country could change.

Secondary Highway 539 continues northeast to Highway 36, which heads toward the Trans-Canada Highway and Brooks (25 kilometres), the largest community close to Dinosaur Provincial Park, a popular tourist destination. (For more on medicine wheels and other ancient Native sites in Alberta and Saskatchewan, read my book *Stone by Stone*, also published by Heritage House.) ❖

EAST–WEST JOURNEY

Most of the land south of Alberta Highway 3 is — or was — arid, part of the huge triangle of country that Captain John Palliser, leader of the 1857 British North American Exploring Expedition, reported as unfit for settlement. Europeans came anyway, breaking their backs and their dreams on a dry and unforgiving landscape, until the years of the great dust bowls forced them away. Today, the southern base of this triangle is arid still and forms the lovely desert lands around the Milk River. But farther to the north, irrigation from dams on the Bow, St. Mary and Waterton rivers has turned the sagebrush and cactus scrub to farmland, a nurtured landscape of many colours and textures as the seasons turn from green to gold. Abandoned now, old homesteads and barns of the first settlers add a nostalgic appeal.

Threading west through this countryside, a series of interconnected secondary roads provides a slow and scenic route well worth exploring. The journey starts west from Medicine Hat along Highway 3 through Bow Island, then ducks south along Secondary Highway 879 to the village of Foremost. From here, thread a cross-country course almost due west to the communities of Warner and Pincher Creek. The one-way distance is less than 250 kilometres, but you will need to allocate a full day, particularly if you plan to make explorations en route.

The land around Foremost was opened for homesteading in 1910, and a post office was opened at Webber to serve the new settlers. Three years later, when the Canadian Pacific Railway (CPR) built a branch line into the area, a new townsite was laid out where the railway met the wagon road; like most prairie settlements of the era, this one was given a grand and hopeful name. Certainly Foremost eclipsed Webber, which "closed" when the post office closed, but even the new settlement did not live up to its expectations. Today, echoing the trend toward rural abandonment, Foremost is only a shred of its former self. Along its wide main street are a

Windmill on a high and golden hill.

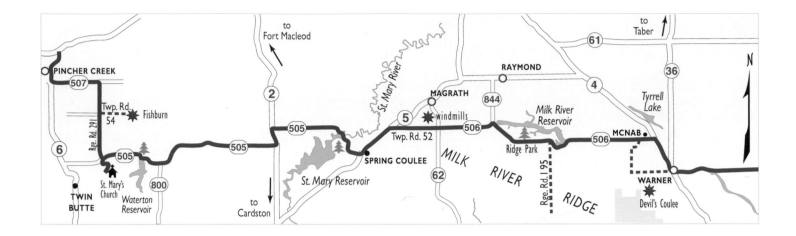

few stores and offices and a great little eating place, the Sweetgrass Café. But the countryside all around is visually tempting. South lies Vernon Lake bird sanctuary. A few kilometres north is a beautiful old deserted homestead, flamboyant in prairie sunset light. East lies the settlement of Etzikom (Blackfoot for "coulee"), with its museum collection of pioneer windmills; nearby, down a side road labelled "Hoping" (Range Road 93), lies a picturesque collection of old barns, one a silo several storeys high. This whole area provides a wealth of pioneer architecture, often stranded now in irrigated fields. Despite the domestication of the landscape there is still much wildlife—birds in prairie potholes, deer and pronghorns in grain fields. And to the south lie the alluring lands of the Milk River (see chapter 1).

The town of Foremost was once the scene of a theatrical bank robbery. On the night of August 29, 1922, members of the notorious Reid and Davis gang on a robbery spree throughout the West stole tools from a railway shed, severed town telephone and telegraph lines and broke into the Union Bank. At the time, two bank employees slept on the premises. The gang tied up one of them and forced the other to open the safe. The robbers escaped with more than $10,000 in cash plus $60,000 in bonds. But the Alberta Provincial Police were soon on their trail: they arrested two men and retrieved $860,000 worth of loot, part of a huge haul from banks the gang had robbed in Manitoba, Saskatchewan, British Columbia and North Dakota. U.S. marshals rounded up the rest of the gang, and bank managers in all the small western towns let out huge sighs of relief. Foremost settled back into country quiet.

Highway 61, which cuts east–west through the town (alongside the railway and the grain elevators), has been named the Redcoat Trail because it roughly follows the march of the North West Mounted Police on their trek west from Winnipeg to Fort Macleod. Take this route east for 10 kilometres, past the town campsite, and watch for Range Road 130—Legend Road. A

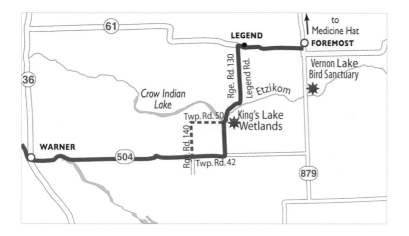

Start early and stop often for this long day's journey east–west across southern Alberta. Mostly paved roads from Foremost to Pincher Creek.

whistle-stop settlement on the railway, Legend was named for a nearby lake in which, according to legend, there lived a fish so huge it swallowed canoes. Legend Road leads south into Etzikom Coulee, a wide glacial meltwater drainage channel. At the coulee bottom, a small dam backs up the waters of Etzikom Creek to form the long, skinny finger of Crow Indian Lake. Here there is an astonishing red barn, huge, square and three-tiered. Beside it, Kings Lake Wetlands provides good birding. In the summer, look for black-crowned night-herons nesting in the reeds. The local farm dog is very friendly.

Legend Road climbs out of the coulee onto prairie level and continues straight, as all range roads try to do. But turn right at the coulee rim and drive above the lake for a while, then duck south on Range Road 140, which will meet, eventually, Secondary 504 west. Just before the town of Warner, the road crosses the north end of Verdigris Coulee, so called because it is bordered in places with green crystalline rocks. One of several glacial meltwater drains that run diagonally through these farmlands, the coulee contains intermittent lakes known for good birding and, if you know where to look, First Nations petroglyphs.

Warner deserves a stopover to visit the Devil's Coulee Dinosaur Heritage Museum, an interesting mixture of geological, Native and pioneer exhibits. It is known chiefly as the centre for tours of Devil's Coulee, where in 1987 local schoolgirl Wendy Sloboda picked up what she thought were the fossilized shells of dinosaur eggs. Experts from the Royal Tyrrell Museum in Drumheller agreed, and when they searched the coulee, they found the nest of a duck-billed dinosaur known as Hypacrosaurus, complete with eggs and embryos, the first such discovery in Canada. The site, scene of ongoing research and recovery, lies on the north side of the Milk River Ridge, southwest of town. At present, two tours a day are scheduled from the museum during the summer months.

Our journey strikes northwest along Highway 4 for a few kilometres, then turns left along Secondary Highway 506, signposted to Ridge Park. (Avid birders, though, might choose to continue north a little way to Tyrrell Lake, where surrounding marshes provide nesting areas for red-winged and yellow-headed blackbirds and black-crowned night-herons; in fall, it's a staging area for snow geese and tundra swans.) Highway 506 dips into a north–south coulee, and here at the CPR siding of McNab sits a lone grain elevator, one of a vanishing breed, painted brick red.

Stay on 506 west all the way to the edge of the Milk River Ridge Reservoir, a lake formed behind a dam on Middle Coulee, part of the extensive St. Mary River Irrigation Project. Rimmed by sand bluffs, the lake has been stocked with walleye and pike and attracts many migratory birds, including swans, white pelicans and lots of gulls. Ridge Park campsite on the lakeshore provides good access. South of the lake, the Milk River Ridge—parts of which escaped glaciation—rises gently 300 metres above the plains. It is surprising to realize that this low heave in the landscape divides the continent's drainage: north of the ridge, all rivers flow into Hudson Bay; south, into the Gulf of Mexico. The higher elevation of the hills results in damper conditions that support not only luxuriant native fescue grass but also thick fields of wildflowers in spring and early summer. Several unpaved range roads lead south up onto the ridge, and these are worth exploring for flowers, extensive views (south to the Sweetgrass Hills of Montana, west to the Rockies) and a wonderful sense that here lies land untouched and unspoiled, as it was perhaps when buffalo roamed here. Range Road 195, for example, will take you 10 kilometres up into these flowery pastures, where the ridge is not a single spine but a series of gentle hills, in

Deserted homestead north of Warner in sunset gold.

spring a serene, blue tapestry of lupines or bright with sticky geraniums, clumps of gaillardias and buffalo beans. These roads, however, are rough and steep, likely to be very muddy, and should be driven with care.

About 12 kilometres beyond Ridge Park, Secondary Highway 844 goes north to Raymond, and Highway 506 forks left and turns west to Highway 62. Directly across this highway, what looks like an impossibly steep, unpaved road leads up to a ridge topped by a line of windmills. Take this road (Township Road 52); it's not as steep as it looks. If you stop to count, there are at least 29 windmills in view. The ones on the ridge, right beside the road, loom large against the sky, and in summer the surrounding fields of glowing yellow canola set a scene that is not easily forgotten. It's well worth the rough trip up.

Road 52 leads inevitably down again from the windmills to meet Highway 5. Turn south for about seven kilometres to the old hamlet of Spring Coulee, then drive west on Secondary 505, which leads across the dam at the northeastern end of St. Mary Reservoir. Hidden now beneath the turquoise waters of this lovely lake, where the Rocky Mountains seem to float on the southern horizon, is perhaps one of the most important archaeological sites in Canada. At Wally's Beach, when lake waters were drawn down for spillway repairs, the sandy lake bed was uncovered and later stripped by prairie winds down to an ancient mud floor. Here, like a photograph from Pleistocene days, were found footprints of animals long extinct: camels, mammoths, muskoxen and giant bison.

And if that were not exciting enough, there were bones, some of prehistoric horses, animals extinct in Alberta for at least 10,000 years. Archaeologists determined that these bones were from animals hunted and butchered by early man. Nearby they found flint choppers, scrapers and several beautifully chipped spear points. To clinch the evidence, ancient residues on the spears tested positive for the blood of muskox and horse, furnishing the first North American proof that early people hunted horses for meat. Carbon dating of the animal bones gave dates of between 11,000 and 11,300 years ago. Surprisingly, the green chert of the spear points was found to have come all the way from quarries in today's Montana, some 400 kilometres off.

Excavations at Wally's Beach were done hurriedly: there was only so much time available before work on the spillway was finished and lake waters reflooded the site. Today, there is nothing to be seen of this grand archaeological discovery, but the lake is lovely in itself, and there's a fine recreation area in the river canyon below the spillway.

Secondary Highway 505 heads west from the lake to Highway 2, where it jogs three kilometres south before continuing west over the Blood (Kainai) Nation reserve. Here, huge fields of grain sprawl across the landscape, leading the eye to the peaks of the Rockies along the western horizon. About 15 kilometres beyond the highway junction, the community of

Laverne sports a pretty little church, and just beyond, beside the Belly River, is a cairn marking the location of the historic Cochrane Ranch bungalow. Of sandstone construction, the home was built in 1895 from plans brought from England by Helen May Brisco, the new English bride of William Cochrane, son and heir of the huge Cochrane Ranching Company. Far more grandiose than a "bungalow," this elegant residence had two floors containing 18 rooms and all modern conveniences, including gas lighting,

Yellow-headed blackbird.

bathrooms, hot-water radiators and windmills to pump water from the Belly River. The house was furnished every bit as lavishly as an English stately home, complete with a Pianola player piano from which tinkled the music of Chopin. Outside, in a traditional country garden planted with imported trees and shrubs, stood a fancy Victorian gazebo. Later the ranch was sold to the Church of Jesus Christ of Latter-day Saints, who subdivided it for homesteads; the Cochranes moved on. The bungalow was abandoned and later demolished.

It's less than 20 kilometres from the Belly River to another large lake whose waters are a bright, icy green. Waterton Reservoir is almost a carbon copy of St. Mary Reservoir, with the Rockies on the horizon, a road across the dam, a recreation area below the spillway and a campsite by a beach. It's another incredibly beautiful spot, though without the buried treasure. On the road beside the spillway, there's an osprey nest (usually occupied) on a tall snag.

From here on, the journey west is dominated by the Rockies, which rise ever nearer, blue shoulders on the skyline. On an intervening foothill ridge, the white spire of St. Mary's Church completes a scene somehow reminiscent of Switzerland; a good vantage point for photography is beside a group of round grain bins on the left side of the road. To drive up to the church, which sits in a little garden, yellow with dandelions and hedged with caragana, follow Sam Bonertz Road left and up to the hilltop for good views of the reservoir, the mountains and the countryside around the settlement of Twin Butte.

Opposite this road, Range Road 291 leads north, and this is the route to follow all the way to Pincher Creek. The road is signposted as Sergeant Wilde Road to commemorate the North West Mountie who was shot to death near here by Charcoal, a Blackfoot who had murdered his wife's lover and who was the focus of a massive manhunt throughout southwest

Classic red barn in stubble field.

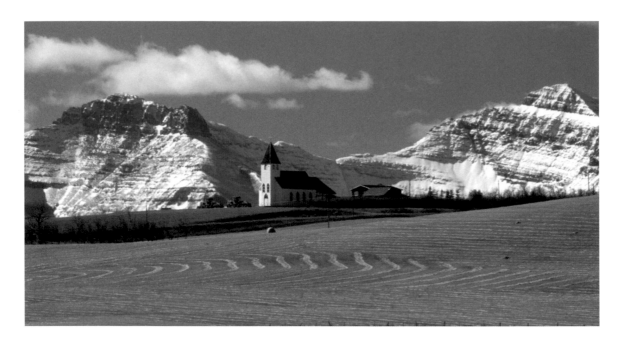

Alberta. (For the full story of Charcoal, a tale not just of infidelity, murder and revenge but of an irreconcilable clash of cultures, read *Charcoal's World*, by Hugh Dempsey.) Continue on this road in roller-coaster fashion across a railway and Foothills Creek, and head due north to meet Secondary Highway 507 east of Pincher Creek, which is a pleasant little town with views of windmills on just about every ridge in sight; it also has an interesting museum set in a "village" of pioneer buildings moved in from the surrounding area. ✤

FAITH AND IMMIGRANT DREAMS

In 1872, the Canadian government approved the Dominion Lands Act. This was a momentous piece of legislation, for not only did it launch the Dominion Land Survey, which divided most of western Canada into orderly sections, but it also opened the land for mass settlement. The vast prairies and parklands, by then empty of both the buffalo and their hunters, desperately needed populating and the government made it relatively easy for prospective settlers with $10 in their pockets to lay claim to a quarter section (160 acres, or 65 hectares) of unbroken land. They could have clear title after three years, provided they cultivated a specified number of acres, which varied according to terrain, put up a permanent dwelling and lived there for at least six months of each year. Land-hungry peasant families, mostly from Europe, began streaming in to Western Canada, encouraged by glowing advertisements sponsored by the Canadian Pacific Railway. They came from all across the Old World, enduring long ocean journeys in cramped emigrant ships and cross-Canada trains, often in cattle cars. They worked hard, survived hunger in the bitter winters and flourished (at least, most of them did), and they helped make a great country.

Nowhere is this tale of immigrant dreams and desperate determination more deeply stamped on today's landscape than in east central Alberta, where 170,000 Ukrainian peasants moved onto the land between 1891 and 1914. They came mostly from the Galicia and Bukovina regions, seeking relief from the economic oppression of Russian rule, and they brought with them very little apart from a few seeds and their unquenchable faith. The first Ukrainian settlement in Canada began with the arrival of four families, all from one village, who took up adjoining homesteads in the vicinity of Star. More immigrants followed, attracted to this nucleus colony, and soon the whole area between Fort Saskatchewan and Vermilion, more than 8,000 square kilometres, became identifiably Ukrainian. The shining onion domes of their beautiful and

Rainbow in the rain over wheat fields in the Ukrainian bloc.

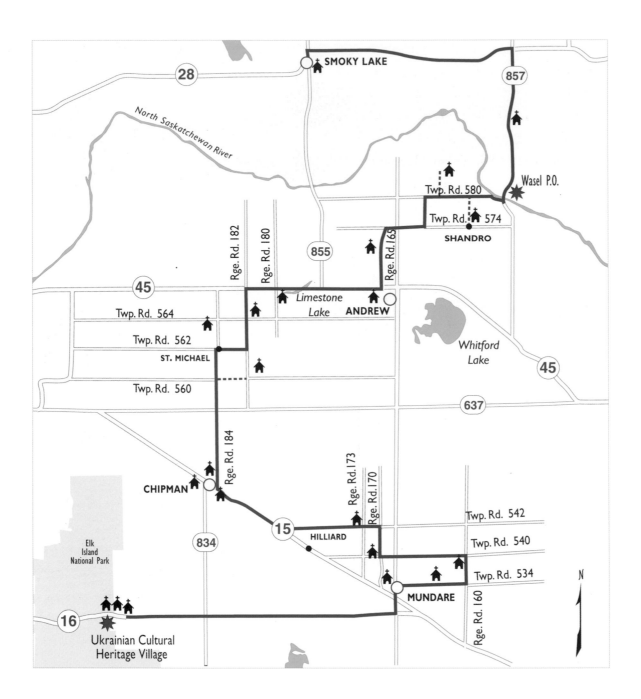

The many onion-domed churches east of Edmonton are tucked away in country settings. This tour leads to as many as one could wish to see in a long day from Edmonton to Smoky Lake. But you'll need an extra half day at least to explore the Ukrainian Heritage Village.

LEGEND

○ large community
● small community
✷ place of interest
🌲 park/recreation site

- - - optional route
╫ bridge
⛪ church
✳ ferry

elaborate churches became symbols not only of a rich spiritual heritage but also of the solidarity of the communities.

This journey threads through the rich farmlands and aspen parklands of what is known as the Ukrainian bloc settlement, where astounding numbers of these churches can still be found, some in small towns and villages, most of them scattered along quiet rural roads. Set among fields of wildflowers or sheltered by evergreens, they appear unexpectedly, seemingly in the middle of nowhere, their incredible architecture and opulent interiors often contrasting with the humble homesteads in ruins nearby. This route is chosen to bring 20 of the churches to your attention. But there are other roads and other churches—several dozen of them. Once in the area, you could make your own discoveries.

The beautiful church of Sts. Peter and Paul, high on a hill north of Wasel.

To set the scene, start the tour at the Ukrainian Cultural Heritage Village on Highway 16 just east of Elk Island National Park. Here, buildings salvaged from all over east central Alberta tell a vivid story of Ukrainian settlement, from a thatched-roof homestead, its garden bright with poppies and feathery dill, to the first rural communities and the towns that grew up later beside the railway, complete with stores, hotels and grain elevators. The village is a beautiful, unstructured place, where history can be learned through the eyes and the feet: there are enticing paths linking the different time segments, and there is much to see. Costumed interpreters acting the parts of pioneers help bring the past to life.

In this time-warped place there are three churches, all of them domed. The grandest is St. Vladimir's Greek Orthodox, built in Vegreville and moved to the "townsite" near the Wostok Hardware Store, Hilliard Hotel and Radway Livery Stables. The church has been restored inside and out to its 1934 splendour. Inside, it's an artistic treasure, painted in shades of blue and pale gold. Ukrainian churches are not only sophisticated architecture, their interiors soaring under the domes of the roofs, but their inside walls also are beautifully painted with religious scenes and richly embellished with gilt. Most of the churches along backcountry roads are locked, and

St. Vladimir's Greek Orthodox Church in the Ukrainian Village.

Inside St. Vladimir's church: soft shades of blue and gold.

Gardens filled with dill and poppies, from seeds the immigrants brought with them.

St. Nicholas Russo-Greek Church, from Kiew, built of simple wood.

their interiors cannot be viewed unless prior arrangements are made with the caretakers. This is a pity; all are worth seeing, particularly those painted by the renowned church artist Peter Lipinski, who spent a lifetime in Alberta travelling between the churches and making them beautiful. His trademarks are angels and stars on the blue "sky" of the domes and various effects such as cut stone and marble on the walls. In 35 years, he painted the interiors of more than 45 Alberta Ukrainian churches.

Depending on your interests and stamina, you could easily spend at least half a day at the Ukrainian village. Afterward, drive east on Highway 16 to Mundare, a town so steeped in its Ukrainian heritage that in 2001 it commissioned a huge loop of kielbasa sausage, 12.8 metres high and made of fibreglass, for display at the entrance to the main street. Total cost: $120,000. Stawnichy's meat-processing factory in the village helped fund the scheme. (Farther east along Highway 16, the town of Vegreville, though still very much a guardian of its French heritage, has as its roadside symbol a giant revolving Ukrainian Easter egg, or pysanka, gloriously co-loured and gilded.)

Mundare is better noted for its church history than its sausages. There is an excellent museum, run by the Basilian Fathers, featuring the story of the Ukrainian community in Canada and the missionary work of the priests who established a monastery here in 1902. The museum is beside the new church of Sts. Peter and Paul, a modern building that replaced the original onion-domed structure built in 1910. Across the street is the monastery, an imposing two-storey building of red brick that once housed 50 priests and was the motherhouse for Basilian clergy throughout Canada and the United States. Beside it is a grotto known as the Golgotha of Mundare, built into a small hill, with chapels, prayer stations and catacombs. This is open to the public, and the well-groomed gardens are lovely.

The first rural church on this route lies slightly north and east of town. From the museum, drive north on Secondary Highway 855, then east on Township Road 534 and north on Range Road 162 to the Siracky Chapel. The rectangular chapel is of multicoloured field stones, with a barrel roof and a false front capped by a cross. Roughly 4 x 2.5 metres, this diminutive building of distinctively European style is known as the Church of the Weary Traveller. If you peer in through the windows you can see the tiny altar and a statue of St. Bernadette. The church was built in 1940 on the land of homesteader Peter Siracky and dedicated at the 50th anniversary of the Ukrainians in Canada. Most of the splendid Byzantine domed churches in the area date from the1920s and '30s, when communities were larger and could find the money for such lavish architecture. The first churches, like this chapel, were much humbler.

Continue north from the chapel, turn right on Township Road 540, then right again on Range Road 162. The church here, known as Spas Moskalyk after the pioneering family who gave the

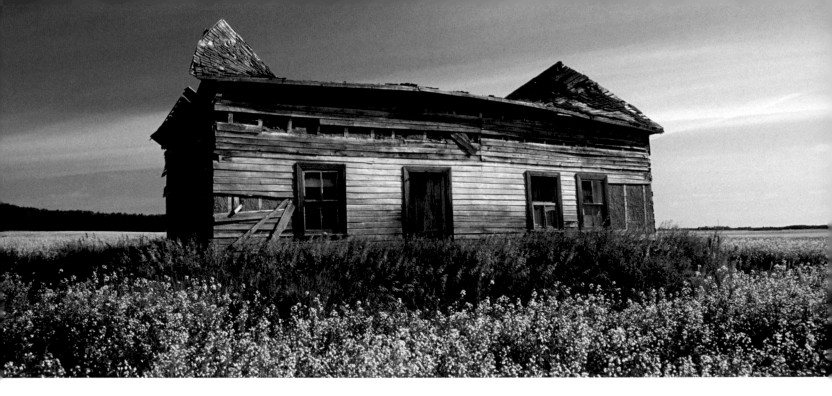

land, dates from 1924, when it replaced a small chapel built by settlers 20 years earlier. It is a beautiful building, spectacular in morning light, its silver dome agleam through the long, neat rows of grave markers. The interior is maintained in its original condition, though now only one major service a year is held here. Officially the Church of the Transfiguration of Our Lord, this Ukrainian Catholic church was registered as a historic monument in 1994.

Township Road 540 leads west to the next church, St. Jacob's Russo-Orthodox Church, in an area once known as Beaver Lake. Marked by a large cross, this is one of the oldest churches in the area and in some ways the loveliest. Built in 1901 by a local craftsman, its design was based on a three-part plan, not the architecturally more sophisticated cruciform plan of later churches. There are two onion domes, both crowned with the three-armed angled cross that indicates an Orthodox church. (Roman Catholic sanctuaries usually display the single cross.) Unlike traditional Ukrainian churches, which have separate free-standing bell towers (in the old country, they doubled as watchtowers guarding villages against marauders), St. Jacob's belfry is built in above the narthex. Inside are beautiful icons, painted by Peter Lipinski. The church was thoroughly renovated, placed on concrete foundations and covered with stucco, in 1942.

Nearby, at the intersection of Township Road 542 and Range Road 173, is the 1926 Catholic church of St. Demetro, a larger Byzantine structure with a single silver dome. Its separate bell tower was constructed on the site of the earlier 1903 chapel. Known as the Farm Church and still served by the Basilian Fathers from Mundare, St. Demetro sits in a large mowed field edged by aspen and poplar. In fall and winter, the bare trees look like a fringe of black lace.

Roofless homestead beside Highway 45.

As you drive from church to church through farmland wrested from the rough aspen parklands by pioneer ploughs, you can't help but notice the number of abandoned barns and homesteads along the way, a melancholy reminder that this rural area, like others across the Canadian west, is in decline, as the farming economy changes and people move into the towns. The churches, still maintained in immaculate condition, have often only a few parishioners to care for them.

The grid system of prairie roads is easy to follow, but here it is made somewhat perplexing because Highway 15 west of Mundare runs on a sharp 45-degree diagonal, following the line of the Canadian National Railway. If you turn right (north) off the highway, you're likely to be on an east–west township road, so watch for the road signs. Fortunately, the Canadian Automobile Association has posted signs to the most popular church sites.

St. Mary's, Chipman.

Highway 15 leads through the hamlet of Hilliard and on to Chipman, which was named after a commissioner of the Hudson's Bay Company and has three churches of note. Commanding a prime position beside the highway at the east entrance to town is a huge modern, rectangular Ukrainian church, built to replace an onion-domed structure of 1923; the Roman Catholic church of St. Bonaventure (1918) remains a cherished landmark on Main Street, and the triple-domed St. Mary's Ukrainian Catholic Church sits just north of the highway. Built in 1916, the interior of St. Mary's was painted in 1928 by artist Lipinski with his trademark angels and cut stone. In the cemetery is the grave of Wasel Eleniak, in 1891 one of the first Ukrainian settlers to arrive in Canada.

From Chipman, take Range Road 184 north and detour east on Township Road 560 to St. Nicholas Ukrainian Catholic Church, built of rich red brick in the Byzantine style, with three large silver domes. It is the only brick church on this tour, and it's a stunning landmark. Return to Range Road 184 and continue north to the hamlet of St. Michael, huddled beside the CP railway. There is little here; the hotel and several nondescript buildings are closed, though the post office remains open. Nearby is the splendid church of St. Michael the Archangel, after which the station community was named. It can be seen from afar across the fields, its Gothic spire towering above lines of evergreens. This is not a Ukrainian church; the original log chapel

was built in 1900 by the first Polish settlers and came under the administration of the Roman Catholic Oblate order.

Keep north along Range Road 184 and detour east on Township Road 564 to the Russo-Orthodox church of Holy Trinity. A stand of trees in the field opposite the church marks the place where 300 settlers gathered, in July 1897, to celebrate the first Orthodox liturgy sung in Canada. Two years later, when the area became known as Wostok (the Slavonic word for "east"), parishioners built a log sanctuary, the first Orthodox church in the country. The building burned in 1907, was replaced, then burned a second time. A third church was built in 1938 on the site of the original sanctuary. It's a historic spot, now known as Old Wostok; when the CP rail line was built a few kilometres distant, the settlement of Wostok moved in beside it, leaving the church behind. Another Orthodox church, St. Nicholas, a simple square, log structure with a small central dome, was built in 1900 near (new) Wostok. The logs of this humble building have been stuccoed over and painted a kind of shrimp pink; the roof is brown shingles. It is the oldest original church in the 27 townships of Lamont County.

Highway 45 lies 3.2 kilometres (two miles, or one township road) north of Old Wostok. East along this highway is another St. Michael the Archangel church, this one Ukrainian, with three domes. Different from most of the onion-dome roofs, the silver covering here fits snugly, like a cap, without the usual lip around the rim. The first congregation, formed in 1898, held services in private homes until they were able to build a church from logs hewn by hand and hauled to the site by oxen. The present stucco building dates from 1939. Beside the church a road leads down to Limestone Lake, in spring full of nesting shorebirds and frogs ribbiting in the reeds.

The village of Andrew near Whitford Lake farther to the east announces itself as a duck-hunting centre with "the world's largest mallard duck" in effigy. There's a good museum here, a restored grain elevator and another fine Ukrainian Orthodox church. Range Road 165 just west of the village leads north to the Church of the Nativity, an elaborate construction with two large domes and three cupolas, built in 1950 after fire destroyed the earlier pioneer church of 1902. A small creek separates the church from its cemetery. The bridge across the creek, still used for access, is one of the earliest in the area; it was constructed by the government to serve traffic along the south trail to the Victoria Methodist Mission and Hudson's Bay Company's Fort Victoria trading post, on the far side of the North Saskatchewan River.

Church of the Nativity, near Andrew.

The river is very close, and our journey leads to one of the main bridges at Wasel. But before this, there is another church to see, one with golden domes and a sky blue roof. The Church of the Holy Trinity lies screened by trees on a hilltop above the river beside Range Road 162 (north of Township Road 580). It was built in 1932 by a splinter group of Ukrainian Greek Orthodox parishioners who broke away from Holy Trinity Church at nearby Sunland. After visiting this

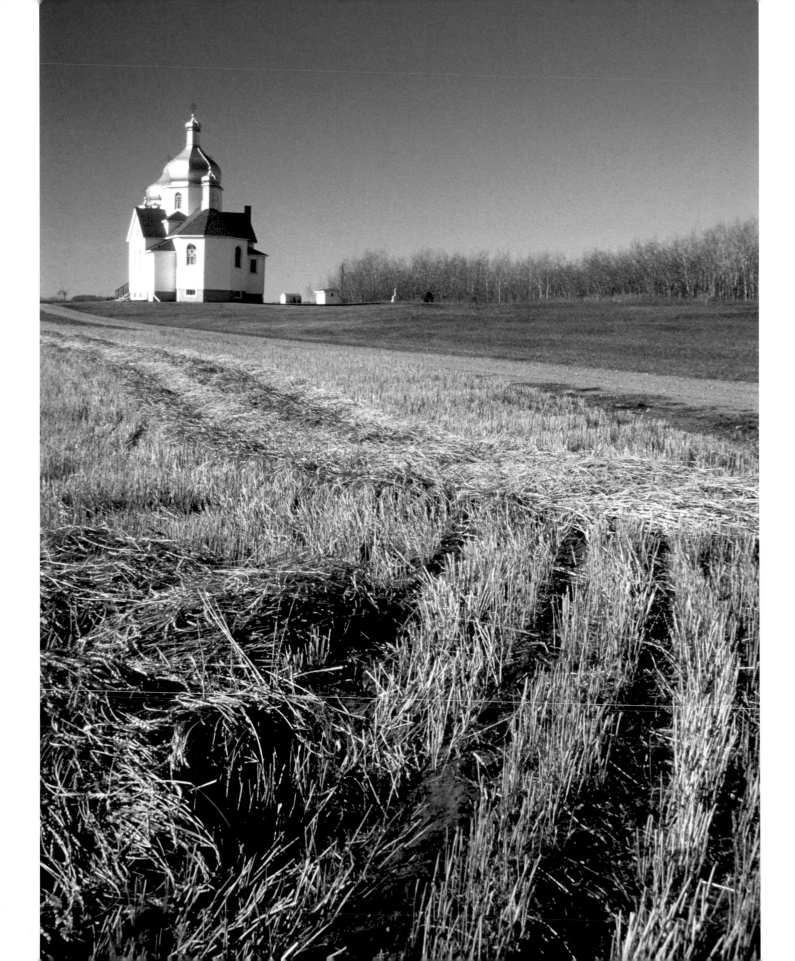

Between the churches, wonderful fields of green and gold.

church (and perhaps one other, lovely St. Mary's at Shandro), go east on Township Road 580 to Secondary Highway 857 and cross the North Saskatchewan River. On the hillside above the bridge is the derelict log post office of Wasel and several picturesque old barns. The name Wasel commemorates the first postmaster, William (Wasel) Hawrelak, who came to Canada from Bukovina at the age of 18 and reached his homestead here by floating downriver on a raft.

Several kilometres north up Highway 857, standing proud on a high bluff, is the Russo-Orthodox Church of Sts. Peter and Paul in a place the settlers called "wild bush" or dickiebush; hence the church is also known simply as Dickiebush. Built between 1909 and 1914 of logs (later covered by siding), it is one of the region's earliest cruciform churches and one of the first with an open dome. Inside, the "sky" of the dome extends 20 metres above the floor, creating a wonderful sense of space. Amazingly, this intricate church was built by a local carpenter who could neither read nor write but who carried with him an image of churches he had seen in the old country. It is architecturally interesting for its semicircular rather than rectangular wings, a treatment that emphasizes the building's height. Painted a soft yellow, the church is an outstanding landmark, well worth the steep drive up the hill to view it at close quarters.

There are so many churches, so many pioneer barns and homesteads in this area, that it is difficult to know where to end this journey. But here's a suggestion: Drive 10 kilometres north of the Dickiebush church along Secondary Highway 857 to Highway 28 just south of the settlement of Bellis (whose station and grain elevator were moved to the Ukrainian Heritage Village). West about 24 kilometres along Highway 28 is the town of Smoky Lake and Holy

Journey's end: the largest Ukrainian graveyard in the area, at Smoky Lake.

Trinity Russo-Orthodox Church, another fine example of 1920s onion-dome construction. Why end the tour here? Adjacent is the largest Ukrainian graveyard in the area—rows and rows of cemetery crosses, some of them ornate, inscribed in Cyrillic script and emblazoned with flowers. Somehow, as the sun goes down, graveyards seem a fitting way to close the day, encouraging reflection on such things as faith and mortality.

There are two excellent booklets to take along. *Lamont County, Church Capital of North America* is a guide to the area's 47 churches, with suggested driving routes (and a list of contacts for viewing interiors). *Ukrainian Churches in East Central Alberta* is a more studious approach, published by the Canadian Institute for Ukrainian Studies at the University of Alberta. Both are available at the Ukrainian Heritage Village and at the Basilian Fathers Museum in Mundare. ❖

AROUND THE HAND HILLS TO DOROTHY

East of the foothills of the Rocky Mountains, the prairies stretch toward the sunrise. Alberta has been described as "big sky country," where little obscures the horizon. This does not imply, however, that the countryside is flat, though it has been well smoothed by the passage of thick glacial ice. Much of the land is undulating, in places even hillocky. There are swells in this "inland sea" that rise to substantial heights. The wooded Cypress Hills (see chapter 3) straddling the Alberta–Saskatchewan border are one such prominence, reaching to 1,245 metres, the highest point in all of Canada between Labrador and the Rockies foothills. This fact is well known, and the hills, large parts of which remained free of ice during the Pleistocene epoch, are a popular playground.

But the prairie also reaches for the sky just east of the dinosaur lands around Drumheller. Here are the Hand Hills, and their highest point, Mother Mountain, lies 225 metres above prairie level, just a few metres lower than the Cypress Hills. The Hand Hills are not well known and are seldom visited, though they contain fine grassland and some of the loveliest landscapes in Alberta.

The Rockies and the foothills are all uplifts, land heaved skyward during deep geological paroxysms. The Cypress and Hand hills—and other prairie highlands—are remnants of the Tertiary plains of 60 million years ago, protected by thick gravel blankets from the grinding ice and water that eroded the land around them. They are like ancient islands in a prairie sea rippled by waves of glacial debris.

The first written record of the Hand Hills comes from the Hudson's Bay Company explorer Peter Fidler, who passed nearby on his return from the Crowsnest Pass area in the winter of 1793. From high ground, probably somewhere south of today's Stettler, he remarked on a "long

"Big sky country," north of Drumheller.

A circular route up into the Hand Hills and a scenic return along the Red Deer River. A good half day from Drumheller.

LEGEND

○ large community

● small community

✸ place of interest

🌲 park/recreation site

- - - optional route

‖ bridge

⛪ church

✳ ferry

range of hills...called the Oo chis chis or the Hand, being seen a long way off and directing Indians thro these extensive plains." It was once prime buffalo country: the Blackfoot and the Cree both claimed the hills as theirs, and several battles were fought here. When the buffalo had gone, the rich grasslands were given over to cattle ranching until the land was opened to homesteading in 1909.

The Hand Hills plateau has been sculptured by deeply incised streams into five main ridges, the fingers of the hand, making much of the land awkward for agriculture. Here on slopes and coulees, the native northern fescue grasslands that once fattened buffalo remain intact, one of the largest remnants of virgin prairie in Canada. In wetter years, the hillsides blaze with wildflowers; nesting birds include the long-billed curlew, Baird's sparrow, Sprague's pipit, upland sandpiper, loggerhead shrike and the rare piping plover. Here also are dancing grounds, or leks, for sharp-tailed grouse. White-tail and mule deer frequent the area, along with pronghorns, coyotes and jackrabbits.

Although much of the land remains in its natural state even today, homesteaders did settle here to cultivate small stretches of arable soil, thus adding a human dimension to the landscape. Scattered through the hills are the remains of old farms and homesteads and the sites (though seldom the buildings) of 14 schools and seven churches, suggesting a once fairly numerous population. Today one can drive through the grid of country roads that cross-hatch the hills and see hardly a soul, though the tourist throngs of Drumheller are only an hour or so away. The nearest community is Delia, 10 kilometres to the north.

This journey into the Hand Hills begins at Drumheller, in the midst of the colourful badlands of the Red Deer River valley, full of dinosaur bones. Take Highway 9 north across the river, past the turning signposted to the Royal Tyrrell Museum, and swing east (right) on Secondary Highway 576. This wriggles through the narrow valley of Michichi Creek where a little farm presses up against badlands cliffs; then the road clambers up to prairie level. Several side roads lead back to the valley lip, and these are worth exploring for the views. On top, the summer prairie is green and rolling, lovely in early morning or evening light, and the Hand Hills beckon in shades of blue on the eastern horizon.

Drive for about 25 kilometres until you reach Range Road 181 and go north, undulating along the base of the hills for about 20 kilometres to Delia. Then return south on Secondary Highway 851, which climbs through aspen woodlands right over the summit of Mother Mountain, headwaters of Willow and Michichi creeks, which cut deeply into the western flanks of the hills. On just about the highest point of the highway, take Township Road 300, which crosses the divide into the Fish Creek drainage and strides straight east across undulating farmland, where bright fields of canola add a touch of glory—and abandoned homesteads more than a

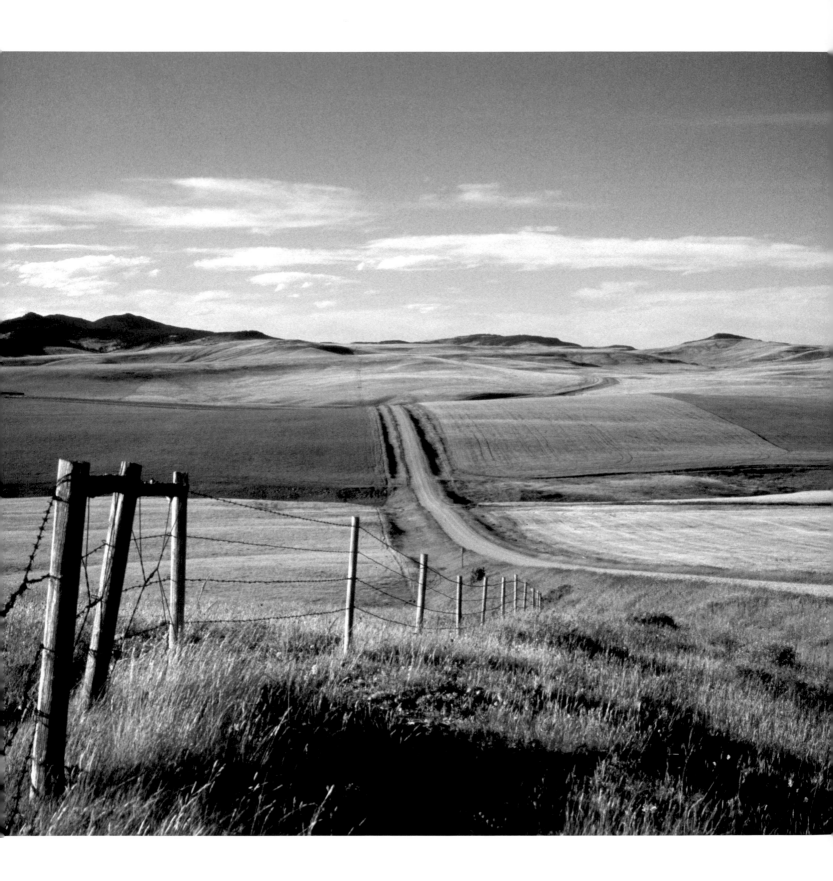

touch of pathos. Then turn south on Range Road 162. This will lead to Hand Hills Lake, fairly large and shallow and susceptible to drought, like others in the area. In a dry summer, pale alkaline mud flats surround the lake, and on windy days huge, white clouds of dust spiral into the sky. However, the pebbly shoreline still provides preferred nesting habitat for the piping plover and other shorebirds.

For access to the lake, watch for a side road east, usually marked by a sign to Hand Hills Club or, if it's midsummer, to the Hand Hills Rodeo, the oldest rodeo in Alberta. Started in 1917 by rancher Jack Miller to raise funds for the Red Cross war effort (it produced $3,200), the rodeo has taken place every year since then. At the same intersection are historic-site signs for Hand Hills High School and the United Church, both built in the 1930s. Down at the lake edge, across from the spiffy rodeo grounds and ball diamond, is the church itself, a small, stark white building with a Gothic spire, moved here from its original roadside location and placed beside the old community hall, which looks a bit like a Quonset hut. Nearby are several weathered sheds, derelict in the long grass. Look for owls nesting here. On the church wall is a road map of the hills, with the locations of all the defunct schools and churches. There's also a sign about the piping plover, whose population here declined from around 50 in 1992 to only six in 2002. The beach is off limits during the nesting season, from April to July, and all dogs must be leashed.

Return to Secondary 162 and continue south, past the site of Bethany Mission Church and a photogenic old homestead still hedged about with lilac and caragana. At the junction with Township Road 292, keep right and cross Fish Creek to join Secondary Highway 851, which leaves the settled part of the hills and goes south to Little Fish Lake Provincial Park, where there are 100 campsites and picnic tables in the shade of planted aspens. The lake, originally called Lake of the Little Fishes, was well named. Native tribes camped here to stock up on fish to dry and smoke for winter supplies, and the tipi rings of their campsites can still be seen. In the 1920s, settlers came fishing. Wagonloads of fish were reportedly caught by nets and hay forks and hauled away for food and fertilizer. The lake was later popular for sport fishing.

Since the 1980s, diminishing water levels in this shallow and slightly saline lake have caused a decline in the population of yellow perch, and the lake is no longer stocked. Once a popular swimming hole, today even this sport is not advised in summer because of the possible toxicity of blooming blue-green algae. But bird life abounds. At least 15 species of ducks and shorebirds regularly nest here, and the lake is an important migratory staging ground for Canada geese and sometimes thousands of snow geese. There are also white pelicans, loons, avocets, phalaropes, willets and godwits and even the piping plover. The area around the lake is mostly in rough fescue, oatgrass and bluegrass, and a large section of this native prairie has been preserved in the Hand Hills Ecological Reserve around the lake's northwestern shore. Here among the grasses

Hand Hills on the skyline and a rolling road through the fields.

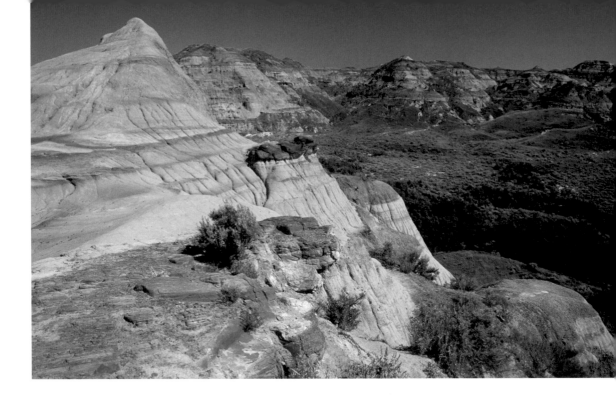

Badland buttes above the Red Deer River.

bloom crowfoot violet, shooting star, yellow paintbrush and evening primrose. This reserve is on Crown land, but it is leased for controlled grazing and is only accessible on foot. Range Road 170 south from Secondary 576 will lead you close to the northern limits. It is well worth exploring.

From Little Fish Lake Park, continue south to Secondary Highway 573, which cuts west through rolling grasslands, south of the reserve. Turn left on Secondary 848 for 10 kilometres to Dorothy, back down in the Red Deer Valley. At first glance a quintessential ghost town, Dorothy doesn't really live up to the claim because a handful of people live there still. But otherwise it has all the right attributes: empty buildings, bleaching in the sun against a backdrop of badland buttes. There are two derelict churches, a store, a lone elevator standing alongside ghost rail tracks, and several other buildings.

The settlement dates from the early 1900s, when local storekeeper Percy McBeth applied for a post office that he modestly suggested should carry the name Percyville. The district inspector obviously didn't like Percy, or at least his name, and he decided to call it Dorothy after the daughter of a local rancher. The post office opened in 1908, and the community grew slowly. Two years later, when the railway came through, a sudden spurt of building activity produced a school, general store, butcher's shop, poolroom, telegraph office, restaurant, three grain elevators and two churches. The little settlement became a focal point for religious and social events in the valley. But, suffering the fate of many pioneer towns trying to weather the Depression and the closure of valley mines, Dorothy gradually faded away. The school closed in 1960, the two churches had given up the ghost by 1967, the railway pulled up tracks and two of the grain elevators were taken down. Most of the residents moved away. The buildings that are left—the

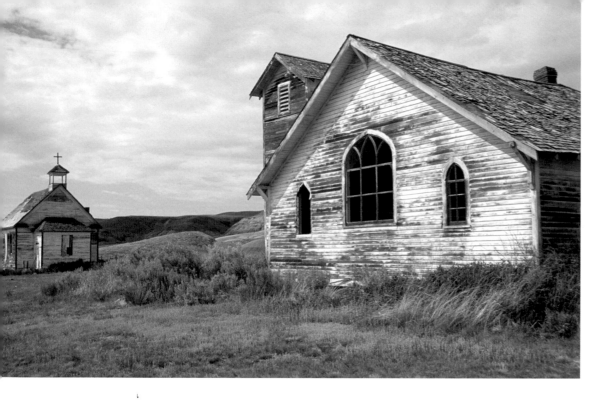

The two ghostly churches of Dorothy.

United and Roman Catholic churches, the lone store and the grain elevator — sit out in the desert sun like a set from a Western movie.

The United church, with its large, many-paned, Gothic windows, has a history of its own. Once a residence in the now vanished settlement of Finnegan, it was moved to Dorothy in 1932 and remained in service for nearly 30 years. The smaller Catholic church, built here in 1944, was abandoned in 1967. Both are very picturesque, probably among the most photographed relics in the Drumheller area.

For a bird's-eye view of Dorothy and its badland setting, drive across the narrow Red Deer River bridge on Secondary 848 and wind your way up the coulee on the opposite side. As you reach the valley lip, turn left onto a gravel turnaround for a spectacular view of the road up the coulee, the bridge across the river, colourful cliffs and, far below, the tiny toytown of Dorothy. The turnaround track itself is worthy of attention: it circles a well-defined tipi ring. Be careful not to drive over this Native site.

From up on the valley rim, continue south on 848 for 12 kilometres until it meets Secondary 564. Follow this road northwesterly across the flats, then down another colourful coulee back into the Red Deer Valley and on to East Coulee, where the Atlas Coal Mine Museum commands attention south of the river. Dinosaurs brought fame to the Drumheller area, but it was coal that provided the impetus for growth and settlement.

Peter Fidler was the first European to spot the seams of coal along the Red Deer River, in 1792, and it was geologist Joseph Tyrrell about 100 years later who put Drumheller coal on the map and encouraged mine development. When the Canadian Pacific Railway came through the

valley in 1911, providing access to markets, the mining boom took off. Immigrant miners poured in to make homes for themselves and their families in the stark badland valley that freezes in winter and bakes in summer. By the early 1940s, at the height of the boom, 139 mines were operating; the population of the little town of East Coulee, one of several mining communities in the valley, climbed to 3,800.

As always, bust followed boom. The discovery of oil at Leduc in 1947 reduced the need for coal, and the mines closed, one by one, most of them in the 1950s. The population drifted away. The Atlas Mine was the last to close; it operated until 1979, when its owner gave the mine to the province of Alberta, which has turned it into a museum. Its eight-storey ore-sorting wooden tipple, the only one of its kind in Canada, is an arresting landmark on the river's edge. There is also a restored mine office, complete with artifacts from this and other mines, and an original miner's shack. Guided tours are given, and there is an impressive array of old mine machinery to investigate.

This National Historic Site is worthy of a visit. So, too, is the town of East Coulee, itself now teetering toward ghost town status. Here, the once grand 12-room school is now a community museum and includes an authentic classroom, complete with blackboard and school books. (There's a great little tea room, staffed by volunteers.) Beside the highway, the Royal East Coulee Hotel is still in business; there is also a library and a small store. The streets of tiny houses are neat but seem mostly unoccupied, and little else remains of a once thriving community. Even the bridge across the river to the Atlas Mine is out of commission.

From East Coulee it's only a short drive (24 kilometres) back along Highway 10 to Drumheller. High points of the drive include the miners' suspension bridge that crosses the river from Rosedale to the site of the Star Mine, and the road up the rambling Rosebud River to the hamlet of Wayne. This is memorable because of the 11 one-lane wooden bridges that cross the river en route, and because of the destination: all that is left of Wayne, at the top of the valley where once six mines operated, is the historic Rosedeer Hotel and its Last Chance Saloon. ❖

The railway has long gone, but Dorothy's abandoned grain elevator still stands beside the tracks.

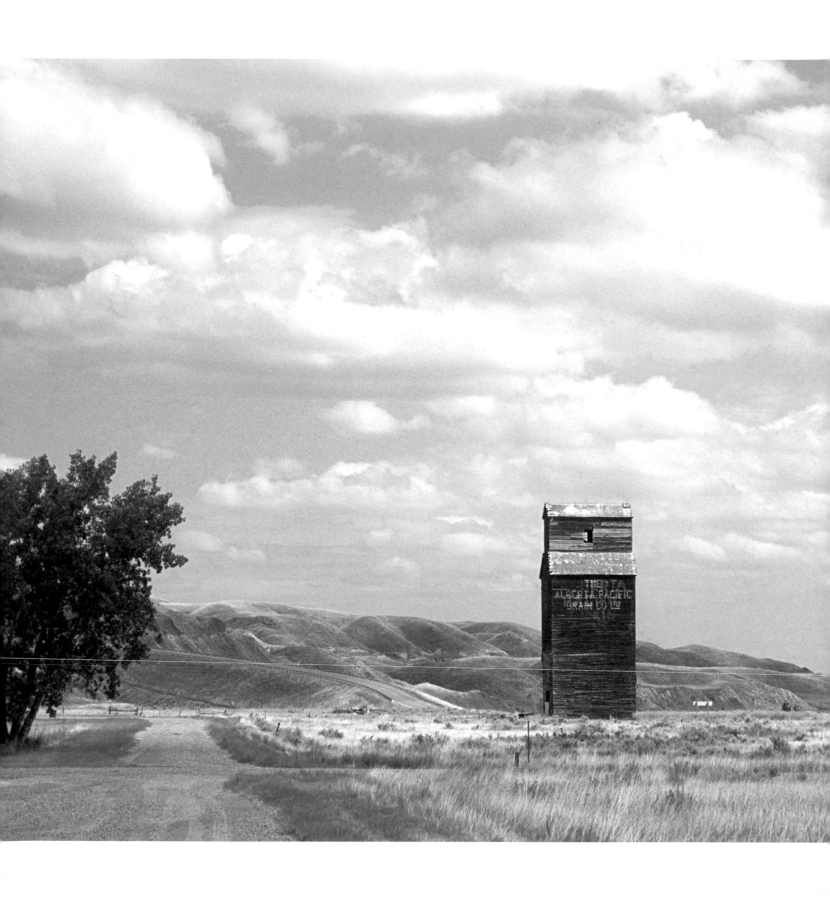

BACK ROADS TO HEAD-SMASHED-IN

No traveller to southwest Alberta should fail to visit Head-Smashed-In Buffalo Jump, at the southeastern edge of the Porcupine Hills. It's one of the oldest, largest and best preserved of all the jumps on the North American plains, and it has been expertly brought to life at a stunning interpretive centre built right into the cliff. Visitors are taken back into the world of the prehistoric buffalo hunters who came to this site to stock up on provisions for the winter. The hunters stampeded large numbers of North American bison over the steep cliffs to their deaths, butchered them and preserved the meat. It was a method of communal hunting so successful that it lasted for thousands of years.

Head-Smashed-In is also a very beautiful spot. From the clifftop above the jump one can look down across rose-bush scrub and prairie sage, south to the willow-lined Oldman River and west to the Rockies. On the plateau above are ancient petroglyphs and a vision-quest site. A group of brightly painted tipis completes a scene that one can believe has changed little since the jump was last used. At sunset, when visitors have gone and shadows creep across the land, the pungent smell of sage and the shrill peep of nighthawks can easily conjure visions of past times.

This popular UNESCO World Heritage Site is easily reached by a turning off Highway 2 north of Fort Macleod, but there is a far more interesting approach, one that will heighten anticipation: through the hills from Pincher Creek. In essence, the route simply dodges along quiet back roads, and it does not really matter which of these range and township roads (for explanation of these, see the introduction to this book) you take: just head generally northeast. The following suggested route is, however, a good one, allowing a leisurely study of the rolling landscape and a visit to the dam and reservoir on the Oldman River.

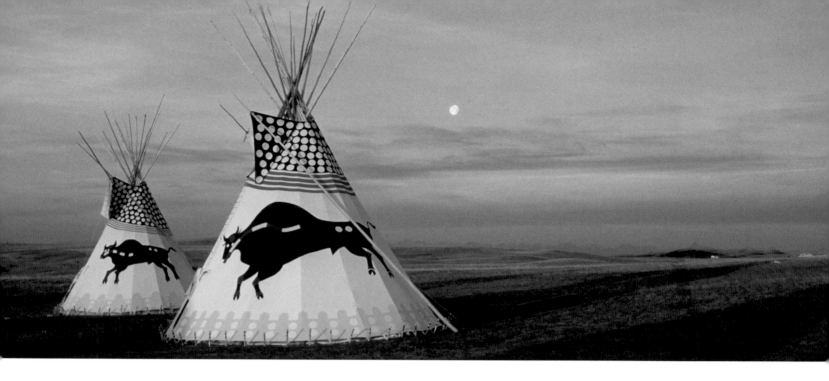

Head-Smashed-In tipis at dawn, with the moon in the sky and long, long shadows.

From Pincher Creek, take the eastern exit to Highway 3, which will bring you to Secondary Highway 785 north, beside a line of three vertical-axis wind generators (they look a bit like squat egg beaters). These are Darrieus generators, named for their French inventor. Relying on long aluminum blades instead of propellers, they are said to be less expensive to build and easier to maintain than tall, horizontal-axis windmills. Scores of the latter, their three-armed propellers mounted on slender towers, can be seen in windy southern Alberta, all adding power to the provincial grid, but there are only these three "egg beaters."

Keep north on 785 across the Oldman River dam to the reservoir; Oldman Dam Provincial Recreation Area, the largest provincial park in Alberta, accommodates some 1,000 campsites and preserves large tracts of native grassland and wetlands. Windy Point here is a favourite location for windsurfers from around the world, and a kite festival is held every summer. Picnic tables are behind shelters because the point really does live up to its name, receiving the brunt of Alberta's chinook winds howling down from the Rockies. The reservoir is a popular spot in summer for boating, swimming and fishing (native pike, rainbow and brown trout.)

Paved Highway 785 leads directly to Head-Smashed-In, but instead turn off at the T-intersection some eight kilometres from Highway 2 (there's often a herd of buffalo here), and drive west along Secondary Highway 510 heading for Cowley, along the north shore of the reservoir. Take in the views south across the water and west to the rocky ridge of the Livingstone Range. Several side roads branch north (including Ashvale Road, which leads to a very good rock and fossil museum), but drive straight on for another eight kilometres to Range Road 300A, which curves around a house and joins Upper Tennessee Creek Road as it heads up into the Porcupines. At the next T-junction, turn right (east) along Sheep Camp Road. None of these roads

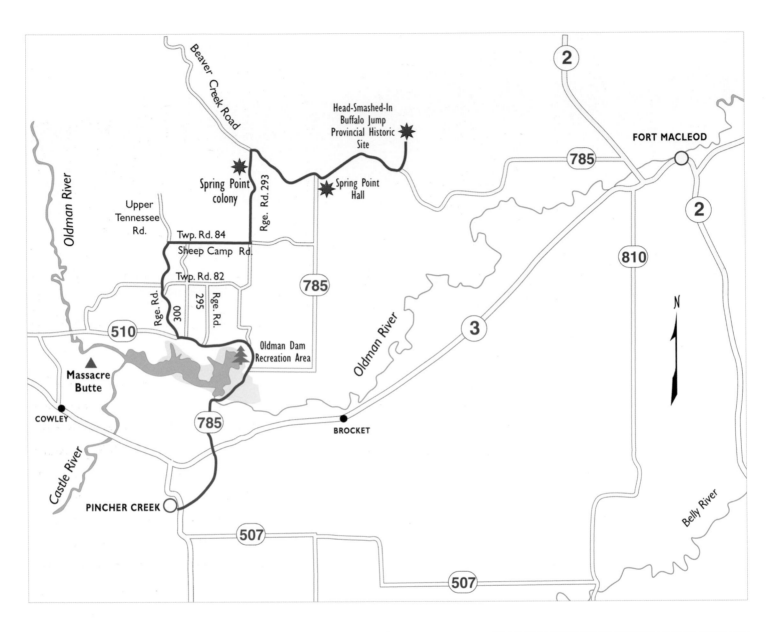

There's a quick and easy route to Alberta's famous buffalo jump at Head-Smashed-In, but this one is far more scenic. Allow a leisurely morning from Pincher Creek, and save the afternoon for the jump itself.

LEGEND

○	large community	- - -	optional route
●	small community	‖	bridge
✸	place of interest	⛪	church
🌲	park/recreation site	✳	ferry

The jump cliffs stretch along the southeastern edge of the Porcupine Hills.

is paved, but all are idyllically bucolic; expect to see many birds, deer and cows amid fields that provide endlessly beautiful patterns of swath lines and hay bales. The road edges in summer are bright with wildflowers. Sheep Camp Road (Township Road 82) runs east–west against the grain of the Porcupines slopes, and the sharp hills are a delight. A cluster of old buildings around a pond suggests that this could be the camp after which the road is named, and Cairnstone Farms presents some interesting red and grey sheds. From here, there's an excellent view south down the long, sloping line of the Rockies, and to the north the horizon prickles with the evergreens on Porcupines summits. Turn north (left) at the intersection with Range Road 293, but before you drive on, stop and look south: the roller-coaster road shoots as straight as an arrow to the mountains. Keep on this road for about eight kilometres , passing Springpoint Hutterite Colony, then turn right. (Left is Beaver Creek Road, which leads to a wilderness recreation area in the thick of the hills and eventually connects to Skyline Road along the crest of the Porcupines. See chapter 4.) In August, fields to the south along the Beaver Creek drainage are carpeted with bright pink locoweed.

Springpoint Hall, built in 1904, sits at the intersection with Secondary 785, the paved road coming north from the Oldman Reservoir. This route bends around and strikes east, heading somewhat circuitously around the base of the hills to Head-Smashed-In, where you will want to spend the rest of the day. If you're in the mood for fuller immersion in Native history, book ahead to stay overnight in one of the tipis, which are decorated with brightly painted buffalo. (The design has its own story; ask about it at the visitor centre.) Sunrise from the tipi campsite

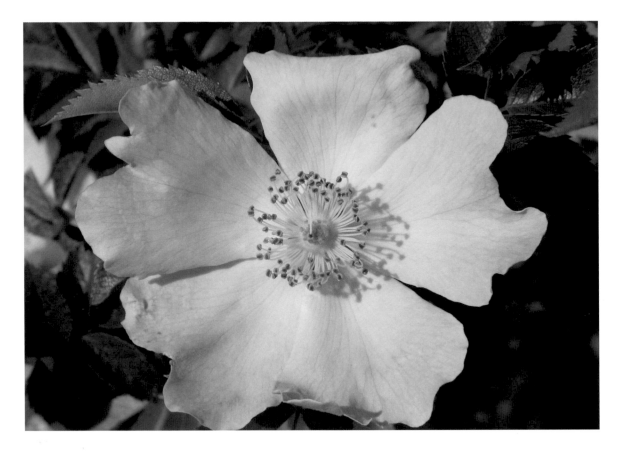

Wild roses in the scrub under the cliffs.

is spectacular, and at night the stars here seem extra bright. It's all part of the magic of Head-Smashed-In.

Just down the road is the historic town of Fort Macleod, known for its streets of heritage sandstone buildings (including the 1912 Empress Theatre), the oldest golf course in the Canadian west and the North West Mounted Police fort and museum. Visit in summer (but not on Tuesdays) to witness the inspection of troops and the famous musical ride inside the palisade. ❖

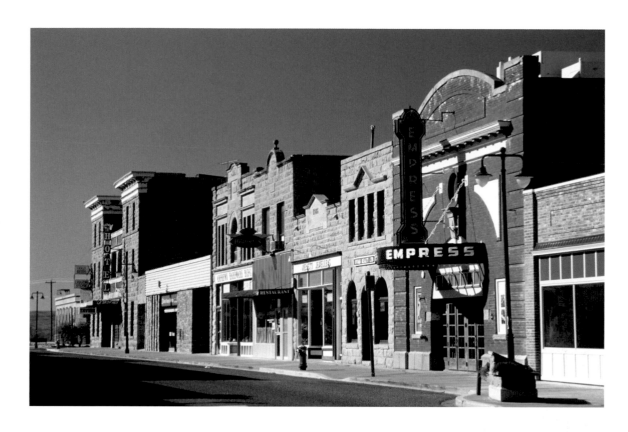

Main street in Fort Macleod, a classic heritage look.

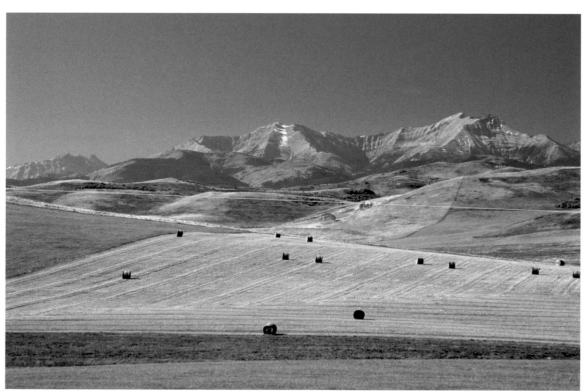

Pieced together like a quilt, fields roll upward toward the Rockies.

EXPLORING THE LIVINGSTONES

North from the Crowsnest Pass town of Bellevue, the pale limestone ramparts of the Livingstone Range stride in a straight, almost unbroken line for some 40 kilometres. This steep, serrated rock wall, an eastern outlier of the Rocky Mountains, is southern Alberta's last defence against the thrust of moist Pacific air and helps to keep the foothills and plains to the east dry and clear. The Blackfoot people called this mountain range, which sometimes appears as a flat design painted on the sky, "the Tipi Liners," because it resembled the decorated half walls of hide that hung inside their tents to hold in the warmth. Perhaps they saw the mountains as performing much the same function, insulating the plains from western storms.

Named by explorer Thomas Blakiston in 1858 in honour of the great African adventurer David Livingstone, the range consists of rock so pale that sometimes in summer, if the light is right, it seems covered with snow, an astonishing contrast to fields of wildflowers. In fall, with real snow on the slabs and the aspens in the valley aglow, or with dark storm clouds boiling, the scenery is spectacular. This journey explores the many aspects of the Livingstones, first along the valley that separates them from the gentler swells of the foothills, then following the Oldman River where it cuts through them in a canyon known as Livingstone Gap, or simply "the Gap," and finally riding right over them on a high alpine pass to join Highway 22.

Pincher Creek is a pivotal point of departure for several interesting journeys, lying as it does in the interface between mountains and plains near the mouth of the Crowsnest Pass. It's a lively little town with a great museum—Kootenai Brown Pioneer Village, named for the frontiersman George "Kootenai" Brown—where some of the area's heritage buildings, including Doukhobor barns, old ranch houses, log cabins and an Oblate missionary church have been relocated for preservation. The area is also interesting for the stupendous number of wind turbines, which

White limestone ridges gleam like snow above fields of summer flowers.

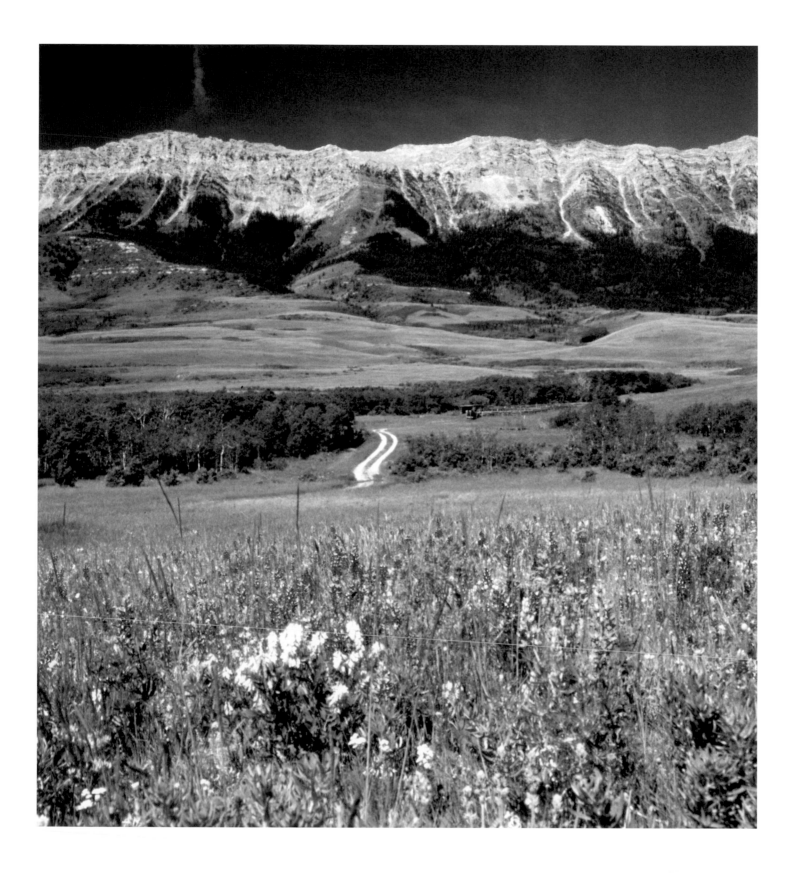

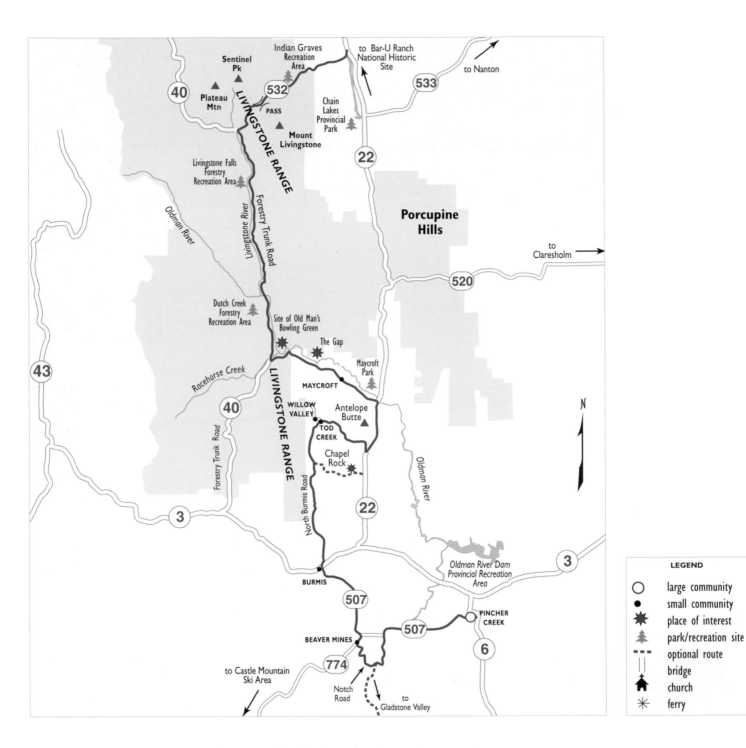

This exploration of the Livingstone Range goes beside, through and over the mountains, for all aspects are astoundingly beautiful. It's a day from Pincher Creek to Longview. There is one rough, steep stretch of road, but the rest is easy.

Near Cowley, lines of windmills, eerie in the snow.

look a bit like airplane propellers mounted atop tall poles. Lined up along north–south ridges to catch every breath of wind, these windmills generate electricity for the Alberta grid. Some roads around Cowley lead right up to them. Standing at their feet, the sound of the generators and the wind in the blades create an eerie hum.

From Pincher Creek, Secondary Highway 507 west offers good views of the Porcupine Hills and the Livingstone Range north across ranch fields and lines of twirling windmills. In late autumn, a fresh snowfall lends an ethereal quality to the landscape and sets hungry cattle bawling at fence gates. Go past Highway 775 which dead-ends at Beauvais Lake Provincial Park, and take instead a more scenic secondary road south, signposted to Gladstone Valley. At about eight kilometres from the turn, at a right-angle bend where the rugged peaks of Gladstone Mountain and Mount Castle loom close, a narrow road leads off to the west. Marked for summer use only, Notch Road leads up from the valley, climbs over a break in the ridge and descends to meet Secondary Highway 774, the well travelled route to Castle Mountain ski resort. Just north of this intersection is the community of Beaver Mines.

The coal mines here opened in 1909 and, despite a major strike during World War I, remained active until 1971. Today little trace of mining remains. In fact, there is little left of the town other than a few homes, a pub, St. Anthony's Mission Church and a general store where the coffee pot is usually on and where everyone stops to gossip. The road (now you're back on Secondary 507) crosses the Castle River to Lee Lake and then goes over the Crowsnest River, north toward Highway 3. All these mountain streams are well known to trout fishermen.

In a field of
buttercups, an old
log barn and a few
spindly aspens.

Another prime fishing spot, and an excellent place for a picnic, is Lundbreck Falls Provincial Recreation Area, which lies just a few kilometres east along the highway, well worth the short detour. Good camping here, if you can sleep through the roar of rushing water.

Directly across Highway 3, North Burmis Road climbs swiftly away from highway noise into a pastoral valley known for huge expanses of spring and summer flowers. Fields white with daisies, golden with buttercups, purple with vetch and pink with showy locoweed present startling, luxuriant contrasts to the stern, pale grey rock of the Livingstones' eastern ramparts. There are several ranches along the way—one with cow skulls mounted high on the gateway; this valley, wedged between the Livingstones and the forested foothills, is prime cattle country.

At about 15 kilometres from the highway, the road skirts a series of marshy ponds and curves in front of a perfect geologic syncline, a small hill showing the arches of upward-thrusting rock strata, an example of the tectonic upheavals that built the Rockies. Just beyond, by the 1913 SK Ranch, Chapel Rock Road leads east via a landmark rock that looks like a church and along Cow Creek to Highway 22, an alternative route—and such a pretty drive that you might like to drive it and double back. If you resist this temptation, veer left and continue northwest, following the line of mountains, for another eight kilometres to a second intersection at the small community of Willow Valley, with its restored historic schoolhouse. The road continues north, but it soon ends at a cattle ranch gate, so turn right and follow Todd Creek east past Antelope Butte to Highway 22.

For many years an unpaved backcountry route, this highway today is a high-speed alternative to Highway 2, though far more scenic. It provides both quick access and marvellous

RIGHT
The old settlement
of Maycroft:
the stone house
is abandoned.

104

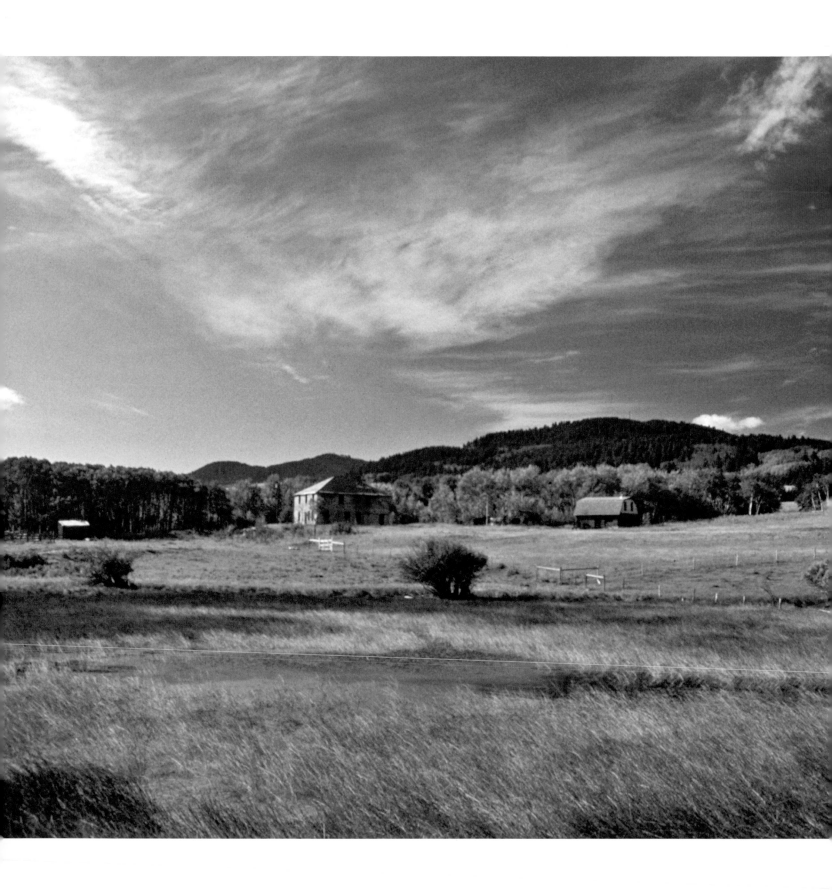

Wild daisies mimic the white shoulders of the Livingstones.

views as it swoops along between the Porcupine Hills and the Livingstones. Go north along the highway to the Oldman River Bridge, then turn left (west). This road, which follows the river's south bank, has no number but is signposted to Maycroft, an old ranching settlement.

Six kilometres from the bridge is the old community schoolhouse; a bit farther on lies the church, now converted into a residence (the owners kept some of the Gothic windows); nearby, a large square stone house, one of four similar heritage houses in the area, stands derelict. To the north across the river lie the billowing green hills of the Whaleback Ridge, now part of an ecological reserve. Peter Fidler was perhaps the first European to come this way, with a troop of Peigan people, back in 1793. (For more about his trip, see chapter 14.)

The road enters the Bow-Crow Forest Reserve and continues east through Livingstone Gap, a spectacular S-shaped, narrow canyon cut through the otherwise uninterrupted wall of the mountain range. Geologists believe that the Oldman drainage system was already in place when later mountain uplift and tilting caused this and other streams to flow faster and to cut more deeply into bedrock. The gap was cut by the river, then widened by the action of glaciers, but it is still narrow. In places there is room only for the river and the road. In July, masses of low-growing fireweed smother the rocks at water's edge with rosy magenta blooms. It's a favourite spot for fly fishermen.

Beyond the gap, the river cuts under the steep shoulders of Thunder Mountain; where Race-horse Creek flows in from the south, the road meets the Forestry Trunk Road, a useful access route that sidles along the edge of the Rockies all the way from the Crowsnest Pass to Kananaskis Highway 40. Turn right here across the Racehorse Bridge and follow the trunk road and

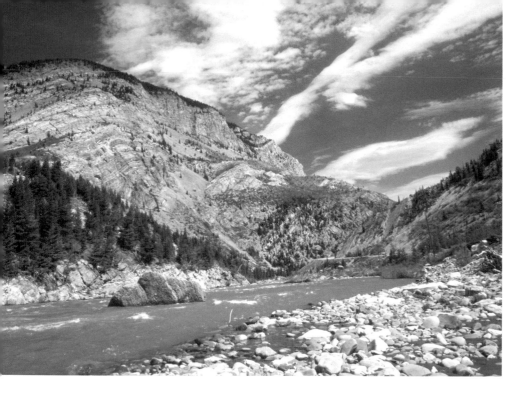

Livingstone Gap: the river has carved a passage barely wide enough for the road.

the Oldman River as they cut north through the forest. Fly Hill to the west is green and grassy, with a line of eroded rimrocks and clumps of aspen, but for some distance north, the route will be in evergreen shade. Livingstone Gap Fire Base lies just past the intersection, and nearby is Gap Pond, a former highways department gravel pit that has been filled with water and stocked with cutthroat trout. If you need a break, this might be the spot.

North, the road crosses Dutch Creek, which flows east from Tornado Pass on the Continental Divide. Across the valley is Livingstone Fire Lookout, at 2,160 metres one of the high points. Beyond, the Oldman River turns northwest to its birthplace high under the spine of the Rockies. A road follows the river for 20 kilometres to Beehive Natural Area, more than 800 hectares of pristine old-growth spruce/fir forest set aside as a wildlife refuge, principally for wolves and grizzly bears.

Though the upper Oldman retains its wilderness flavour, it has been tramped by humankind ever since the first Native hunters came here, set up their tipi camps and built cairns to mark passes through the mountains. Europeans later mined the area for lead and zinc; the river road itself was hacked out to reach the Galena Mine on the slopes of Mount Gass, where old mine shafts and some abandoned equipment remain. Today the upper Oldman road provides access to the north–south Divide Trail, one of Alberta's premier hiking routes.

The Forestry Trunk Road continues north, following the Livingstone River, a tributary of the Oldman, though the river is, for the most part, hidden in the trees. The route is not totally forested, however. There are just enough patches of open grassland to allow views of the mountains: Horseshoe Ridge to the east, Cabin Ridge and Twin Peaks to the west. At Livingstone Falls (not a patch on its African namesake) the river splits into two small cascades, not very high

but geologically interesting. Most waterfalls are formed by erosion of the river bedrock, but here the water slides down rock ledges that were thrust upward against the flow of the river. The forest shade, good trails and the bright chatter of the Livingstone River create a popular campsite.

Northeast lies the peak of Mount Livingstone itself, and ahead looms the huge, high shoulder of Plateau Mountain, its broad, treeless summit cresting at more than 2,400 metres, where the Livingstone River rises. Another geologic oddity, the summit bulge of Plateau Mountain is covered with circles and polygons of loose rocks forming a sort of crazy-quilt design. Such patterned ground, well known in Arctic climes, is a product of extreme soil movement caused by seasonal deep-freeze and thaw. This mountain summit was never glaciated, its head too high to be smothered by the sea of ice, but it suffered the intense, cracking cold of the Pleistocene epoch, and the rocks tell the story. What remains today is a flashback to ice age conditions, a fossil footprint of Earth's history. There are several roads and trails leading up Plateau Mountain, and the patterned ground has been set aside as a provincial ecological reserve.

This mountain massif blocks the northward route of the Forestry Trunk Road, forcing it northwest toward Kananaskis Country. At the turn, Secondary Highway 532 climbs steeply east over the top of the Livingstones and back down to prairie level. This road, signposted to Nanton, is unpaved, and its sharp switchbacks make it generally unsuitable for vehicles with trailers; in muddy or slushy snow, it can be treacherous. In summer, though, conditions are usually kind enough for a splendid drive, up through the forest and into open grasslands to arrive, after only four kilometres, in the windy subalpine region of bald rock and lingering snow patches. On the ridge to the north, a forestry fire tower overlooks the 1,800-metre pass where a small, round mountain tarn provides a good excuse to stop to catch your breath and study the route ahead.

It's a precipitous and spectacular plunge east into the green valleys of Johnson and Willow creeks and down, down into the blue haze of the prairies. An exciting mountain road with breathtaking views, it is also, perhaps fortunately, a lonely road. You don't have to worry too much about meeting other vehicles on one of the hairpin bends—you can see their dust from afar. As you drive down the switchbacks, there are a few places to pull over to admire not only the view ahead but also behind, where the thin line of the road snakes steeply down from the skyline ridge. Soon you're out of the subalpine zone, and here the road levels off as it rides through the foothills, all open rangeland broken by clumps of aspen. In June, the meadows are bright with dandelions and the woods crowded with wildflowers—Indian paintbrush, arnica, red wood lily and blue lupine.

Where Johnson Creek flows into the Willow, Indian Graves Provincial Recreation Area provides good camping and a popular staging ground for pack-horse trips. East of the corrals, a rock ridge rears up like the fluted ribs and backbone of some prehistoric beast. And just

Scarlet Indian paintbrush.

across the creek, half hidden in the trees is a grave, marked by a white wooden cross behind a picket fence. Is this one of the "Indian graves"?

It's only about 20 kilometres from that mountain tarn at the high pass to the pavement of Highway 22, just north of Chain Lakes. From here it's an easy drive north to Longview and Calgary or south to the Nanton crossing of the Porcupine Hills and Highway 2. One could also drive south along Highway 22 for a last, long look at the Livingstones' fluted ridges in the sunset. ❖

Southeastern Alberta is dry and relatively flat, part of the sedimentary tableland of the interior plains. Buried under a veneer of hummocky glacial deposits and later eroded by wind and water, the plains surface is young—the most recent ice age that affected it ended only 12,000 years ago—and still being remodelled, mostly by human intervention, though wind and floods still play a part. The prairie has been grazed by livestock, ploughed and planted, carved into townships, stripped for coal, flooded for irrigation and scarred by roads and railways. But there are still areas where the land has resisted cultivation, where sagebrush and sand lilies continue to hold sway and where there remains much evidence of the long occupation of the plains by the indigenous peoples.

Two great rivers flow through southeastern Alberta, the Red Deer and the South Saskatchewan, and it is along the convoluted edges of their deep and sinuous valleys that some of this beautiful, almost untouched land can be enjoyed. The rivers converge near the little town of Empress, a good base for explorations and the focus of a short journey through these wild lands. But first, there is a mystery to uncover.

The confluence of the two rivers, known as the Forks of the Saskatchewan, and the traditional wintering ground for the Gros Ventre and Blackfoot nations, was the site chosen by Peter Fidler of the Hudson's Bay Company for a fur-trading post. He and a group of 18 men, accompanied by several wives and children, including his own, arrived in September 1800 to start construction of the cottonwood log buildings. Hot on their heels was their chief rival in the fur trade, the Northwest Company, and another, the XY Company. All three organizations built fortified trading posts here at the Forks. Records show that the HBC's Chesterfield House was large and commodious, built of local cottonwood logs, with stone fireplaces and parchment

Pockets of virgin grassland still remain in southeastern Alberta.

110

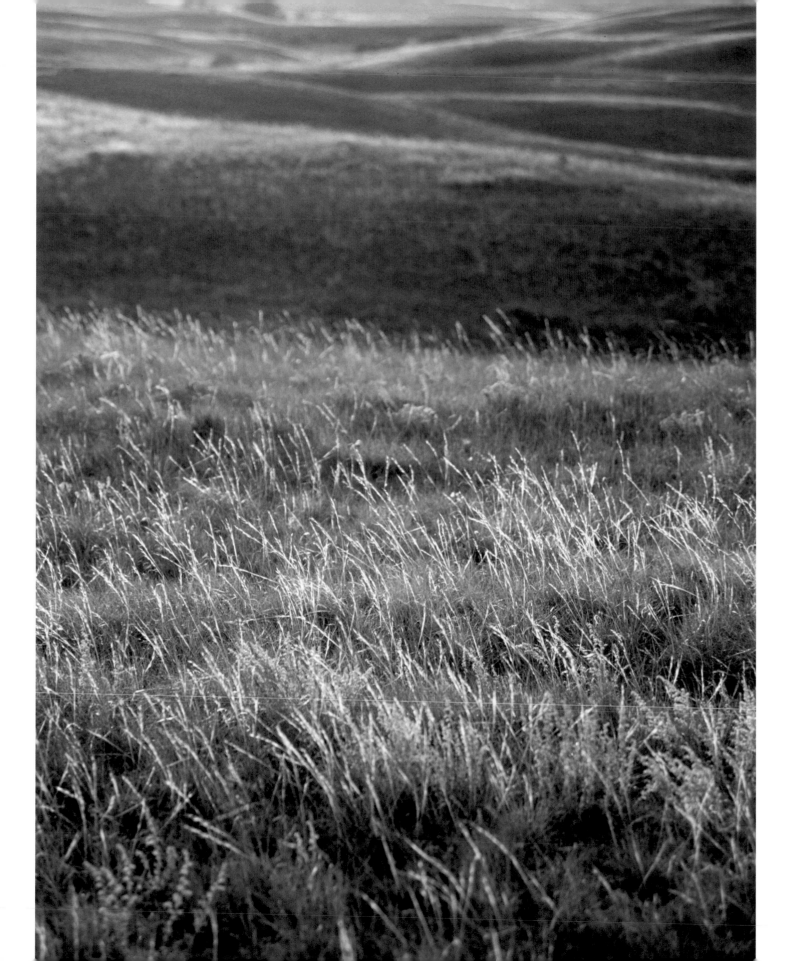

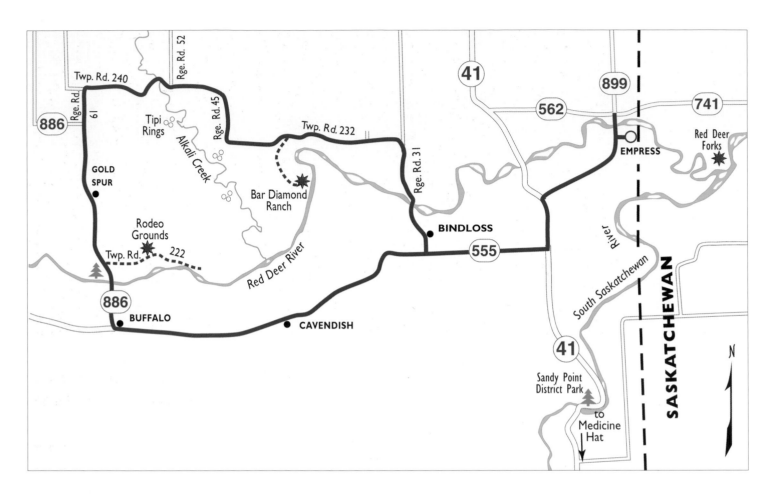

The little town of Empress is a good base for explorations. This route leads along the Red Deer River through a landscape little changed since the time of the buffalo. It's a half day from Empress. Expect some long stretches of dusty country road.

LEGEND

○	large community	- - -	optional route
●	small community	‖	bridge
✸	place of interest	♠	church
♠	park/recreation site	✳	ferry

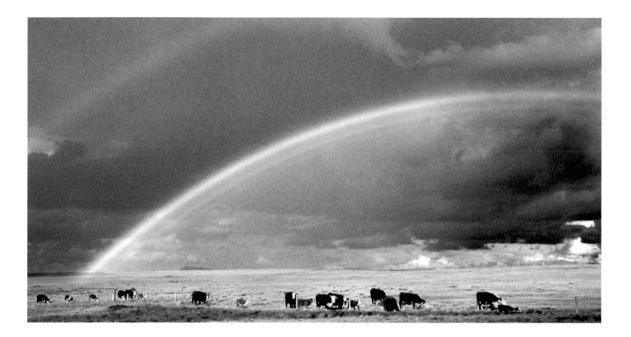

Cattle graze the dry grass, under the light of a double rainbow.

windows. It and a separate trading shed were protected behind a stout stockade. The Northwest Company built immediately adjacent: in fact, the two stockades had a common wall. The XY Company built about 30 metres away.

That fall about 1,200 Natives camped at the trading centre, and the posts had to send to Fort Edmonton for more supplies. Excursions were also made to the Cypress Hills to collect pitch for the York boats, the big canoes the men built here to transport the furs east in spring along the inland water route. Fidler's post journal lists the furs traded that first year as including good numbers of fox, wolf, badger and beaver—but did not mention the fact that his third son, George, was born here on November 10, 1800, the first Métis child to be born in southern Alberta. (Fidler and his Cree wife, Mary, had 14 children.)

Prospects looked good at Chesterfield House for the trading of fur and pemmican, but fire, blizzards and Native unrest led to its abandonment after only a few years. The site was reactivated in 1823, but again, traders were driven away. Despite good documentation, plans and maps showing exact locations, no trace of any of the three trading posts has been found. Archaeologists have searched in vain on the land between the two rivers and have come away mystified. Were they looking in the right place? Were all remains burned, or washed away by river floods? Will someone someday discover the remains of the stone chimneys, the log palisade?

The Forks area was later settled by Métis buffalo hunters, but by the time the Canadian Pacific Railway (CPR) reached the region in 1914, the buffalo were all gone, the Métis cabins had been abandoned and ranchers had moved in to graze herds of cattle on the buffalo lands

beside the river. The news of the proposed railway had galvanized the area. In anticipation of boom times, the population of the little supply centre swelled to more than 800. It was named Empress out of loyalty to Queen Victoria, the Empress of India, though she had been dead for several years. Here the CPR built a roundhouse, a water tower, the largest stockyards west of Winnipeg and an elegant railway station. But the war of 1914 scuttled railway plans to make Empress a division point, and traffic was diverted to Medicine Hat. Empress sank into a decline, and by the beginning of the dust-bowl Depression many of the townspeople had moved away. Farmers abandoned land in the dry belt to try their luck elsewhere.

Although the rail lines have been torn up and the bridge across the river dismantled, Empress has lingered, its streets neat and its tiny park shady with trees. The old railway station, a lovely 1½-storey structure with large arched windows and three carved rosettes on the ridge line, is being restored at the edge of Peter Fidler Park beside the Red Deer River. To reach the village, which lies right on the Saskatchewan border, take Highway 41 north from Medicine Hat. This road traverses the Little Sand Hills east of Canadian Forces Base Suffield and zooms down to cross the South Saskatchewan River at Sandy Point District Park, one of the few places for riverside camping and access. Here beside the willows of the campsite are snatches of badland hoodoos, eroded coulees and glacial erratics, a great place for a picnic.

Start this journey just south of Empress and drive west on Secondary Highway 555, which heads to the riverside settlement of Bindloss and on to Buffalo, passing the overgrown cemetery of the vanished settlement of Cavendish. Bindloss was named after Harold Bindloss, the author of several Victorian novels about the Old West. Today, it's almost a ghost town, with old but

Pioneer farmstead, dwarfed by a field of gold.

appealing deserted buildings to be found along the road, though there are a few streets of new homes. (The Red Deer River crossing here is part of the return loop.) All the prairie high above the river valley is dry country, dependent on irrigation for its crops. Oil wells abound. Buffalo, another semi-ghost town, has a small post office and general store and seems to be the hub of a lively though unseen community: the local agricultural society hosts several annual events, including a rodeo, country fair, dog trials and a strawberry tea, though it is hard to imagine strawberries growing in such arid surroundings. Originally known as Gold Springs, Buffalo's current name seems perfect for a place once thick with bison, but in reality the community was named by an early settler after his home town of Buffalo, New York.

Turn north (right) here on Secondary Highway 886, and cross the Red Deer River. On the far side of the one-lane bridge is a shady riverside campsite under tall cottonwoods, a delicious spot on a hot summer day. The road to the Buffalo Rodeo Grounds (Township Road 222) leads east along the river's north shore to dead-end down by the river. Keep going north on 886 for about nine kilometres. Then take Range Road 61 (it goes straight, where 886 bends west) to a T-junction with Township Road 240. Turn east, and stay on Road 240 through several turns most of the way back to Bindloss.

This road is not one to wow the senses. It is a ranch road and as such is dusty, and it travels for the most part through unbroken prairie, full of small hills, glacial erratics and deep creek valleys. But drive slowly and absorb the atmosphere: it's the closest one can come to the ancient land the buffalo roamed and where the First Peoples of Alberta pitched their tipi camps, travelling at first with only dogs, then horses to haul their possessions. Thousands of stone rings still

*Magnificent
medicine wheel
on the banks of the
Red Deer River.*

lie on the prairie to mark their campsites. At about 17 kilometres from the Buffalo Bridge, there's an enormous glacial erratic, rubbed to a high gloss by hundreds of years of itching buffalo. There are several such buffalo rubbing stones along this road. A deserted three-storey settler's house speaks of dashed hopes and broken dreams of a far later vintage.

At about 25 kilometres, the road describes a giant S around the rim of Alkali Creek. In the 1970s, the archaeologist Gary Adams conducted a survey of tipi rings in this valley and excavated 88 of them. He determined that the most common grouping was three to four, representing a small, inter-related family group of around 25 members who travelled together. Such groups would join others of the tribe for communal events such as buffalo hunts or ceremonies at medicine wheels. The unploughed prairie is often well endowed with tipi rings, some of which, deeply embedded, date back 5,000 years, evidence that this form of housing was so ideally suited to a nomadic existence that it did not need to be changed.

On the far side of Alkali Creek, there are a few fields scratched out of the prairie, as well as a few old homesteads. At 36 kilometres, a sign denotes the site of Evadne School District, populated from 1914 to 1927, and just beyond the school sign, a road beside some corrals loops down to an old ranch by the Red Deer River. The Bar Diamond Ranch runs some 650 head of cattle on the prairie where buffalo once grazed. The original log house, built in 1902, has been turned into a guest lodge for upland game hunts and jet boating (on the South Saskatchewan) and for touring a medicine wheel site that lies on ranchland nearby. This site, splendidly situated above a bend in the river, contains two wheels, a couple of effigies (of a snake and a turtle) and a sprinkling of tipi rings. The site has been mapped but not thoroughly investigated, and lodge staff will lead guests on guided tours. Beyond the ranch turning, the road rides high above the river, then angles down to cross the bridge back into Bindloss for the return to Empress.

The village itself provides a hub for other explorations: there's an outstanding medicine wheel that overlooks Empress from the eastern bluffs above the river, and a buffalo jump in O'Connor Coulee to the north. To tour both of these, call in at the art gallery in the old Empress bank building: they may know of a guide. Another interesting circle tour leads into Saskatchewan, where you can cross the river on a ferry and explore for yourself the site of Chesterfield House at the Forks. Who knows? You may be the one to find the first solid trace of the missing fur-trading post. ✣

12 TRACKING THE MOUNTIES TO POLICE OUTPOST

In many ways, the southwestern corner of Alberta is the loveliest in terms of scenery. Here the plains swell voluptuously into a narrow foothills belt before bumping up against the towering grandeur of the Rocky Mountains. Perhaps it is the sudden change from horizontal to vertical, from fields of glowing grain and wildflowers to snow and hanging icefields that gives the land its appeal, the attraction of opposites. Everywhere, in every season, there is great beauty. Waterton Lakes National Park, in the extreme south, is well known to travellers, and two major scenic highways lead there. But there are other roads, just as inviting.

One journey begins in the town of Pincher Creek and wends its way south to Police Outpost Provincial Park, smack on the Montana border, returning to civilization at Cardston. From Pincher Creek, follow Secondary Highway 507 east through ranchlands known as Halifax Flats. Just past the turnoff to Brocket is the little Halifax schoolhouse, now abandoned like most one-room country schools. Two little outhouses survive, but the schoolyard is abuzz only with beehives. Turn right (south) along Range Road 284, signposted to Fishburn. Like other section roads in the area, this slices straight south, across the grain of the land, up hills and down again. From the tops of the hills, the mountains to the south seem exhilaratingly close. Fishburn is a ghost town that has vanished almost without a trace. Named after the first settler, A.M. Fish, and given a post office in 1884, it was described in a 1901 police report as "the centre of a thriving settlement." Of the town, only a little church remains, a few kilometres east on Township Road 54.

Keep south on Range Road 284, then turn east on Township Road 50 for a visit to another abandoned schoolhouse, this one with the hopeful name Utopia. A wrought iron sign commemorates its birth in 1904 and its demise in 1950. Behind the schoolhouse, the land falls away steeply to the Waterton Reservoir, its slopes carpeted in June with the gold of balsamroot sunflowers, a

A red-hot sunrise colours the hay bales and mountains, west of Pincher Creek.

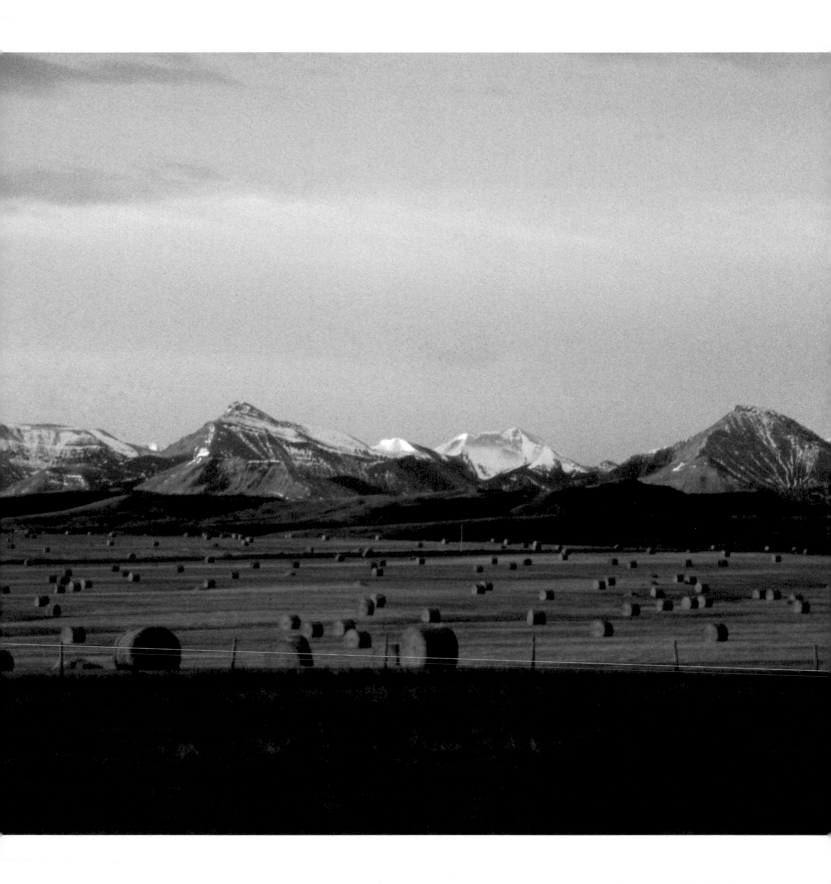

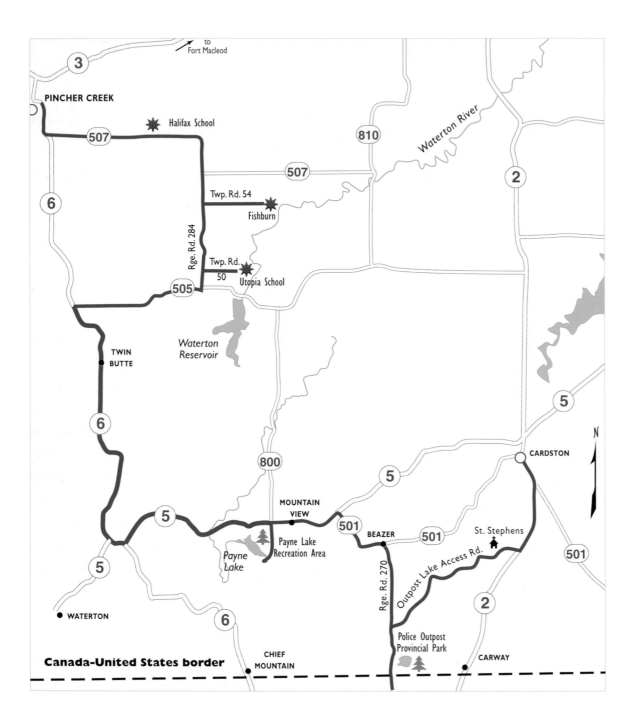

An easy drive to the loneliest police outpost in North West Mounted Police history, and it doesn't matter that there's nothing left to see: the countryside is beautiful. Half a day from Pincher Creek to Cardston.

LEGEND

○ large community	- - - optional route
● small community	‖ bridge
✹ place of interest	♙ church
🌲 park/recreation site	✳ ferry

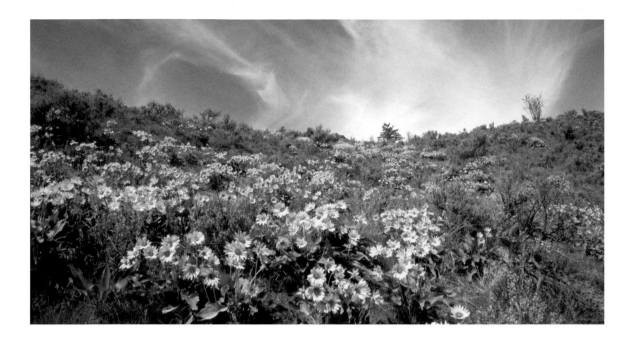

Balsamroot sunflowers bejewel prairie slopes in spring.

glory that the children must have loved. And on the horizon the hatchet face of Chief Mountain looms blue. It is tempting when you reach Secondary Highway 505 to turn east and go over the dam at the northern end of the reservoir (this route is described in chapter 6). Instead, turn west and head to Highway 6, the main route to the Montana border, a fine, rolling road that offers endless mountain views. Twin Butte, named for two prominent nearby hills, has an excellent restaurant, brightly outfitted with Mexican tile, part of the general store/post office that is the heart of this old settlement. From here the highway sails due south, veering only a little as it climbs around Pine Ridge. Highway 5, meanwhile, slips in from the east, crosses Highway 6 and leads into Waterton Park itself. This is the road to follow, though not into the park (at least, not on this trip); instead, go east toward Cardston.

After 20 kilometres, Secondary Highway 800 intersects and continues south a short distance to Payne Lake Provincial Recreation Area, one of the most beautiful grassland sites imaginable: the lake edges are thick with summer wildflowers, and a ring of dramatic mountain peaks floats on the horizon. The reservoir lake was formed for irrigation purposes by damming the coulee and filling it with water from the Belly River. It has been stocked with rainbow trout and is very popular for camping, boating and fishing, a wonderful spot for a leisurely picnic.

Just east along the highway is the community of Mountain View, founded in 1895 by Mormon settlers. The Church of Jesus Christ of Latter-day Saints' church is still by far the largest building in this small and pastoral community. The view, as you might guess from the name, is spectacular.

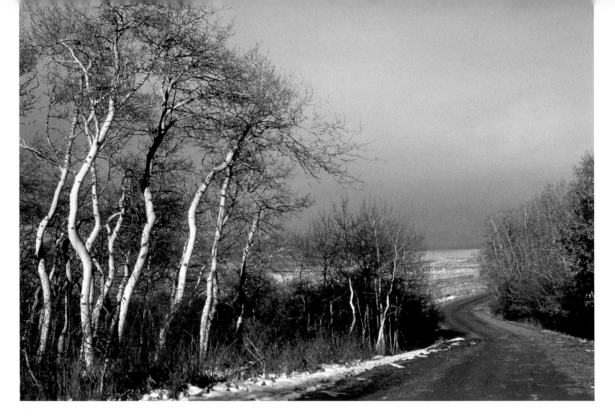

The Mormon settlement of this part of Alberta began in 1887 when Charles Ora Card led 40 members of his Salt Lake City-based church north from Utah by wagon train, crossed the border at Immigration Gap and founded Cardston, the city named after him. Here he later built a great white granite temple, the first Mormon church in the British Empire. Before the Mormons were allowed to settle on Canadian land, they had to relinquish their polygamous traditions; the men could bring with them only one wife apiece. History does not record what happened to the discards. From this religious centre, splinter groups spread out to establish other communities. Mountain View was one of these. By 1898 it had a blacksmith shop, a carpenter, a creamery and, later, a cheese factory.

Four kilometres east of Mountain View, Secondary Highway 501 (signposted to Police Outpost) heads south to another old Mormon community. Beazer, established among the cottonwoods of Lee Creek, used to be a ghost town, but today, because of its scenic location and proximity to Waterton, it has forged for itself a new life as a recreational centre. From here Range Road 270 goes toward the border and to Police Outpost Provincial Park, which preserves the site of a lonely North West Mounted Police base, home to a detachment of four men between 1891 and 1899.

When the police arrived to establish Fort Macleod in 1874, their first job was to stamp out the whiskey traders who sold their inferior products to the Natives and fomented much unrest. The times were difficult: Sitting Bull and some 5,000 of his men were in exile in Canada following the Battle of the Little Bighorn; the buffalo were almost gone, and people were starving. Somehow,

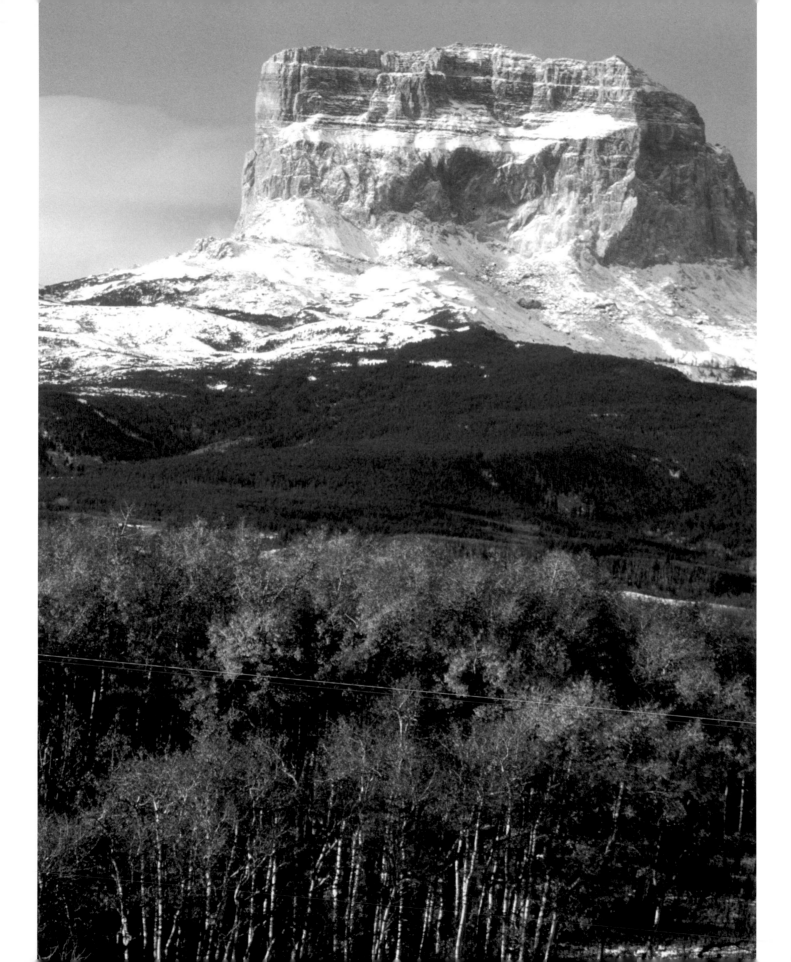

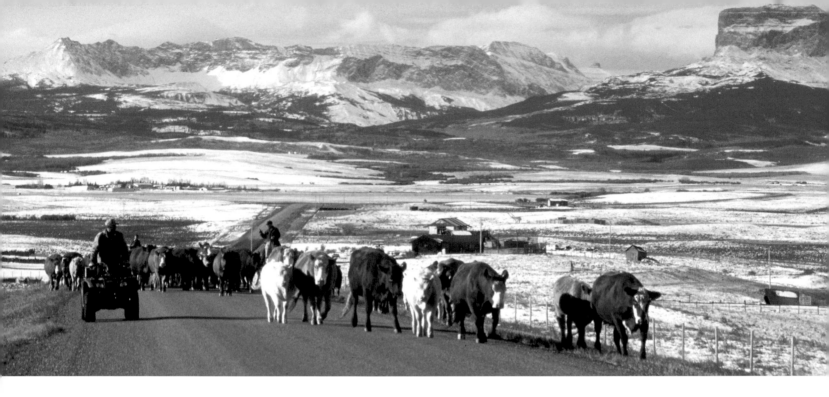

the small handful of red-coated Mounties, the only representatives of British law and order in the wilderness west, managed to keep the peace. Later the Mounties patrolled the boundary between Alberta and Montana, on guard against cattle rustlers and rum-runners. Remote Outpost Lake, several days' ride from detachment headquarters in Fort Macleod, cannot have been a popular posting.

After the station closed, it lay vacant for three years until a lone officer was sent to reopen it. He found the buildings in such a state of disrepair that he could not live there and boarded instead with a local settler. In 1909 the Outpost Lake NWMP post was closed for good. Later police patrols merely camped at the lake. It's not surprising that the actual site of the police post, with its log house, kitchen, stables, oat shed and corrals, documented as being on the southeast corner of the lake, has never been found despite the best efforts of archaeologists.

Under the shadow of high peaks, including the square jaw of Chief Mountain, Police Outpost Park is a compelling place, lying in a transition zone between grasslands and aspen parkland where more than 240 species of plants and flowers endemic to both zones seem to thrive. In spring, grasslands are carpeted with blue camass and shooting star, along with prairie crocus, coltsfoot and locoweed. In the damp woodlands, wild orchids and wintergreens are common, and lupines, sunflowers and roses brighten the dry bluffs. The lake has been stocked with rainbow trout; there are campsites and picnic tables, boat-launching sites, trails and beaches. On summer weekends this little park can be crowded, but mostly it is a quiet place, just as it was for those first Mounties.

Adjacent to the park is Outpost Wetlands Natural Area in the marshes and ponds of Boundary Creek, a great place for nature watching of all kinds but particularly for birds, including

Cattle drive on the road southwest of Cardston.

The first flower to bloom in the prairie spring is the crocus, botanically an anemone.

sandhill crane, bittern, red-necked grebe, cinnamon teal and northern water-thrush. The marshland trails are closed during nesting season.

There are two routes from the lake to Cardston: Secondary Highway 501 from Beazer or an unnumbered road that swings northeast at the old Boundary Creek Schoolhouse, a wavering diagonal that leads to Highway 2 just south of Cardston. Each road is worth travelling, but perhaps the latter is preferable, if only because it provides such outstanding views (over your shoulder) of the mountain backdrop to the south. It also leads to another of Alberta's pioneer churches. The white-painted St. Stephen's Church was built on South Hill in 1901 but rebuilt on its present spot in a dip along a side road in 1907. Its Gothic spire and lonely graveyard create a quiet finish to the day, whether in summer flowers or wrapped in a blanket of snow, with its windows white-shuttered. The church is a poignant relic of the pioneer past.

At Cardston, home of the famous Remington Carriage Museum, the imposing white marble Mormon temple is a startling contrast to the modesty of Charles Ora Card's small log cabin. The Mormon tradition is still strong here: the whole town is "dry." But a marvellous place to eat and overnight is historic Cobblestone Manor, an endearing little house on a side street with a story (and a ghost) of its own. ❖

KANANASKIS BYPASS

Kananaskis Highway 40, the highest paved road in Canada, travels over the Highwood Pass on its way from the Banff–Calgary corridor southeast to Longview, south of Calgary. It is undeniably a superb route to travel through the mountains. But there is a slower, back-country way that offers history and prehistory, as well as scenery. This begins at Canmore, then skirts the Rockies along an interesting foothills trail and emerges onto the plains around Bragg Creek. There's just one thing to remember: like the Highwood Pass on Highway 40, this backcountry route is closed between the end of December and May 15.

In Canmore, take Highway 1A and drive east on the north side of the Bow River past the Old Camp and Gap Lake picnic areas, watching out for Rocky Mountain sheep. About 10 kilometres on, Grotto Pond is worth a stop, not just for the fishing but because of the hiking trail that starts here and leads up the creek (now mostly dry) into Grotto Canyon, where a thin stream spills down a sheer, high cliff. It's a beautiful spot, cool and shady, and there are tall trees and forest flowers along the way. On the steepest part of the pale limestone canyon walls, sheathed by a translucent film of mineral deposits, are some of the strangest Native pictographs in Alberta. Drawn in red ochre, they show elongated men with big shoulders and wasp waists but each with only one leg. The figures wear headdresses, and they hold spears or staffs and objects that look like baby rattles or ice-cream cones. One herds a group of beautifully drawn elk. Oddest of all is a tiny flute player, almost identical to figures painted in New Mexico and Utah to represent the hunchback Anasazi god called Kokopelli.

Archaeologists are trying to understand how this art style, known as Fremont, migrated here, some 600 kilometres north of its focus. The pictographs are very difficult to see, even if you know exactly where to look, but this adds to their allure—and helps protect them from vandalism.

The picture-postcard view: fall reflections in Wedge Pond in the Kananaskis.

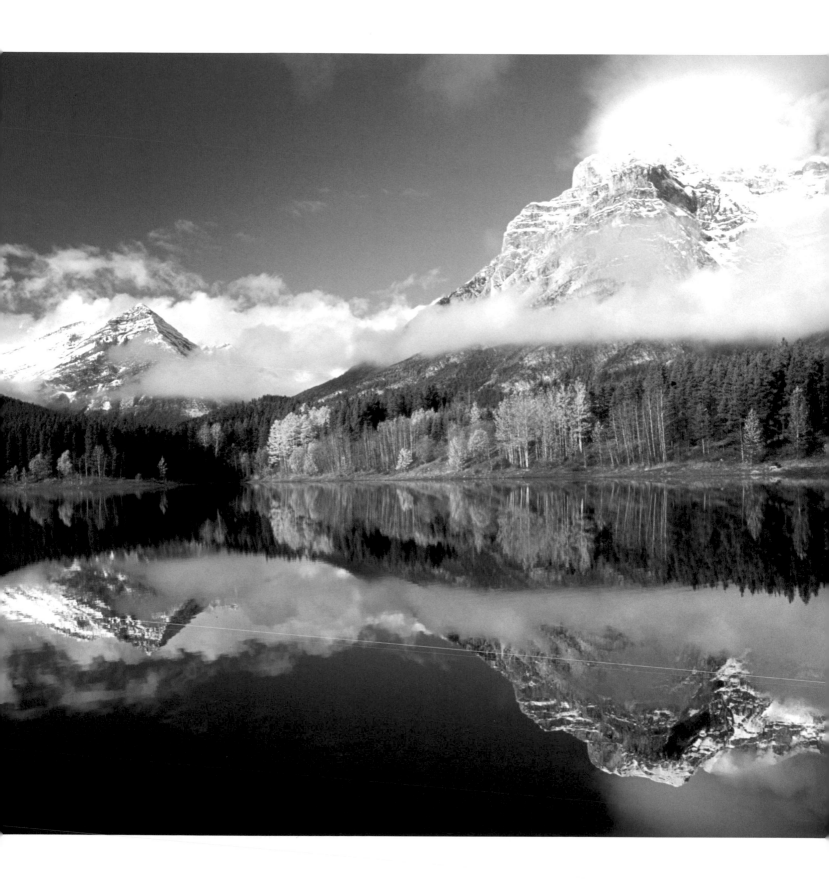

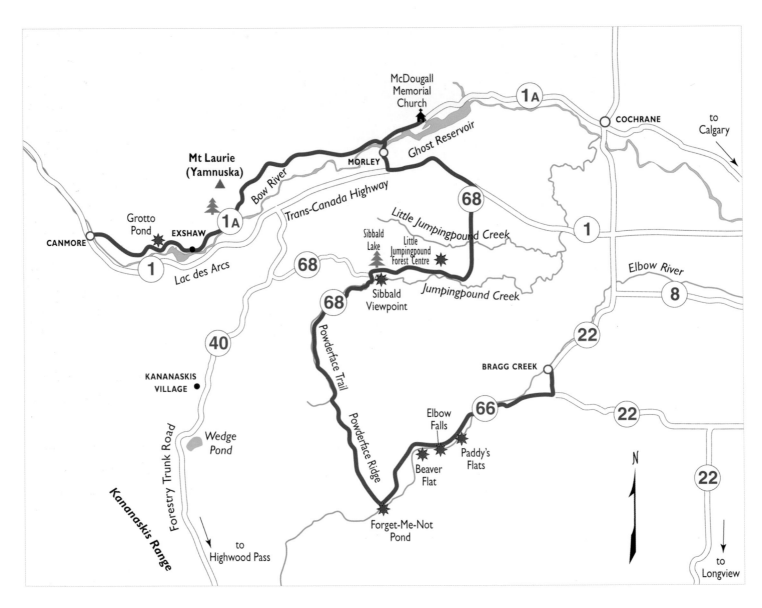

If tourist traffic is heavy along Kananaskis Highway 40, it's good to have an alternative route south, such as this one through a lower mountain valley. A half day from Canmore to Bragg Creek. Summer road only; check road closures.

LEGEND

○	large community	- - -	optional route
●	small community	�ⵜ	bridge
✳	place of interest	⛪	church
🌲	park/recreation site	✳	ferry

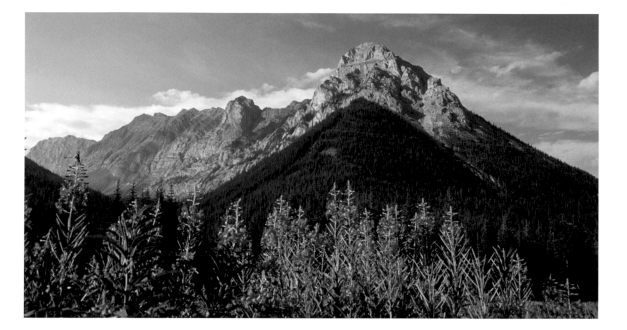

Mountain fireweed.

Chances of finding them are better in slanting light and after a light rain when the rock is damp. Pictographs aside, the canyon is so lovely that it's worth a visit for itself. Allow a leisurely two hours for the return hike through the forest.

From Grotto Pond, keep east on Highway 1A through Exshaw and its limestone quarries and onto the Stoney (Nakoda) Nation reserve. Chief Goodstoney Rodeo Centre lies south beside the Bow River, and a signed road leads to a buffalo paddock at Stoney Indian Park. Nearby is Nakoda Lodge, on Chief Hector Lake. The Stoney people are cultivating the tourist trade, though their wealth today is derived from oil.

North of the road rise the steep limestone cliffs of Mount John Laurie, better known as Yamnuska, or "the Yam." It's the best rock-climbing wall in the Rockies: there are more than 70 different routes up its sheer south face. The area around the cliffs has been set aside as a provincial "natural area" and contains three very different ecosystems—foothills, plains and mountains—and more than 300 different wildflowers, including lady's slipper orchids and red lilies. Some 180 species of birds have been recorded here. A 3.5-kilometre trail from the parking lot leads very steeply onto the Yam's eastern ridge, but you don't have to exert yourself: you can watch the rock climbers in action from below, through a good pair of binoculars. The cliffs are dramatic in the fall, framed by the glow of golden aspen.

Thirty-four kilometres beyond Grotto Pond, a side road leads south across the Bow River to the settlement of Morley. George McDougall and his son John, driving 11 cows and a bull, came here in 1873 from Fort Edmonton to establish a Methodist mission among the Stoney and

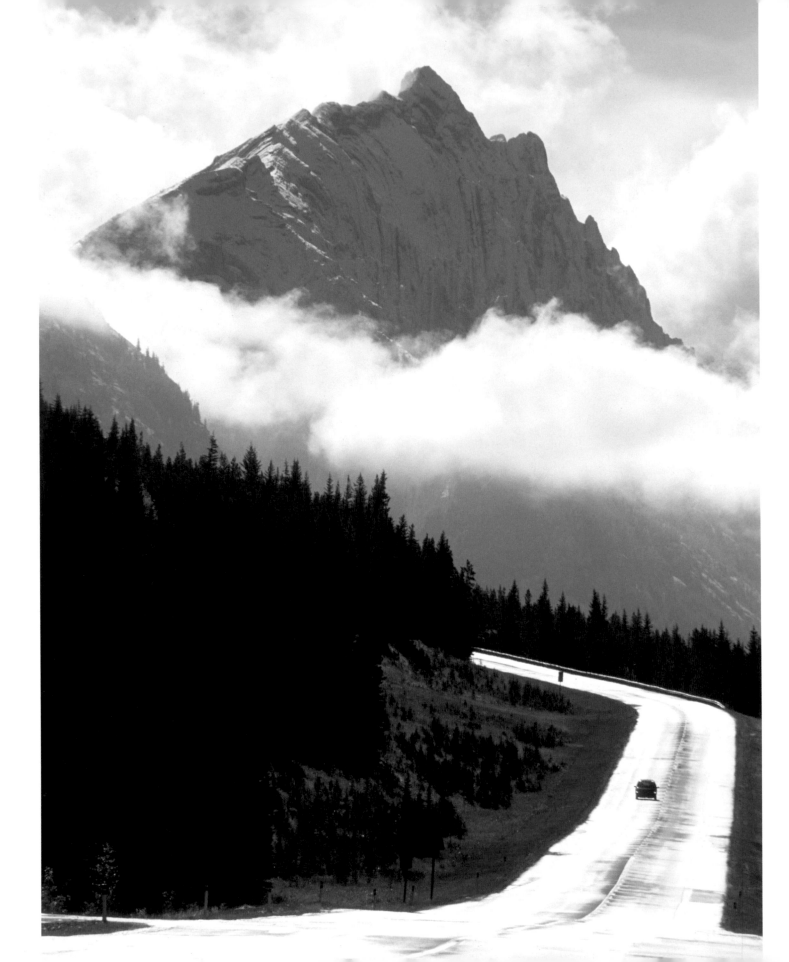

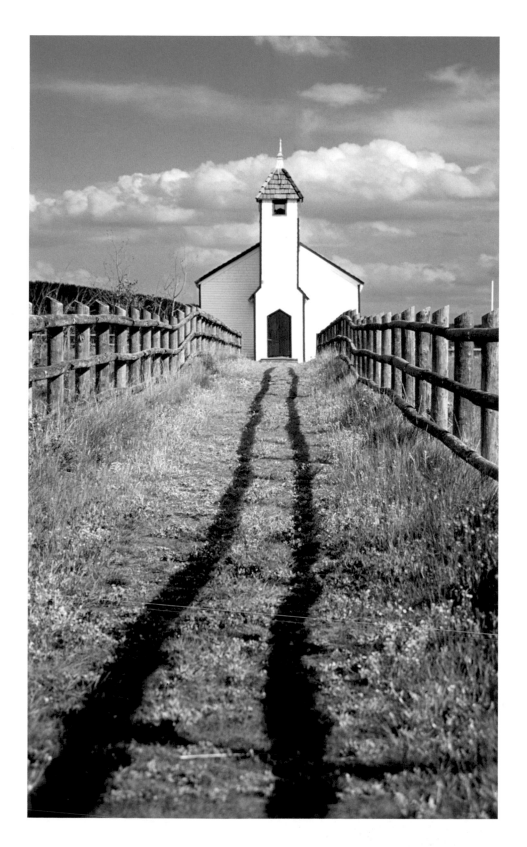

Blackfoot tribes. Two years later, on a meadow beside the river, the McDougalls built a small wooden church. To visit this church (now the McDougall Memorial United Church), dwarfed by its grand surroundings of hills and preserved as a historic site, drive a few kilometres east of the bridge turnoff along Highway 1A. The pretty little building is framed by a very special gateway, with an inscription in both English and Cree, but there is tragedy here: a year after building the church, George McDougall failed to return home from a buffalo hunt in a blizzard and was later found frozen to death. He is buried in the churchyard.

Others continued the missionary work, and the supply trail they made between Morley and Fort Calgary became Highway 1A, the only road into the mountains until the building of the Trans-Canada Highway. It is still a pleasant road to travel.

Return to the junction, and drive across the river to Morley and out

FAR LEFT
The dramatic road to Highwood Pass, early morning after a rain.

LEFT
Historic church at Morley.

to the Trans-Canada Highway. Drive east for about five kilometres and exit onto Highway 68, marked as Sibbald Creek Trail. This is a hillocky road that first heads due south through coniferous forest, crossing the several tributaries of Little Jumpingpound Creek and passing small ponds known to be spring stopovers for migrating trumpeter swans. A right-angle bend points the road almost due west, where Jumpingpound Forest Interpretive Centre offers a self-guided educational drive through the woods for a look at current forest management practices. Beyond, a short road leads south to a high viewpoint overlooking an extensive meadow where Sibbald Creek loops through like a silver ribbon. The flats were named for the area's first settler, Frank Sibbald, who brought in a herd of longhorn cattle in 1890. But this is recent history.

During construction of the road, remains of an 11,000-year-old campsite were brought to light. Archaeologists uncovered, among small heaps of stone chips, a finely flaked spear point of green siltstone identical to those made by Clovis people, who hunted giant bison, woolly mammoths and mastodons in the waning days of the ice age. There is a modern campsite beside Sibbald Lake, as well as several hiking trails.

Sibbald Creek Trail continues west, following the creek through a narrow valley made marshy by beaver dams and vibrant with summer flowers, past Sibbald Meadows Pond to meet Highway 40, but a more adventurous route takes off south just beyond Sibbald Lake. Down the hill from the viewpoint, Powderface Trail leads enticingly across the meadows, following Jumpingpound Creek into forested foothills. It's an unpaved summer road, likely to be muddy after rains, so drive with care. A point of interest along the route is a memorial cairn built on a clearing with a fine view of distant Mount McDougall, named for the Morley missionaries. In 1941, a Royal Canadian Air Force training plane from Calgary slammed into the shoulders of this mountain, killing two of the three on board.

The mountain vistas are memorable as the road passes under the shoulder of Jumpingpound Mountain and skirts the eastern edge of Don Getty Wildland Provincial Park. Across a low divide, the trail runs under Powder Face Ridge and emerges at Forget-Me-Not Pond in the valley of the Elbow River. Highway 66 begins here and leads out to Bragg Creek (28 kilometres) southwest of Calgary.

There are several places of interest along Highway 66, including well-stocked fishing ponds, though flooding in 2005 changed some of the landscape. Beaver Flat is true to its name: there is (or was) an active beaver lodge here. There's a short hiking trail beside the river at Paddy's Flats. But the most outstanding sight and most popular venue is Elbow Falls, where the river gushes through a narrow gap in the bedrock and tumbles into a deep, turquoise pool. There's a fine park here, and well-worn trails lead down to viewing platforms above the falls. The Elbow River is popular for canoeing and kayaking, and there are several mountain hiking trails nearby, including an easy one to the fire tower on the summit of Moose Mountain. Bragg Creek Provincial Park headquarters has the details. ❧

Arctic willow, one of the first to bloom in the mountain valleys.

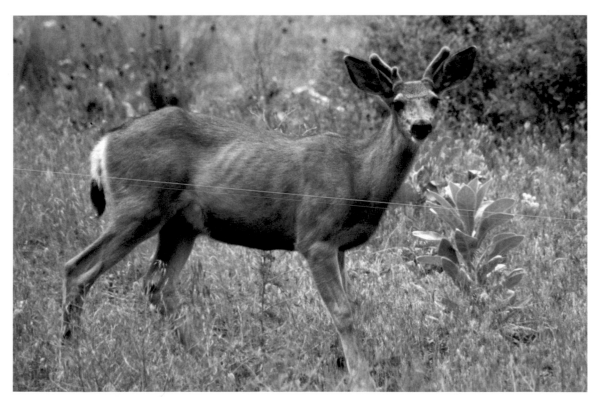

Roads throughout the Kananaskis are good places to see wildlife, such as this mule deer.

FIDLER'S QUEST

Winter nipped at the heels of Alberta's north country, smothering the prairies with 20 centimetres of snow and choking the North Saskatchewan River with ice. It was November 8, 1792. Young Peter Fidler surveyed the scene from the high bank where the newly built Buckingham House trading post provided a few rough creature comforts. Ahead, once he had chivvied his little entourage of three Peigan guides across the river, lay a journey to the far southwest, through country for the most part unknown, possibly hostile and certainly unmapped. It was a journey that was to cover roughly 1,000 kilometres and last for nearly five months.

Fidler, four years out from safe and civilized England, was 23 years old and no greenhorn. He had already spent two years with the Chipewyans of the north from his base at the Hudson's Bay Company's Cumberland House and, in company with chief HBC surveyor Philip Turnor, had mapped Athabasca Lake and the entire 2,500 kilometres from the lake to Hudson Bay, the main route of the fur traders. But now he had his own mission: chief trader William Tomison had ordered him south "to make some observations at the Rocky Mountains," which were not then pinpointed on any map. As well as his guides, Fidler had the company of John Ward, a more seasoned HBC employee. Neither Fidler nor Ward could speak a word of the Peigan language. Both men had two horses, one to ride and one to carry the assortment of knives, guns and hatchets, beads, kettles and tobacco that were to be doled out as payment to the guides—and for trade. In his own kit, Fidler had a brass sextant, a compass, a watch and a thermometer, pretty simple survey tools compared with the global-positioning system equipment available today.

Fall sunrise over the North Saskatchewan River, just west of Buckingham House site.

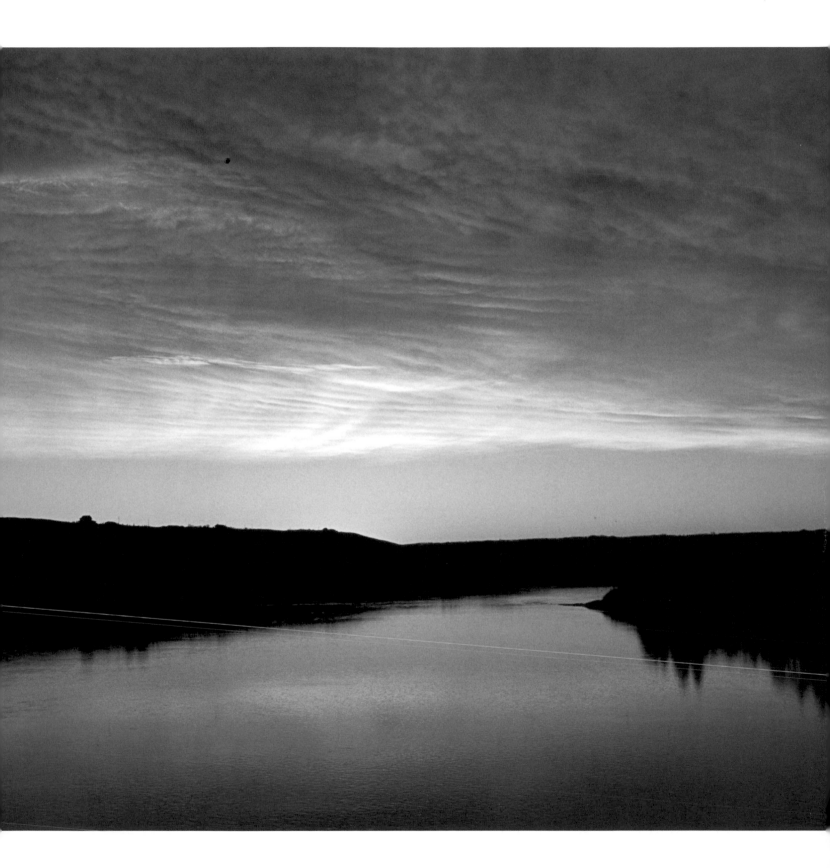

At 2 PM we took leave of Mr. Tomison and crossed the Horses over the river which was full of driving ice and very dangerous, made a large fire after we crossed to warm and dry them after swimming across the river, then went up the Bank on the South side, which is very thicketty and steep in places ...

They camped eight kilometres south of the river, already well away from the cheerful civilization of the trading post and in the grip of an icy winter in the wilderness land that was later to be called Alberta.

Their journey through uncharted territory was a momentous one. Other fur traders had ventured into parts of southern Alberta a few years before, but none left records of their early movements. Fidler was the first to put the Rocky Mountains on the map, the first to survey many of Alberta's great rivers and hills, the first to record the presence of coal and cactus, the first to meet Snake and Kootenay people and to experience their way of life. But his epic journey, unlike David Thompson's or that of Lewis and Clark, has gone mostly unremembered, though the details are included in his handwritten expedition notes, "Journal of a Journey over Land from Buckingham House to the Rocky Mountains in 1792 & 3," kept at the HBC archives in Winnipeg.

This journey follows Peter Fidler's epic travels, a long, meandering diagonal across the huge and beautiful land that lies between the North Saskatchewan River and the Crowsnest Pass. It does not tread in his exact footsteps; as an auto route, it is forced to conform to the structured grid system laid down by the Dominion land surveyors in 1871 (for further explanation, see the introduction to this book). But it is close enough. As one drives through the parkland onto the prairies, one can, with the help of Fidler's journal, recreate his grand adventure. He wrote not just about the landmarks (so well described that they essentially pinpoint his route) but also about the people he travelled with and those he met, presenting one of the first and most engaging pictures of Native life. Today's landscape has been changed by the plough and homestead lights diminish the darkness of the night, but there is still a sense of wilderness, even of loneliness, as one drives the gravel back roads of Albert's great landscapes. The beauty of the countryside is often heart wrenching, the ever-changing sky huge and all engulfing.

Fidler took five winter months to make his journey out and back, and each leg was slightly different. On his return he veered east of his outward route to travel through the badlands of the Red Deer River, undoubtedly one of the highlights of his adventure. In this book the two routes have been combined into one. This way you can cover the ground, if you wish, in only three days. It is suggested that, unlike Fidler, you complete your drive in summer or fall.

Alberta's range roads cut straight through the golden hayfields.

DAY ONE ❖ THROUGH THE PARKLANDS

The journey starts on the North Saskatchewan River in east central Alberta at the town of Elk Point, where a monumental wooden statue of Peter Fidler stands at the northern entrance. On the banks of the river southeast of town lie the ghosts of two fur-trading posts, the Northwest Company's Fort George and the Hudson's Bay Company's Buckingham House; Fidler helped to build the latter. The site is now a Provincial Historic Site, though apart from the exhibits in the interpretive centre, there is little to see in the stubby willows and aspens except for a few excavated foundations. But you can stand on the bluffs and see where Fidler splashed the horses and goods across the river to begin his quest so long ago; the steep, bushy banks are likely little changed.

Cross the Saskatchewan River—not here, but on the road bridge south of Elk Point—and head south on Highway 41, then west to Derwent, either on Highway 45 or zigzagging on Township Road 550 and Range Road 73, a route that gives a better idea of the rolling, wooded landscape. Fidler didn't get very far that first day; he and his party travelled for only four hours after leaving the fort, and by the time they set up camp at around 6 p.m., it was already pitch-dark. The next day, they travelled southwest by Landon Lake, then headed west, and in his journal Fidler remarked on the number of small lakes, most of them inhabited by beaver. Near today's Derwent they caught up with more Peigans, who had left the fort several days before, and the reunion resulted in "drinking all night" and next morning a late start, due to "their heads rather heavy" with hangover.

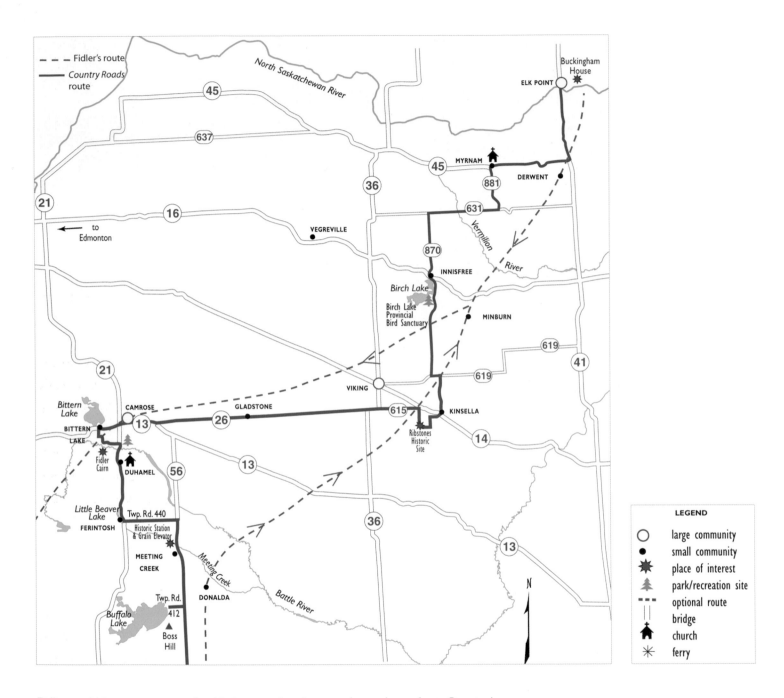

Fidler and his entourage made this journey in winter, and mostly on foot. Our trek
follows a crooked path across the aspen parklands from Elk Point to Camrose, then
south to Ferintosh, an easy day's drive. Don't miss the Ribstones.

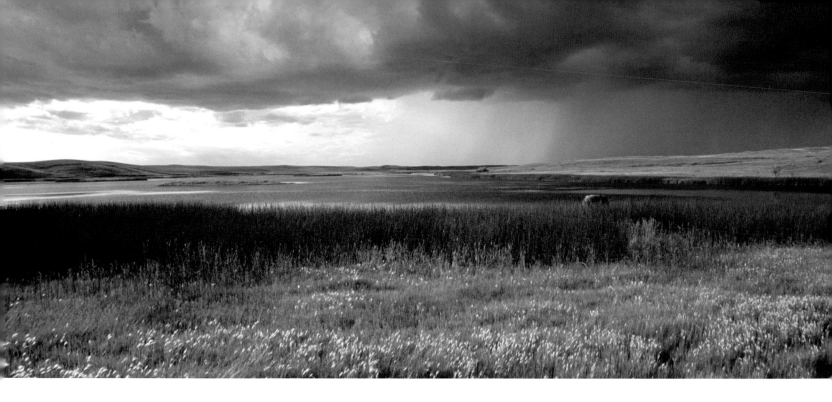

A storm threatens the peace of a prairie pothole.

Derwent today is a small town named by the Canadian Pacific Railway after Derwentwater in England's Lake District, though its hotel advertises "Pyrogy Fridays," a hint of a different ethnic alliance. Continue west on Highway 45, through fields spotted in fall with round hay bales; pass the Farmer's Independent Cemetery and a few old barns and homesteads to reach Myrnam, a village founded by Ukrainians in 1908 and embellished by a beautiful onion-dome church. The community's name means "peace to us." Head south here on Secondary Highway 881, then west on Secondary 631 to cross the Vermilion River fairly close to where Fidler crossed, and south again on Secondary 870 past St. Peter's Greek Orthodox Church to Innisfree. In fall, huge flocks of snow geese migrate through this country, often settling to dine in the stubble among the hay bales: white birds in golden fields, all of the visitors talking at once.

By road from Elk Point to Innisfree is 100 kilometres, little more than an hour's drive. This leg of the journey took Fidler and his party three days, travelling a diagonal route. Fidler reported that the grassland was all burned except around the edges of small lakes, and they had trouble finding grass for their horses in a land that was "all small hills and vallies," the hillocky terrain of the Viking glacial moraine.

South of Innisfree is Birch Lake, with its prominent islands and provincial bird sanctuary. If Fidler had travelled earlier in the fall, he could have had duck for dinner—the lake is usually full of them. Instead, as he passed nearby, he joined forces with Chief White Owl and his men, on their way to the Rocky Mountains "to hunt beaver," Fidler reported. The group, now substantially larger, killed three buffalo bulls and "took the best parts of them for our supper." They kept to a diagonal course and camped on Torlea Flats, northwest of today's Viking.

From Innisfree, drive south beside Birch Lake on Secondary Highway 870 through a string of little lakes and jog over by Camp Lake County Park to Kinsella, which lies on Highway 14, a road that breaks all the rules of the grid system—it goes diagonally, following the line of the Canadian National Railway. Kinsella is a bit to the east of Fidler's route, but this detour is worth making. Nearby lies Ribstones Historic Site, an intriguing Native heritage site that Fidler did not see, probably because his guides were Peigan and they were in Cree country. On a little knoll, today fenced off from surrounding cultivated land, an ancient stone cairn is topped by two large, pale boulders carved with ribs and backbones to represent buffalo, perhaps as a form of magic to ensure good hunting. The stones are alien, brought here by glaciers during the ice age. Known as ribstones, they are mysterious and alluring, still sacred to First Nations people who often leave offerings here—braids of sweetgrass on the rocks or long ribbons of coloured fabric hung in the copse of twisted poplars just over the brow of the hill. To find Ribstones Historic Site, drive northwest from Kinsella on Highway 14 for four kilometres, west on Secondary 615 and south on Range Road 120A. The stones lie near the summit of a small hill, and the area around them is marked by short white posts and kept neatly mowed. From the top there's a grand 360-degree view of the knob-and-kettle landscape created by the glaciers and now transformed into farmland.

Return to Secondary 615, which becomes Highway 26; keep travelling west through the cultivated countryside and head for Camrose. If you want to see buffalo (domesticated), there is often a herd of them a short distance north on Koppernyk Road (Range Road 254), roughly 45 kilometres from the ribstones. Another 25 kilometres west brings you to a dilapidated white

Mysterious ribstones on a hill near Viking.

140

clapboard church with a squat, square tower and, a little farther, to the one-room Hampton Schoolhouse, built in 1904 and now a historic site. The community of Hampton itself, it seems, has disappeared.

Camrose is a pleasant town, its streets lined with heritage buildings, and right in the centre is pretty Mirror Lake with its nature trails: a good refreshment stop. Navigate through town and take Highway 13 west to the resort community of Bittern Lake, at the southern toe of the lake itself. The short main street here flanks a central linear park, complete with benches and the original village water pump from 1910. An area of aspen forest north of the village has been set aside as a "habitat conservation area," and trails provide access to the lake, which is home to numerous waterbirds.

It is Fidler's day seven. He reports "not a single pine to be seen" as he keeps on a west-south-west course through "pretty open land." He angled across today's Camrose, then followed the south shore of Bittern Lake, where he reported seeing swans, ducks and geese. Throughout his trip, he took careful readings of direction and worked out latitude and longitude. He positioned Bittern Lake as latitude 52°59'37". He was just about spot-on: the railway station at Bittern Lake is almost exactly at 53 degrees. Where he did make an error was in estimating distance: he generally underestimated how far his party travelled each day, but historians can correct for this, since he took astronomical observations at most major landmarks. From Bittern Lake, Fidler crossed the "Battle or Fighting River," its name a reference to the incessant warfare between the Cree and the Blackfoot that took place in the area. It is one of the old geographical names that European map-makers have not changed. There were a few pines growing near the river, a fact that Fidler commented on, since these were the first he had seen since leaving Buckingham House.

A stone cairn has been built at the approximate place of this river crossing, one of the very few commemorative markers of Fidler's epic journey. To find the cairn, take Range Road 215 south past Rosenroll cemetery (all that is left of a pioneer settlement), and drive down into the river valley. The cairn lies at the southwest corner of a narrow country bridge.

From the Battle River crossing, Fidler travelled southwest, roughly paralleling today's Highway 2A. After about 20 kilometres, he and his troop arrived to spend the night at a Native camp of 17 tipis somewhere south of today's Wetaskiwin. The chief's tent, Fidler remarked, was very large, made of 30 buffalo skins, and heated by two fires. The liquor kegs were broken open and, as usual, most of the men proceeded to imbibe too much. The following day, they went nowhere. The journal notes: "With last nights boose of Drinking, the Indians did not move this Day, as they found themselves indisposed after their debauch."

Fidler next made a beeline for the Red Deer River, where his Peigan guides had left their families in camp. Since all the families were to go home together, the travel party was now quite

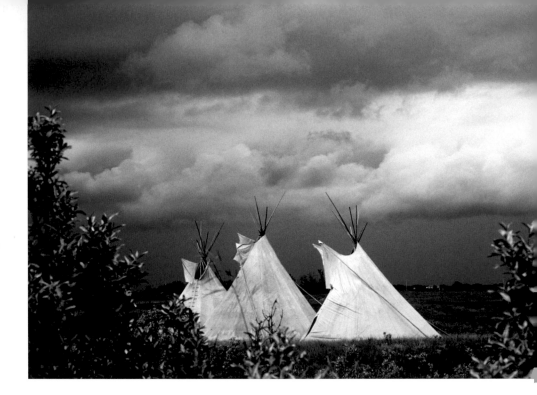

Fidler's Native companions would likely have camped in tipis like these photographed in Saskatchewan.

large, and Fidler was able to witness the band's methods of travel, using horse- and dog-drawn travois that he called "sledges."

"The men in general ride as it would be debasing themselves to walk," he wrote. "The women seldom or ever ride when they pitch along." The party crossed the river on November 20, probably at the lower end of the canyon due east of Red Deer city. This was a momentous day for Fidler: "Here I first got sight of the Rocky Mountains, which appeared awfully grand... very similar to dark rain like clouds rising up above the Horizon in a fine summers evening." The closest present-day river crossing to his is likely the Joffre Bridge on Highway 11, but even on a height of land, and with good binoculars, it is hard to see even a hint of mountains to the west. Perhaps one needs the clarity of a cold winter's day and a pollution-free atmosphere. From the Red Deer River, Fidler headed almost due south across the treeless plain; he described how the Natives made fires from dried buffalo dung kept burning with "bits of inside fatt" and how they chased buffalo on horseback. They crossed the Bow River near Calgary.

Instead of following Fidler's outward march from Bittern Lake, our route stays close to that of his return journey, simply because it passes through more interesting country. From the Fidler Cairn, continue south on Range Road 215, take the next east fork in the road and make your way to Highway 21 at the Battle River Bridge. Here, a riverside park holds history of a later vintage than Fidler's. A sign gives information about the first settlement here, an early Métis village first known as Laboucane after six brothers who arrived here in 1878. They earned a living by supplying Fort Edmonton with fresh buffalo meat, which they loaded onto their two-wheeled Red River carts, crossing the river on a "bridge" made of five canoes overlaid with

planks. More Métis families settled nearby, and soon afterward a Roman Catholic missionary, Father Hippolyte Beillevaire, arrived and the community built a small church dedicated to St. Thomas. The settlement, which later boasted an 18-room hotel, was called Duhamel after the Archbishop of Ottawa, who presented the church with its fine cast bell. Nothing remains of this historic village except for the 1883 church, still in good condition and containing the original hand-hewn pews. It lies up a side road from the park, across the railway tracks. In its cemetery lie 375 graves, an appalling number of them those of infants.

Another park signboard, complete with an astounding old photograph, gives information about the Grand Trunk Pacific Railway's huge curving rail trestle, built across the river here in 1909. At 1,200 metres long and 36 metres high, it was at the time the largest of its type in the world. But it was used for only 14 years and was dismantled when the railway was sold to Canadian National. The modern settlement of Duhamel then relocated south along the highway.

Settlers from Scandinavia arrived in this part of Alberta in about 1895. The country around New Norway, a few kilometres south of Duhamel on Highway 21, is a pleasant mixture of open fields and lakes set in gently rolling terrain, beautiful in all seasons. In summer, fields ripple with the green of young wheat, the gold of canola or the liquid blue of flax. In fall, thick rows of remnant stubble look like corduroy, dotted with round bales; in early winter, the first snow accentuates the patterns of cultivation. In some ways, agriculture has improved the look of the landscape that Fidler's party tramped through, mostly on foot, complaining of the lack of fire-wood for their campfires. Today, signs near New Norway advertise U-pick saskatoons, berries the Native women would have gathered to add to their pemmican.

Grain swaths like corduroy undulate across Fidler's "pretty open land."

Little Beaver Lake, about 10 kilometres south of New Norway, has an inviting campground among a flaunt of yellow aspens, the kind of place that Fidler might have chosen, and the village of Ferintosh provides an interesting overnight option: bed-and-breakfast at the 1930s Ferintosh Manor.

DAY TWO �֍ INTO THE BADLANDS

Head east from Ferintosh on Township Road 440 to move closer to Fidler's route. At Highway 56, drive south to cross Meeting Creek, a small stream in a wide marshy coulee, where Cree from the north and Blackfoot from the south traditionally agreed to meet peaceably for annual buffalo hunts. When Fidler passed nearby on his return journey, he found here "25 tents of Blood Indians who have been here a long while at a Pound," where they trapped buffalo. Today the main attraction lies just east of the highway, where the modern hamlet retains an early grain elevator, with its original hydraulic engine, and a railway station built by the Canadian Northern Railway in 1913. This well-preserved station building, with its high hip roof and dormer windows, is an architectural gem, neatly painted in regulation cream and green and still on its original site, beside a piece of preserved track. In summer, both the station and elevator are open for tourists, and the station grounds are a community park. The railway, however, is long gone.

South of Meeting Creek, Buffalo Lake sprawls across the landscape. In shape it really does resemble a buffalo lying on its side, its head to the north, legs west and tail (Tail Creek, which drains into the Red Deer River) on the south. At the south end of the lake, the former community of Tail Creek was once the largest in the area, with 400 log cabins and a population approaching 2,000. This was a rough-and-ready supply centre for Métis hunters who came from the north in search of buffalo. When the buffalo were gone, the settlement faded away, and prairie fires destroyed all but one of the cabins; this was later removed to the museum at Stettler. There is, however, an overgrown cemetery, on a side road north and east of the Highway 21 bridge over the Red Deer.

A rolling sea of blue flax ripples over a field near Meeting Creek.

Buffalo Lake is big—the fourth-largest lake in Alberta—and it's well endowed with parks and recreation sites, most of them accessed from the east and the south. Fidler passed east of the lake, crossing Meeting Creek somewhere north of Donalda, and he camped on Red Willow Creek. But he mentioned Buffalo Lake and gave its bearings, based on information gleaned from his companions. "I could not see the lake myself as there is a small hill running along the ESE side of the lake," he wrote. And later: "[N]o woods except along the East part of the Buffalo head; a small creek runs out of this lake into the Red Deers [sic] River. This lake is pretty deep, with Pike fish in it." If Buffalo Lake was named for its shape, Fidler's informants must have been pretty observant surveyors to have distinguished this from the ground. Today, only maps and aerial surveys show the shape distinctly.

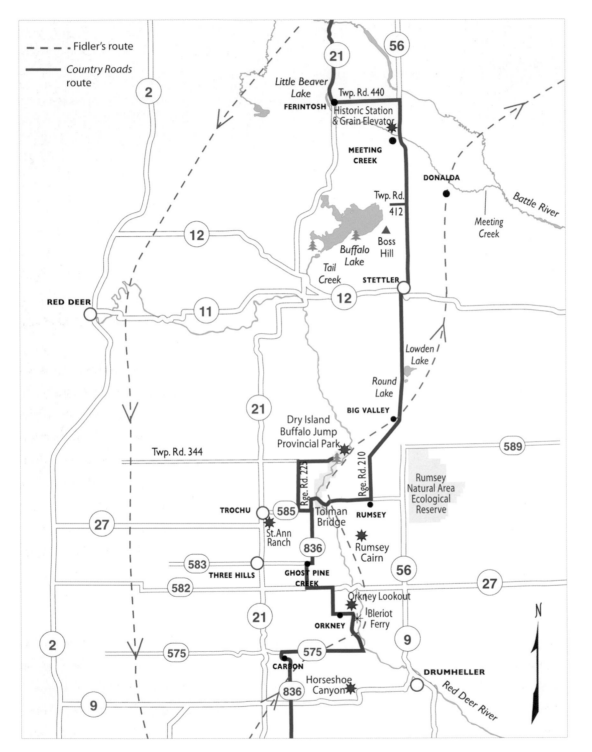

LEGEND
- ○ large community
- ● small community
- ✶ place of interest
- 🌲 park/recreation site
- – – – optional route
- ‖ bridge
- ⛪ church
- ✳ ferry

- – – – Fidler's route
- —— Country Roads route

The journey takes us from Ferintosh to Meeting Creek and railway history, to Big Valley, through summer fields bright with canola or blue with flowering flax. Then it's into the badlands, and an evening visit to Dry Island Buffalo Jump Park.

N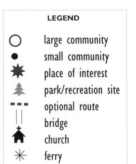

Bright yellow colts-foot blooms around a small alkali pond.

Township Road 412 leads east to Buffalo Lake Provincial Recreation Area, where there is a large campground by a sandy beach just north of Fidler's "Buffalo head," the small, sharp hill now known as Boss Hill. (In the lake's aerial view, Boss Hill is on the hump, or boss, of the buffalo.) Across the lake is Pelican Point, and on the southern rim are Rochon Sands Provincial Park and The Narrows Provincial Recreation Area. With its many shallow bays and deep waters, the lake provides ideal habitat for waterfowl, including the rare piping plover, and it is known for its large population of hawks and eagles. Here, too, are nesting colonies of great blue herons and black-crowned night-herons. And yes, there are still pike in the lake.

Fidler camped near today's Stettler. From high ground to the south he took bearings of prominent landmarks, including today's Gopher Head Hill—"called by these Inds [*sic*]…the Ground Squirrel Hill"—east of Rumsey and the blue outlines of the Hand Hills, two more names preserved from the past.

Stettler derives much of its tourist interest from summer steam train excursions on the Alberta Prairie Railway south to Big Valley. One can virtually follow this railway line all the way on Range Road 201, which passes through the old settlement of Fenn. Wildlife enthusiasts might choose instead Highway 56 just to the east, which runs beside Lowden and Round lakes. In the aspen parklands of Alberta, a land that is all knobs and "kettles" from the retreating glacial ice, all the little kettle holes are worth browsing. Canada geese and snow geese congregate in the fall, and in spring avocets and other wading birds stalk the shallows. Some of the lakes are rimmed with white salts and blazing yellow coltsfoot.

A huge area of this glacial terrain has been preserved as Rumsey Natural Area, east of the highway. The largest uninterrupted tract of native aspen parkland in Canada, its 180 square kilometres are grazed today by cattle. This landscape, apart from the changed species of grazing bovines, has changed little since Fidler's day: his journal makes mention of "plentiful" buffalo. Not widely advertised, the reserve can be reached from Secondary 589, southeast of Big Valley, where there are a few small roadside parking lots. The reserve is restricted to travel on foot, and it is recommended that you obtain permission in advance from the leaseholder (phone numbers are usually given on reserve signs).

Big Valley, the terminus of the tourist steam trains from Stettler, wears its railway history proudly. Its station, built by Canadian Northern in 1912, is the main attraction, well refurbished inside and out, and several rail cars parked outside provide more museum exhibits. A short walk south, the ruins of the railway roundhouse, made of stone, stand stark against the gentle hills, looking for all the world like a Roman amphitheatre or a bullring. Nearby, the Big Valley grain elevator has been preserved, another one of the few remaining giants. And on the northern skyline St. Edmund's Church, painted a bright shade of blue, still overlooks the valley, as it has done since 1917.

Scollard Road, one of the few diagonal roads in this part of Alberta, leads southwest from the town through valley ranchlands where you are quite likely to meet a herd of longhorn cattle. The valley is well named—it is certainly big. Fidler and his troupe camped here for several days to hunt buffalo. Fidler commented of the buffalo: "They are so plentiful that when the Indians run them [on horseback] they immediately fill up the place like waves in the sea." This was on Fidler's return route: his party had followed the Red Deer Valley north from near today's Drumheller and left the river near Scollard to head northeast.

Of all the country that Fidler crossed, enthusiastically surveying as he went, none is as little changed as this section of spectacular valley that slices through the prairie down to the Bleriot Ferry northwest of Drumheller. Largely unapproachable by road, though crossed by a couple of bridges, its relative isolation has kept it pristine. With its steep banks and eroded hoodoos it was never suitable for agriculture, and even today it is used only for grazing. To follow Fidler's route closely, one should be on foot for this beautiful 60-kilometre stretch of the Red Deer. Failing this, the best place to experience the river valley and its badlands as Fidler saw them is Dry Island Buffalo Jump, a provincial park where you can hike or picnic among the willows and cottonwoods beside the river. The park is almost directly west of Scollard, but you can't get there without a fairly long detour. To do this, keep south from Scollard on Range Road 210 almost to Rumsey, then head west on Secondary Highway 585 to cross the river on the Tolman Bridge. From here, Range Road 225 north leads to the park's access road.

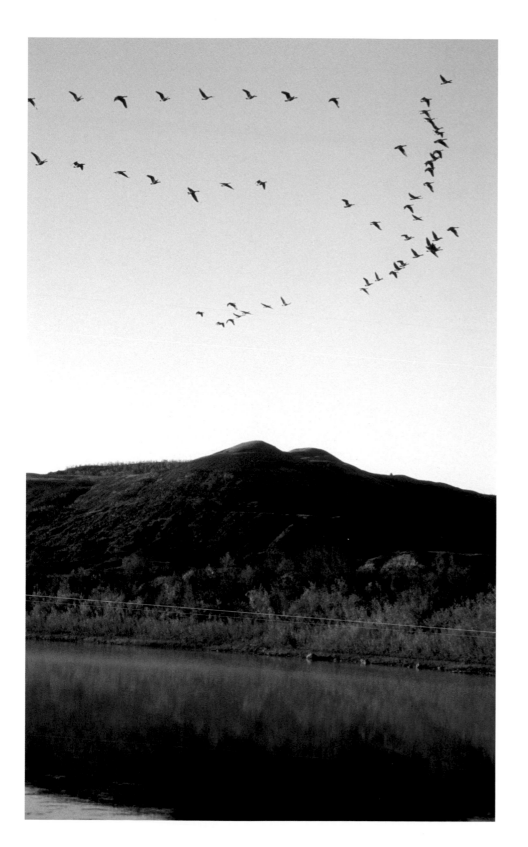

The extra drive is worth it. The park road descends steeply 200 metres into a great sweep of spectacular badlands, the valley broadened by the rush of glacial meltwater, the river cutting deeper around a cut-off mesa, forming the dry island that gives the park its name. At one of the steep cliffs along the valley edge, Native people herded buffalo over a "jump" that archaeologists have dated as 4,000 years old. The park is isolated, little used, wild and beautiful, a marvellous place for birds and flowers and wildlife. Perhaps Fidler himself walked here. Certainly he travelled along the stretch of river near the Tolman Bridge. Today there are campsites, one on each side of the river, and trails that wander off through the badlands and the tall cottonwoods. It's a popular spot to launch a canoe, and there's good fishing. In fall, with the cottonwoods trembling gold and geese rising through the mists, it's a beautiful place indeed.

West of the Tolman Bridge is the village of Trochu, named after

Geese flying over the morning mists of Red Deer River.

Armand Trochu, who, with a group of French cavalry officers, founded the St. Ann Ranch Trading Company in 1905, the nucleus of a settlement that became known as Trochu Valley. Ranch headquarters were situated in a broad coulee, on a tributary of Ghost Pine Creek. The Sisters of Charity later came over from France to establish a school and a hospital on the coulee lip. When the railway pushed through, the settlement boomed—at one time its general store was the largest between Edmonton and Calgary. The village has a good little museum and a fine arboretum with 200 varieties of trees and shrubs. Just outside town, the elegant three-storey ranch house at St. Ann's, now a Provincial Historic Site, is open to the public as a bed-and-breakfast and for afternoon teas. Its architecture and furnishings, and the memorabilia of the founding family, make this a very rewarding destination.

For a look at another historic site, though a far earlier one, return via Secondary 585 to cross the Tolman Bridge and continue east 6.5 kilometres. Take Range Road 213 south to Township Road 330, then drive east up a steep hill toward a communications tower. On the summit to the north (you must walk in) lies an overgrown medicine wheel and some disturbed effigies. Known locally as Stonepile Hill, the area was investigated by archaeologists, but the medicine wheel had been plundered and its cairn stones tumbled. They found arrowheads, potsherds, glass beads and part of a stone pipe. The effigies, laid out in boulders, are difficult to discern, and the central cairn is overgrown with brush, but the site itself, covered with tousled grass and sagebrush, is lovely and the view across farmland to the river is exceptional, particularly at sunset. At one time it must have been a very sacred place.

To drive as close as possible to Fidler's route along the Red Deer River, return to the west side of the Tolman Bridge, then take Secondary Highway 836 south to the community of Ghost Pine Creek, south again, then east on Highway 27 toward the Morrin Bridge and south on Secondary 837 to Orkney, with its single house and a fine little church. (This seems a lot of jogging about, but that's the disadvantage of following range roads.) Where Secondary 837 bends east to the river rim, there's an amazing little park, one often overlooked. Here, on Orkney Hill Lookout high above the river, one can look north into a land little changed in 200 years, where the river winds blue and silky and one can well imagine Peter Fidler and his band of Peigans straggling through the badlands and camping at night in the cottonwoods. The river valley below has been set aside as the Tolman Badlands Heritage Rangeland Natural Area, a large title but a worthy undertaking. One hopes that within this preserve the river valley will stay pristine.

It is clear from Fidler's journal that he enjoyed the Red Deer River valley. He found it full of wonders. On the steep badland cliffs, he watched Native women taking yellow earth to make paint for their faces and to keep their leather shoes and clothes soft after being wet. He saw men making arrows from the wood of saskatoon bushes, which were and still are plentiful in the valley. He

*View of Red Deer River
from Orkney Hill Lookout.*

found and described the prickly pear cactus as "full of sharp prickles…which grew upon a wrinkled round flat… They are very bad to walk amongst running immediately through the shoes."

On Kneehills Creek he discovered deposits of coal in the steep clay banks: "I brought some of this & put on the Tent fire, which burnt very well without any crackling noise." Later, where the creek ran into the river, he found "a large bed of excellent large coal, above 4½ feet thick." But perhaps best of all were the buffalo, which were numerous to the northeast: "…the ground is entirely covered by them and appears quite black. I never saw such amazing numbers together before. I am sure there was some millions in sight as no ground could be seen for them in that compleat semicircle & extending at least 10 miles."

Fidler described how the Natives liked to eat unborn buffalo calves "even when not more than the size of a quart pot," and he told how they prized the albino buffalo with skin "of a pure milk white, with generally curly hair." These skins were worth two horses or more in trade. Somewhere west of Drumheller, probably near today's Crossfield, Fidler saw a buffalo jump, which he called a pound: "[C]rossed a creek a little above a high steep face of rocks…which the Indians use as the purpose of a Buffalo Pound by driving whole heards before them & breaking their legs, necks, etc. in the fall, which is perpendicular about 40 feet. Vast quantities of Bones are laying there…" He also described the formation of drive lanes, "knee high" piles of dry buffalo dung (known as dead men), positioned as corridors to funnel the animals over the cliff: "The men drives the Buffalo within this kind of fence all the way to the rock…some men ly down flat on the ground near the Dead Men and rise up as the Buffalo passes them and follows them with all speed to keep them constantly on the run," a hazardous undertaking.

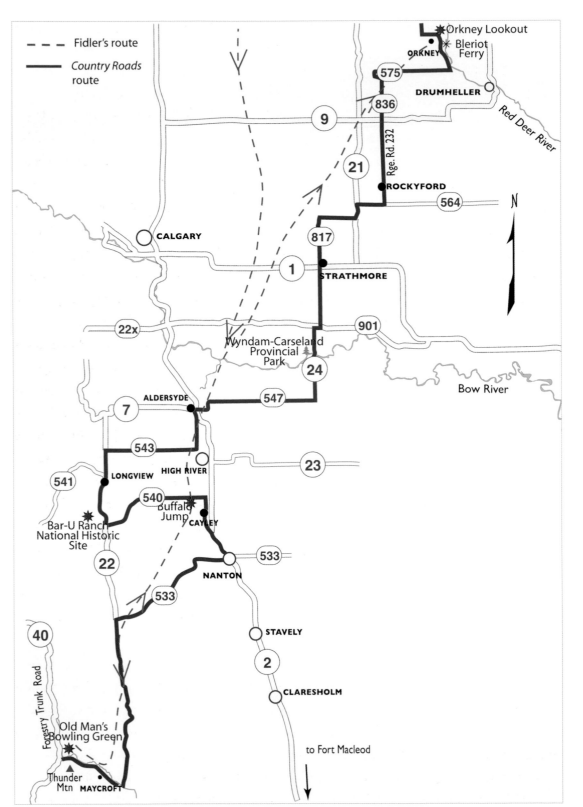

Fidler's route

Country Roads route

Orkney Lookout
ORKNEY
Bleriot Ferry
575
836
DRUMHELLER
9
Red Deer River
21
Rge. Rd. 232
ROCKYFORD
564
CALGARY
817
N
1
STRATHMORE
22x
901
Wyndam-Carseland Provincial Park
24
Bow River
ALDERSYDE
547
7
543
23
541
LONGVIEW
HIGH RIVER
540
Buffalo Jump
CAYLEY
Bar-U Ranch National Historic Site
22
533
533
NANTON
40
STAVELY
Forestry Trunk Road
2
CLARESHOLM
Old Man's Bowling Green
Thunder Mtn
MAYCROFT
to Fort Macleod

From the badlands of the Red Deer Valley, drive south to cross the Bow River and head west into the Porcupine Hills. Finish the day with a visit to Head-Smashed-In Buffalo Jump, or the heritage town of Fort Macleod.

LEGEND

○ large community
● small community
✸ place of interest
🌲 park/recreation site
- - - optional route
|| bridge
⛪ church
✳ ferry

152

DAY THREE ✤ EXPLORING THE FOOTHILLS

Travellers like to spend time in the Red Deer River badlands because of the attractions of Drumheller and the dinosaurs, the magnificent Royal Tyrrell Museum and, farther downstream, the Atlas coal mine, restored and open for tours (see chapter 8). But if you wish to bypass all this, at least for now, Fidler's route to the mountains is better followed through the fields, some made elegant by swirling machine-made patterns or poignant by abandoned homesteads. Continue along Secondary Highway 837 on the south side of the river past Bleriot Ferry (see chapter 8), then climb out of the valley and follow Secondary 575 west for about 20 kilometres. Turn left (south) on Secondary 836 to the little town of Carbon in the sheltered valley of Kneehills Creek. (Fidler apparently never saw the astonishing topography of Horseshoe Canyon, but you can: it lies east along Highway 9.) From Carbon his route lay due south, crossing the Rosebud River near Rockyford, then angling southwest through the present communities of Nightingale and Lyalta to reach the Bow River (the Peigans called it Bad River) just east of Calgary.

Fidler crossed the Bow near the mouth of the Highwood River. He was delighted to find the river free of ice, though the banks were very steep. He wrote: "At 9½ AM, all hands began to cross the Bad river at one of the rapids, which was about 2 feet deep, with small round stones & very strong current. All rode across it, men, women and children, the latter on sledges." From here on, Fidler's outward and return journeys followed much the same route, probably because his guides were in their own territory and followed their traditional trails. Apart from the freeway bridge (Highway 2 south of Calgary), the crossing of the Bow closest to Fidler's is a good 25 kilometres downstream where Highway 24 spans the river at Wyndam-Carseland Provincial Park.

To reach this crossing from Carbon, continue south on Secondary 836 through Rockyford to Secondary 564 and turn west, then south on Secondary 817. This crosses the Trans-Canada Highway at Strathmore (about 55 kilometres from Carbon) and continues south for 25 kilometres to the bridge across the Bow River. In Fidler's day, the Bow ran free, but at least the park at the Carseland Dam preserves a good stretch of river wildland, and the dam site is a good place to observe fish-eating birds such as herons, pelicans and kingfishers.

Once across the Bow (near today's Highwood River Natural Area), Fidler's party camped near an old buffalo pound. The following day provided a highlight in the journey: The Peigans asked Fidler and John Ward to put on their best clothes because a Snake waited nearby and wished to meet them. "…The Snake Indian viewed us from head to feet & from foot to head with the greatest attention, felt at our skin in places and expressed great astonishment at us, particularly at our having a different coloured hair from any Indian." Invited to smoke a pipe with him, Fidler performed a magician's trick of lighting the tobacco with his "burning glass."

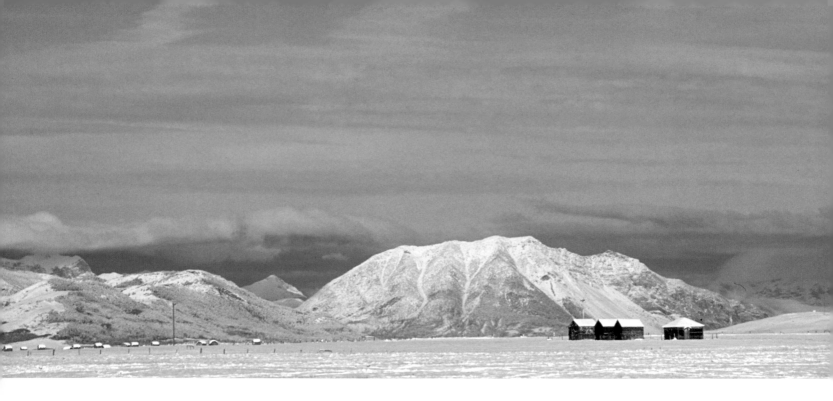

He also demonstrated the use of his surveying instruments. "We was [*sic*] the first Europeans he had ever seen before," commented Fidler. This Snake had hair that dragged on the ground, but Fidler was told that it was mostly buffalo hair woven with his own and plaited into thick ropes (perhaps an early variant of dreadlocks?).

The party camped the following day on Sheep Creek and next morning made its way to a large Peigan encampment on the Highwood River, a stream that Fidler called the Spitcheyee. There were 150 tents pitched on the river bank about five kilometres north of today's High River Station, now the Museum of the Highwood.

To follow Fidler, take Highway 24 south from the Carseland crossing, then Secondary 547 to Aldersyde and Highway 2A. High River is a fine old ranchers' town, with many brick buildings dating to the turn of the last century. There are several purveyors of western wear, including Bradley's Western Store, which has a bit of a museum commemorating the old cowboy days. South of the station/museum is the Highwood Train Project, a fully equipped passenger train and freight train, including the only restored mail car in Canada. Best of all is the dining car, now fully operational as a classy little bistro, all fittings original, the food and service excellent.

The foothills area south of Calgary was home for the Peigans, a land of grass valleys, voluptuous foothills covered with mixed forest, high mountains and game aplenty: deer, elk, antelope, moose, sheep and goat. In winter, buffalo came into the hills to escape the blizzards and deep snows of the open plains, for the weather here was — and still is — gentle. Little snow falls, and this is often melted overnight by warm chinook winds. For six weeks Fidler and his Peigan friends travelled in this lovely land between highways 2 and 22. It is impossible to keep

ABOVE
Grain sheds huddle in the snow, dwarfed by the magnificent winter mountains.

RIGHT
Whiskery fields of grain beneath the blue mountains.

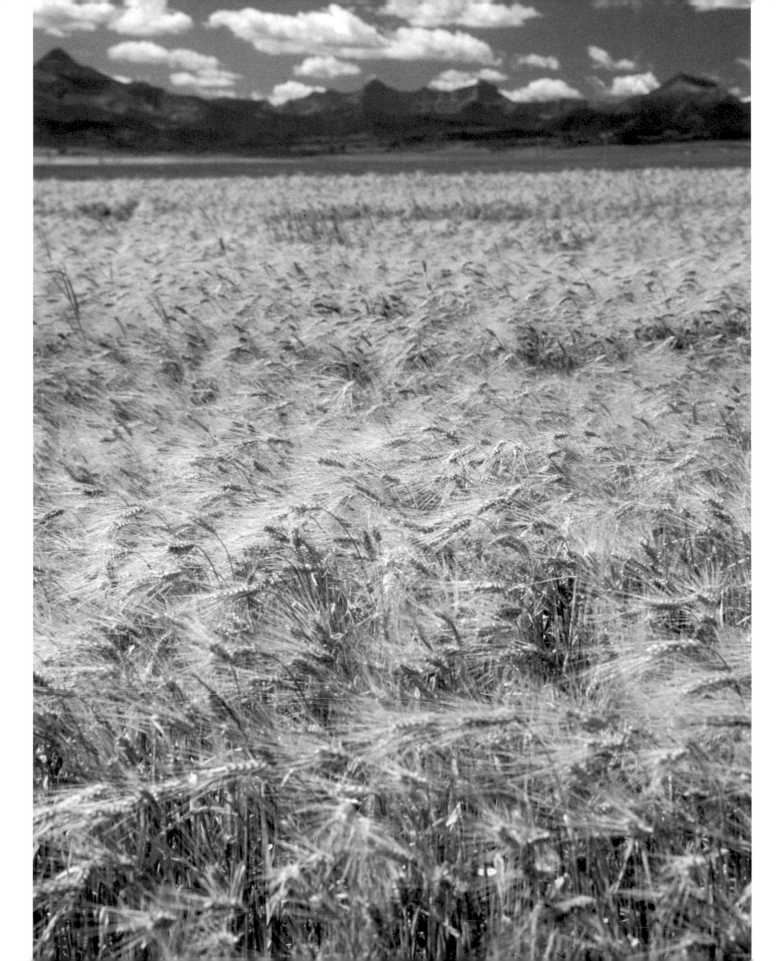

in Fidler's steps, for he meandered at will over the Porcupine Hills and into the foothills. So make your way west from High River to Longview and head south down Highway 22 to Pekisko Creek, where Fidler spent Christmas Day. His journal makes no mention of the date's significance. His Christmas Day entry describes a buffalo hunt on horseback: "They are so expert at this business that they will ride along side of the Cow they mean to kill & while at full gallop will shoot an arrow into her heart & kill her upon the spot." He also remarked on their arrows: "…shod with pieces of Iron hoop, old kettles & old pieces of Iron battered out thin betwixt 2 stones."

On Pekisko Creek more than 100 years later Fred Stimson founded the Bar-U Ranch, one of the first cattle ranches in the area. In 1882, Stimson trailed Durham cattle up from Idaho to start an enterprise that once stretched to nearly 64,000 hectares of open range, with 10,000 cattle and more than 800 horses. Later broken up into smaller parcels, today's remnant Bar-U Ranch was acquired by Parks Canada as a National Historic Site to commemorate Alberta's ranching history. Here, along with the 35 historic buildings, the park recreates the atmosphere and activities of traditional cowboy days. In summer the place is busy with everyday ranch activities and special tourist events—rodeos, calf-roping, blacksmith and chore-horse competitions, bannock and coffee around the chuckwagon, even games of cowboy polo. The visitor centre also provides good cowboy coffee, bannock and buffalo stew. But nowhere is there a reference to Peter Fidler.

From the ranch, drive east on Secondary Highway 540 through what used to be the little settlement of Pekisko, now only a single ranch house. Before it reaches Highway 2, the road passes right beside Old Women's Buffalo Jump, a place that Fidler likely saw in action. It commands the south bank of Squaw Coulee, an old name in an old story. Napi, or Old Man, is a mythical being who appears in Plains peoples' legends as creator of all the earth and the creatures on it. Squaw Coulee was the Blackfoot Garden of Eden. When Napi created humankind, or so the legend goes, he separated men from women; the women lived in Squaw Coulee, the men in Boneyard Coulee, several kilometres south.

One day, a squaw wandering far from home met a man, also far from home. They sat down to talk and introduced themselves to the facts of life. That night, all the men moved into Squaw Coulee, and humankind's future on Earth was assured. Today, there's not much to see in the coulee besides the eroded rimrocks over which the buffalo charged, but it's an important archaeological site, one that had been long abandoned. When a flash flood swept through the coulee 50 years ago, it uncovered a white sheet of buffalo bones below the surface. Archaeologists were alerted and the site was later excavated, revealing seven metres of rich deposits containing clues to many different cultures dating back thousands of years.

Drive south on Highway 2 to Nanton, then head west to cross the Porcupine Hills on Secondary 533, one of the loveliest of the crossings. At a prominent fork in the road (by old Greenbank School), turn right into Williams Coulee, a gravel connection to Highway 22. Since Fidler spent so much time in the area, mostly in and around buffalo pounds of which he provided great and gory descriptions, he must have travelled along every stream and into every coulee, gradually making his way south. We know he explored Mosquito and Willow creeks, and on Sheppart Creek, where the Natives had made a log buffalo pound, he stayed more than three days. While he was there, "Several of our young men arrived here with 25 good horses they have been stealing from the Snake Indians ... These men say that a few tents of Cottonahew [Kootenay] Indians were camped on the [Oldman River] wishing our Indians to visit them, to barter for horses."

This was an invitation Fidler could not resist. No white man had ever seen Kootenays, who were from the west side of the mountains. The Peigans, always eager for more horses, were also anxious to go. They left at 4:15 in the morning on December 30 and walked all day (the Peigans were expecting to ride home on their new steeds), but at around 10 that night, the chief and some of his men, along with John Ward, decided to turn back. Fidler wrote: "The Chief used every method in his power, except force, to persuade me to return as he said that the road was very bad—also a great distance & perhaps the Cottonahews might hurt me." Undeterred, Fidler and about 30 of the Peigans went on, through the night. It was New Year's Eve. "One of our men shot a bull at 3½ am on the 31st, being nearly full moon & very clear & light. We remained here 2½ hours, roasting a little of the bull & took a small nap of sleep." They were in the wooded Porcupine Hills.

Highway 22 more or less follows Fidler's route, though without his deviations. It's a fine road, one of the most scenic in the province, cutting a fast slice between the Porcupines on the east and the foothills to the west. Keep south until you reach the bridge over the Oldman River, with its small Maycroft campsite. Fidler's route went west along the north side of the river. There is a road here today, but it dead-ends at the boundary of Bob Creek Wildland Provincial Park, part of the inviting Whaleback Ridge. Possibly it was from high on this ridge that Fidler saw to the south "a high cliff on the Eastern edge of the Rocky Mountains which the Indians called the King or the Governor." This was Chief Mountain, perhaps the most prominent landmark in southwestern Alberta, though the mountain itself is over in Montana.

Fidler's party followed the Oldman River to the shadow of Thunder Mountain, then crossed the river to the Kootenay camp, which was roughly where Racehorse Creek tumbles into the river beside the Forestry Trunk Road. Just east of here, Fidler came to a place the Peigans called Old Man's Bowling Green, on a level grass plain within 30 metres of the river, its edges then delineated by stones and cairns in the shape of an elongated heart. Fidler drew a diagram in his journal and reported:

> *It is a place where Indians formerly assembled here to play at a particular Game with by rolling a small hoop of 4 Inches diameter & darting an Arrow out of the hand after it & those that put the arrow within the hoop while rolling along is reckoned to have gamed....There are 11 piles of stones, loosly piled up at regular distances along the out sides, about 14 inches in Diameter & about the same height. These I imagine to have been places for the Older men to sit upon to see fair play on both sides & to be the umpires of the Game.*

Fidler asked about the game's origins:

> *They said that a White Man (what they universally call Europeans) came from the South many ages ago & built this for the Indians to Play at ... They also say that this same person made Buffalo, on purpose for the Indians. They describe him as a very old white headed man & several more things very ridiculous.*

South of the Highway 22 bridge, a road leads west to the small community of Maycroft and through Livingstone Gap, known locally as "the Gap," the narrow canyon in the Livingstone Range that the river itself has cut. Fidler described it as "very rocky but a narrow bare pass Betwixt the water & the high perpendicular rocks of the Mountains," very much as it looks today, apart from the road snuggled under the shoulder of Thunder Mountain. The Gap is popular with fly fishermen, and in summer the stony banks are bright with fireweed. But all trace of Old Man's Bowling Green farther upstream, just before the Forestry Trunk Road, has vanished, swept away by river floods. At the Kootenays' camp by Racehorse Creek, Fidler's Peigan guides feverishly traded for horses; when all the horses were gone, most of the Peigans headed back to the safety of their own lands. But Fidler and a small group chose to stay on to explore more of

the country. After climbing Thunder Mountain and making copious and useful observations, both of the landscape and the customs of the Kootenays, he eventually turned around and went back to Buckingham House; the Peigans entrusted with his well-being were anxious to take him home.

Since we have followed parts of his outward and return journeys, it seems fitting to leave Fidler here in the mountains, for we are close to other rewarding places: Head-Smashed-In Buffalo Jump, Fort Macleod, the lovely back roads south to Waterton. No journey in Alberta is ever ended.

And neither was this the end of Fidler's explorations. He returned home to Buckingham House in March 1793 to continue a lifetime of adventures and surveys for the fur trade. He stayed with the Hudson's Bay Company all his life, travelling, it is reckoned, some 78,000 kilometres and surveying almost 8,000 kilometres of rivers and lakes in today's prairie provinces. And he sent his maps and observations to London, where this vital material was incorporated into the first maps of North America, such as the great Arrowsmith Map of 1802, used by all subsequent explorers, railway surveyors, ranchers and settlers. He was just as important a pioneer surveyor and explorer as David Thompson or Lewis and Clark, and in recognition of that he is officially acknowledged federally as a Person of National Significance. Many of his journeys were epic, his journals extensive and descriptive and some of the best records of life on the plains before the European invasion. Why is he not better known? This is the greatest mystery of all.

Like all prudent traders of his day, Peter Fidler amassed some wealth and left a will. After ensuring that his wife and children in Canada and his relatives in England were well cared for, he set aside the rest of his fairly substantial estate to be invested at compound interest until 200 years after his birth. The whole amount was then to be given to the oldest male descendant of his youngest son and namesake, Peter Fidler. But things went somehow awry: After Fidler died at age 53, at the HBC's Dauphin Lake House in Manitoba, his executors did not follow instructions; the money was later distributed among all his family. Nevertheless, when the 200th anniversary of Fidler's birth rolled around on August 16th, 1969, there were quite a few descendants holding their breath, hoping against hope that one of them would become a millionaire. That would have brought Peter Fidler some instant of fame, at least by the mercenary standards of the 20th century. ❖

Quotations from Fidler's "Journal" are from Bruce Haig's transcription, published by Historical Research Centre, Lethbridge, Alberta (hrc@ourheritage.net).

Sunset from the Porcupines, the Rockies in the distance.

ALSO BY LIZ BRYAN

THE BUFFALO PEOPLE
Pre-contact Archaeology on the Canadian Plains

Liz Bryan takes the clues from decades of archaeological research and explains where the ancient people who lived on the Canadian plains might have come from, how they lived their lives and how they faded out of existence and memory. Featuring photos, maps and line drawings.

"It will probably be taken along on a lot of trips to places such as Writing-on-Stone and Head-Smashed-In." — CALGARY HERALD

1-894384-91-1 ❖ $19.95

STONE BY STONE
Exploring Ancient Sites on the Canadian Plains

Liz Bryan explores the Canadian prairies in search of ancient villages, buffalo jumps, vision-quest sites and other tangible relics of a forgotten time when ancients inscribed the pictures and symbols of their world, allowing us to see, however briefly and imperfectly, into their lives. Featuring maps, line drawings and full-colour photos.

"An excellent introduction to this fascinating subject." — PRAIRIE BOOKS NOW

1-894384-90-3 ❖ $24.95

LIZ BRYAN is a journalist by training with an extensive background in magazine editing and publishing. With her late husband, Jack, she was the co-founder of *Western Living* magazine.